The Art of Hokusai in Book Illustration

JACK HILLIER

The Art of Hokusai
in Book Illustration

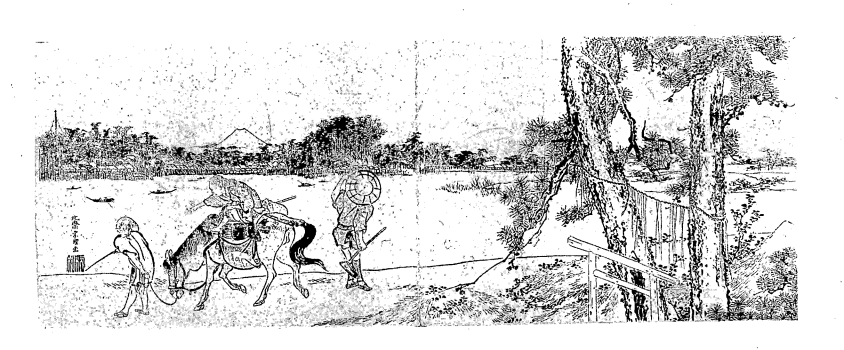

Sotheby Parke Bernet

University of California Press

© Jack Hillier 1980

First published 1980 for
Sotheby Parke Bernet Publications by
Philip Wilson Publishers Ltd
Russell Chambers
Covent Garden
London WC2

Published in the United States and Canada by
University of California Press
Berkeley and Los Angeles

ISBN: 0 85667 066 9 (UK edition)
ISBN: 0 520 04137 2 (US edition)
Library of Congress catalog card no: 79 9687

Designed by Gillian Greenwood
Printed in Great Britain by
Balding and Mansell, Wisbech
and bound by Webb Son & Co. Ltd,
Glamorgan, Wales

Contents

Preface

The text of this book is an expanded version of the 'Cohn' Lecture which I gave at the Ashmolean Museum in Oxford in 1976, and the appendix of books with illustrations by Hokusai is intended to supersede the list that I first drew up for my 1954 *Hokusai* – a list that in the light of subsequent research and discoveries has now proved to be inadequate and inaccurate.

For Chapter 10 and Chapter 15 I have drawn on material already published respectively in *Ukiyo-e Art*, No. 13 (1966) and the Introduction to a reprint of F. W. Dickins's *One Hundred Views of Fuji by Hokusai* (1958).

Acknowledgments

The author is indebted to any number of individuals for help and encouragement in the preparation of this book, and particularly to the following private collectors or museum and library officials who have kindly provided him with, or been instrumental in obtaining for him, many of the illustrations, namely: Walter Amstutz, Huguette Berès, Jan Chapman, Tom and Mary Evans, Guiliano Frabetti, John Gaines, Kenneth Gardner, Luigi Ghezzi, Willem van Gulik, Money Hickman, Heinz Kaempfer, Roger Keyes, Eikō Kondō, Richard Lane, Susumu Matsudaira, François Mautin, Peter Morse, Seiji Nagata, Cornelius Ouwehand, Gerhard Pulverer, Akemi Ohta Shann, Lawrence R. H. Smith, Jūzō Suzuki, Osamu Ueda, Franz Winzinger and Hayashi Yoshikazu.

Acknowledgement is also made to the directors, trustees and other responsible bodies of the following museums and libraries for their courtesy in permitting reproduction of material in their collections, namely:

Museum of Fine Arts, Boston, USA

Art Institute of Chicago, USA

Chester Beatty Library and Oriental Art Gallery, Dublin, Republic of Ireland

Museo d'arte orientale 'Edouardo Chiossone', Genoa, Italy

Rijksmuseum voor Volkenkunde, Leiden, Holland

British Library, London, England

British Museum, London, England

Neuen Pinakothek, Staatsgemaldesammlungen, Munich, W. Germany

Bibliothèque Nationale, Paris, France.

Introduction

In the Edo period in Japan an artist's reputation during his lifetime was established as much or more by his contributions to printed books as by his paintings or even his prints in broadsheet form. There were little or no means by which his paintings could be brought to the notice of the general public; nothing in the nature of exhibition galleries and, on the contrary, a sort of almost secretive possessiveness on the part of the privileged owners. Separate sheet prints, though circulating more freely and to be seen hanging in the dealers' booths, did not bring an artist so widely nor so intimately before the public as the books, addressed as they were to a more or less complete spectrum of the literate population. But a century after an artist's death – and Hokusai is a case in point – the books are apt to be overlooked: it is the paintings, the preparatory drawings or the separately published and avidly collected prints that are given prominence and which form the image of an artist's creativity for us aftercomers. At best, a single opening, one picture from a sequence, is shown or reproduced whereas, properly to be appreciated, a book has to be leafed through, page by page, picture by picture, the impact of the prints being of cumulative effect, the artist purposefully organizing the serial contents to awaken and hold interest, often with a calculated crescendo at the end. These aspects, which are entirely peculiar to artistry in book form, cannot be communicated by individual prints.

It is true that with Hokusai, better known as a print designer than a painter, a few of his books are reasonably well known – one could cite the *Manga*, the 'One Hundred Views of Fuji' or 'Both Banks of the Sumida River' – but the point still holds good that even they are known by limited selections from them, and, if we consider his total output in books, form a very small proportion of the whole. Hokusai, from the very first contact of the western world with Japan, has enjoyed the widest popular acclaim, but that has depended only to a minor extent upon his achievements as an artist of the book.

The term 'book-illustration' does not at all convey the full scope of Hokusai's (or many other Japanese artists') work in book form, though it is hard to find a more acceptable, single, portmanteau word. Hokusai was certainly a very able, sometimes an inspired, illustrator of novels and other forms of literature, but many of his finest prints

in books are not illustrations in the narrow sense of the word, but pictures that stand on their own, unrelated to any text, and which comprise landscape, genre scenes or still-lifes. Sometimes collections of such diverse works were published under the useful Japanese title *Gafu*, for which we have no exact equivalent and meaning, 'A Drawing Book' or even 'A Drawing Manual', since there is a hint that such books convey a style and are in part at least notionally instructional. Through these *Gafu*, the woodcut medium was used to bring an artist's work to the critical attention of the people, other means, as I have explained, not being open to them; and we see in them one of the reasons for the fact that in no other country's pictorial art do prints in book form attain to so high a degree of significance relative to the national art as a whole as they do in Japan.

The medium of reproduction in Hokusai's day, as for centuries, was almost exclusively the woodblock print, and I think it is generally conceded that in this medium, especially the woodblock colour-print, the Japanese were, and are, the supreme masters. That Hokusai was conscious of the importance of the role of the block-cutters and printers might be assumed from the generally high level prevailing in his more consequential works, but it is explicit in a letter that has been preserved in which he called upon his publishers to employ a particular cutter who habitually achieved the effects he desired. It needs to be stressed, because it is a feature contributory to the total artistic effect, that text as well as pictures was cut on blocks (as in western 'block books' of the fifteenth century), and that the text was in a calligraphy – whether by the artist or another – with its own telling individuality. It underlines the complete reliance of the Japanese book in all its aspects on artists and craftsmen: the paper was hand-made; no press was used for printing, only a hand burnisher; and the binding was by hand too.

Two main forms of book were produced. One is what may be called the *ehon*, or 'picture-book' style. For this, sheets were printed on one surface only, folded down the centre and stitched together at the free edges.[1] This meant that pictures spreading across the two pages of an open book were formed of impressions from two separate blocks, or (if in colour) sets of blocks, with a channel or gutter at the inner binding edge and a narrow column, called a *hashira*, at the fold of the sheets which could be used for giving the title of the book, and the volume and sheet number. The covers were almost invariably of paper, rather stouter than that used for the text and prints, and often decorated with printed or embossed designs. The title was printed on a label pasted to the front cover. The method of binding limited the number of sheets per volume, and often several volumes were needed to form a complete work. The most voluminous of Hokusai's *ehon*, the Japanese version of the Chinese classic, the *Shimpen Suiko Gaden*, ran to ninety-one volumes, of which he himself illustrated the first sixty-one before retiring in favour of a pupil.

The other form was the folding album, or *orihon*. In this case each picture was printed complete on a single sheet and the sheets were folded in half and pasted together at the outer edges so that the book opened like a concertina. Covers were attached to the reverse sides of the two outer half-sheets.

[1] The Japanese term for this form is *fukuro-toji*, literally 'bag-binding'.

Perhaps here I should refer to, if not answer, the question that is invariably raised concerning the numbers of impressions constituting an edition. As with so many other aspects of Japanese art and culture, we are still inclined to think in terms normal to comparable western activities. Little has been recorded by the Japanese themselves about the everyday conduct of a publishing house in the Edo period, but we may be sure that it was governed by quite other considerations than those which actuated their western counterparts. The amount of hand-craftsmanship involved in printing probably to some extent dictated the Japanese procedure. There, it seems, an initial batch of books likely to meet the initial demand would be printed: with a *de luxe* poetry album, perhaps no more than fifty, or one hundred, copies; with a novel of popular appeal, perhaps a thousand or more. But the blocks would be stored, and if demand justified it, further impressions would be taken later. Now, because for every single sheet or picture the blocks had to be re-inked by the printer, there are differences between book and book even among the first batch of impressions: but for any new issue, after some time had elapsed, even though the blocks may have been unaltered, fresh wells of colour had to be mixed by the printer and thus there would inevitably be quite noticeable differences in colour from the earlier issues, even when there was no recognizable wear on the blocks. Yet the colophon and date of such re-issues might remain unaltered, and the books would in theory still qualify for the definition 'first edition', meaning a first edition printed piecemeal over a period of time. Hence it is often a matter of nice connoisseurship to determine not what constitutes a first edition, but rather a first issue or impression. So far as Hokusai is concerned, some books, especially the early poetry anthologies I shall mention, are believed to be of one issue only, but many, like the *Manga* and most of the novels, went on being reprinted until the blocks were utterly worn out and the impressions only travesties of the original early printings.

Hokusai's first sheet prints were of actors in their roles in a play performed in 1779, when Hokusai was nineteen. His first book-illustrations were published in the following year, and his last in the year of his death in 1849, almost seventy years later. In all, over 270 titles have been listed as published in that period, some with a single print, others with hundreds. A complete list with brief details of each book is given here as an appendix.

When so much is being said and written about the influence of the Japanese print on western art – almost to the point where one feels that the Japanese print is appreciated less for its own aesthetic worth than as one of the factors in the evolution of Impressionism and Art Nouveau – the importance of such works as the *Manga* and of the 'One Hundred Views of Fuji' in that cross-fertilization cannot be passed over. The *Manga*, indeed, was known in Europe during Hokusai's lifetime. In 1831, von Siebold, long resident in Japan in the early part of the century, began the publication of a monumental work on the country, and among the illustrations he included a few lithographs based on woodcuts in the *Manga*, Hokusai's name appearing on them as the artist. The lithographic versions completely westernized the style of the prints. European artists were not yet ready to heed the lessons that aftercomers found in

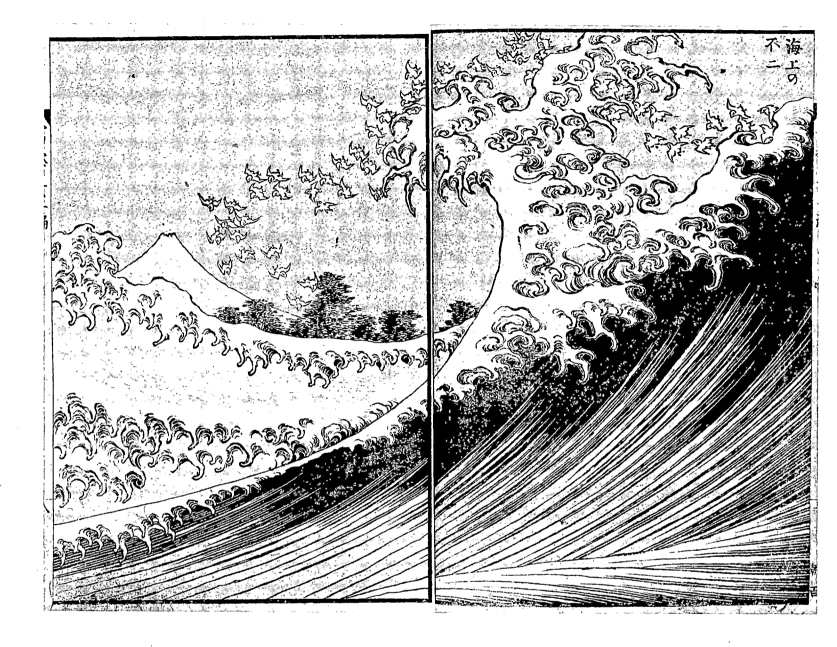

Japanese art, nor, indeed, were the particular Hokusai woodcuts used for reproduction of a kind that might have come as a revelation. But in the 1850s, when copies of the *Manga* began to circulate among the French artists and literatteurs, there were borrowings and adaptations, by Félix Bracquemond in particular, that signalled the beginnings of *Japonisme*, a movement of a significance in the history of western art that has only been fully realized and documented, in exhibition and monograph, in recent years.

The influence of the Fuji masterpiece, while less obvious, was in some ways possibly deeper. The first two volumes of the 'One Hundred Views of Fuji' had been published in 1834 and 1835, but the third and last volume did not appear – judging by the preface date, for the book itself has no colophon date – until Hokusai's last, ninetieth, year. No one has been able satisfactorily to account for that long fourteen-year gap between the second and the last volumes, since the style of the third coincides exactly with that of

1 Fuji above the waves. From *Fugaku Hyakkei*, 'One Hundred Views of Fuji', 1835

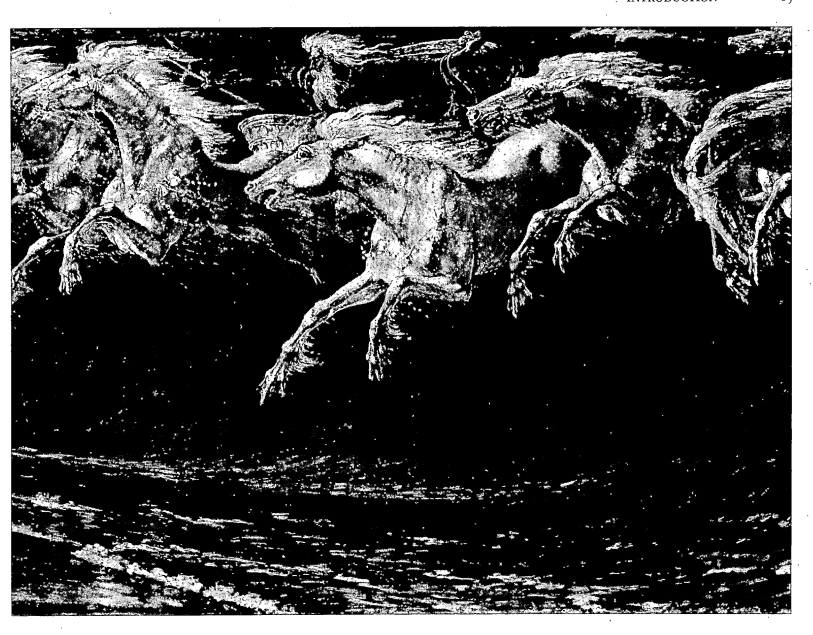

2 Walter Crane, 'The Horses of Neptune', oil painting (detail), 1892

the other two. But the three volumes were reprinted in 1875, and shortly afterwards, in 1880, there was a separately bound introduction in English by Frederick Dickins, who also provided translations of the prefaces and descriptions of the prints. There is little doubt, then, that as early as the 1880s this book was well known to artists in Europe and it had a more widespread effect upon illustrators and graphic artists than has generally been conceded. It is difficult for us to put ourselves in the place of the artists of a century ago confronted with the brilliant contrivance of, say, 'Fuji above the waves' (pl. 1) where the curling spray takes wing in the form of cavorting plovers. There is no reason to suspect Walter Crane of directly borrowing from it for his painting 'The Horses of Neptune' (pl. 2), but a book like the 'One Hundred Views' unquestionably stirred the western imagination, suggesting new directions and novel angles, implanting new ideas in the consciousness of artists, often without them even suspecting their indebtedness.

But however much or little we may ascribe to the impact of this or other Hokusai books upon our own western art, in the first analysis we must judge Hokusai against the background of Japanese art and culture. Indeed, it is hard to find a counterpart among western book artists in the period covered by Hokusai's life. In France, the great outpouring of rococo engravings in books was almost over by 1780, the date of Hokusai's first book-illustrations. Around 1800, P. L. Debucourt made some notable colour-prints not too dissimilar from Hokusai's Edo views, but as an artist he was restricted in scope. In Germany, J. N. W. Chodoweiki illustrated novels with an aptness that reminds us of Hokusai's interpretations of the Kyokutei Bakin novels, but he did little else of note. In England, J. M. W. Turner, Hokusai's near-contemporary, was responsible for a number of splendid books and albums of landscapes, and the steel-engraved vignettes to Samuel Rogers' *Italy* and other verse-books come as close as anything in Europe to Hokusai's *kyōkābon* prints; but Turner was almost exclusively a landscapist. Thomas Rowlandson, in the coloured aquatints of the *Ackermann's Repository* and in the *Dr Syntax* series, is closer to some aspects of Hokusai's work in simple genre; but illustrators like Thomas Stothard and Richard Westall seem of comparatively small stature. Some great illustrated books of natural history appeared in Europe and America during the period but they were the work of specialists in the fields of ornithology and botany, like J. J. Audubon and James Sowerby, and although Edward Lear is something of an exception in that he illustrated his travel books with topographical lithographs and also made drawings for superb bird books, he could not handle figures. In fact, no single artist in the west at the time showed anything comparable to the versatility of the Japanese master. True, Hokusai's prints were the product of a reproductive medium merely, and there is nothing in his output in books that can compare with William Blake's 'prophetic' books, or the *Songs of Innocence and Experience*; nor with Goya's *Disasters of War* or the *Capriccio*, though with them the distinction between book and series of separate prints is blurred; nor even with Thomas Bewick's humbler though exquisite wood-engravings in his long series of natural history books. Comparisons of this kind, the endeavour to situate Hokusai in world art, whilst inevitable nowadays because of our global, ethnic, view of art and culture, tend to be dislocated in the face of unrelated techniques, formats or purpose. But viewed simply in the Japanese context, Hokusai, for almost seventy years during the crucial period towards the close of the strict feudality that had prevailed for centuries and was to break down within a decade of his death, was constantly involved as illustrator of literature of every conceivable kind; as recorder of the Japan of his day, with a unique combination of fidelity and poetry; as designer of albums of prints, often without accompanying text, that cover every facet of nature and human activity, history, legend and fantasy. His books, beyond any other artist's, can be said to mirror the culture of the nation, inherited or evolving over an exceptionally long life-span; and simultaneously, they reflect the gradual unfolding of the art of a comprehensive and incomparable genius.

I *The* '*Yellow-backs*'

For well over a century now Hokusai has been accepted in the West as one of the greatest figures in Japanese art. An image of the man has been created for us that is perhaps one-sided, founded on anecdotes of his eccentricity, his uncouthness, his exhibitionism, and on three self-portraits of the artist as an old man with furrowed features and sunken mouth. Indeed, most accounts of his life and works lay great stress on the *Manga*, (the first volume of which was not published until he was in his mid-fifties), and concentrate on the great print series designed in subsequent decades. We know him, virtually, in his mature years only, and as one who at that time boasted of his peasant boorishness. A study of the illustrated books enables us to restore his youth and early manhood, a time when he was closely associated with the literary circles, the favourite artist of the *kyōka* club versifiers in *surimono* and small anthologies, the chosen illustrator of the more notable novelists, and the author himself of some of the light literature published with his own illustrations.

But before he attained that degree of recognition, he had, for many years, endured the apprenticeship enjoined upon any aspiring pupil in the Ukiyo-e school, and that entailed the illustration of *kibyōshi*, literally 'yellow-backs'. Practically every Ukiyo-e artist of the period began his career with this hackwork. *Kibyōshi* were the cheapest form of novelettes or 'penny dreadfuls', earning their name from the colour of their covers — curiously enough, the same term that we use, and for a similar reason, for trivial, rather dubious fiction. Yet, once despised as 'toy books for women and children', *kibyōshi* have been more seriously viewed by modern social historians as a key to the mentality, and the life-style, of ordinary people of the period when they were in vogue, i.e. during roughly the last quarter of the eighteenth century.

They were the ultimate form of what began in the seventeenth century as juvenile books called *kusazōshi* (the derivation of the word is debatable: *sōshi* (or *zōshi*) is inferior paper, or a notebook roughly stitched together; *kusa* is either 'stinking' paper or cursive *hiragana*, the syllabary that avoided the Chinese characters of serious literature). Different types were denoted by the colours of the covers. The earliest, *akabon* ('red books'), from about 1684–1710, were simplified fairy-tales and they were succeeded by *kurobon* ('black books'), about 1706–36, of more manly, bombastic, 'strong-arm' type,

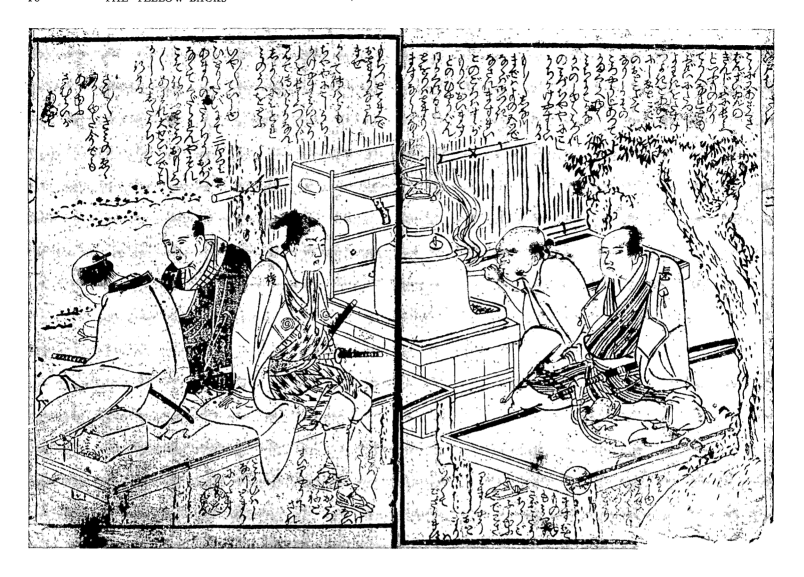

including particularly stories of revenge and ghosts. These were followed by *aohon* ('blue books') which represented a gradual toning down of the crudities of the earlier species and were a prelude to the *kibyōshi* introduced in 1775. The earlier types were not wholly superseded, but after its introduction, the *kibyōshi* was the predominant form.

Copious illustration was a feature of all these publications, but text and picture shared the same page so that the artist had to do battle with the columns of calligraphy that came close to, and all but invaded, his outlines. Paper, block-cutting and printing were all of the lowest standards and it is only rarely that any artist was able to overcome such handicaps. Hokusai succeeded as well as any and entered wholeheartedly into the *melée* of these often rumbustious tales, and though his illustrations are often clumsy and maladroit, they are rarely dull. A few examples from the more than fifty that he illustrated from 1780 to 1795 will be sufficient to represent the whole group.

The first is mainly of interest as being the first *kibyōshi* Hokusai is known to have

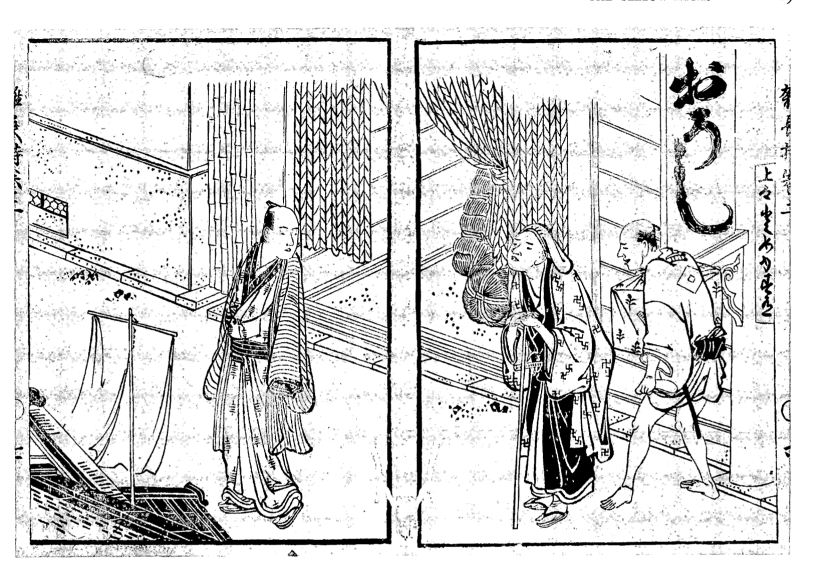

4 Quack doctor and dupe.
From *Kyōkun Zōnagamochi*,
1784

illustrated. It is entitled *Meguro-no-Hiyokuzuka* and is datable to 1780. The double-page
illustrated (pl. 3) shows the curious way the design breaks through the text; and also,
the wear to which these popular yarns were generally subjected, the corners worn
away, the left-hand pages well thumbed. The book presents with new twists the well-
known *jōruri* story of the ill-starred lovers Shirai Gompachi and Komurasaki and their
champion, Banzui Chōei. Plate 3 shows the two men, each identified by the first
character of his name on his coat, seated on benches at a teahouse. The title, like that of
so many *kibyōshi* and novels, is untranslatable without a tedious explanation, and in
common with many other titles of similar obscurity, will be left in Romaji only.

 Plate 4 is from a *dangihon* called 'The Chest Containing Various Teachings', published
in 1784. This was a collection of tales of a moralizing nature and achieved some sort of
popularity, un-illustrated editions having appeared earlier in 1752 and 1757. The first
illustration shows a quack doctor accosting a man in the street. The next (pl. 5), the last

in the book, illustrates the story of a poor schoolmaster, Yōnai, who bought a *kakemono* of Hotei, one of the gods of good fortune, and dreams that the God emerges from the painting hanging on the wall to advise him how to make a success of life. The signature on this page is Katsukawa Shunrō, the name most commonly used by Hokusai in this early period when he was a tyro in the Katsukawa Shunshō school. So far as any style is identifiable in illustrations where the block-cutter may well have obscured any individual mannerisms, it recalls Shunshō, but has little personal flavour.

5 Hotei and the schoolmaster. From *Kyōkun Zōnagamochi*, 1784

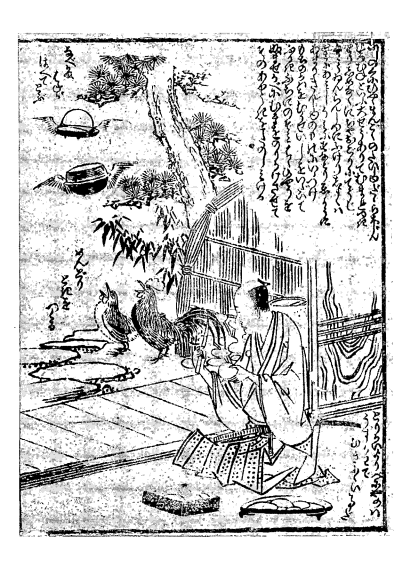

6 Dadara Daijin Hiromune losing his kitchen utensils. From *Kamado Shōgun Kanryaku-no-Maki*, 1800

7 Self-portrait of the artist. From *Kamado Shōgun Kanryaku-no-Maki*, 1800

Actually, the last described is rather superior to the normal type of *kibyōshi*: the next (pl. 6) shows the more usual form where text and illustration jostle for place. This piece, called 'The Book of Tactics of General Oven', published in 1800, was one of the first written as well as illustrated by Hokusai, but no one has considered it worth translating. It can simply be said that the situation of cooking pots taking wing to a chorus of crowing cocks would be nothing out of the way in this kind of story. The more interesting print is the last in the book, the first known self-portrait of the artist (pl. 7). The inscription above, in the form of a spoof letter to the publisher, Tsutaya, begs tolerance for this, the writer's first attempt at fiction, and asks that it might be submitted to the master-novelist, Bakin, for correction.

The *kibyōshi*, though never ranked highly as literature, is not altogether to be despised. During the period up to and including the Kansei Reforms (say from 1786 to 1800), when the Shōgun Sadanobu introduced a succession of repressive sumptuary measures, the *kibyōshi* writers came as near to creating an 'underground press' as was possible under the dictatorship. Several of the 'yellow books' were rather naively disguised satires on the Sadanobu Reforms, and authors ran considerable risk in tilting at the authorities. Koikawa Harumachi's mysterious death in 1789 is thought likely to have been the result of a more than usually violent attack published under his name. Santō Kyōden, an outstanding literary figure who wrote numerous *kibyōshi*, made nonsense of Confucian teaching in another booklet, published in the year of Harumachi's death, and was also responsible for the most famous of the so-called 'serious' *kibyōshi* stories, *Shinjaku Hayazome Gusa* (a popular guide to *shinjaku*, 'learning of the heart', a cult in vogue at the time). This marked a change in the character of the genre. As Shunkichi Akimoto wrote in 'The Twilight of Edo': 'Since the appearance in 1775 of *Kinkin Sensei* "Doctor Moneybags" [the first *kibyōshi*, written and illustrated by Harumachi] *kibyōshi* had been an unabashed organ of "this light and flippant world", but now it made a bold excursion into ethics and morality which it had till then scrupulously avoided'.

Hokusai, in common with other illustrators, was concerned in the production of the 'new' *kibyōshi* as well as the traditional, more trivial type, but none of them gave scope for illustrations that can be treated seriously as art.

2 Early Poetry Books

The break with the Katsukawa sub-school and the restrictions imposed by that adherence, whether the rupture was before or immediately after Shunshō's death in early 1793, was an indication of the individualism that was to mark the whole of Hokusai's subsequent career. It heralded an outpouring of work in all mediums of a singularly appealing lyricism which, for all his triumphs in maturer years, he could never again quite recapture. It was a period in particular of intriguingly designed and exquisitely printed *surimono*, but they were matched by far less well known prints produced by Hokusai for the small poetry albums issued for circulation among members of clubs, for whose members, in fact, many of the *surimono* were also made.

In the *kibyōshi*, Hokusai had been catering for the lowest stratum of the reading public: he had even been the author, as we have seen, of some of these farragoes. But from his early thirties onwards he evidently began to mix with the sophisticated wits of the *kyōka*-clubs, and to be in demand as decorator and illustrator of their occasional publications. *Kyōka* were light verses spiced quite often with questionable innuendo and relying greatly on the wordplays so easily encouraged by the Japanese language. Just as the *mitate*, the pictorial parodies, raised their laughs in irreverent burlesques of the themes of the traditional painters, so the *kyōka*-writers' humour stemmed from the fact that they mocked the classical lyric form of Japan, the *waka*, even to the extent of adopting its thirty-one-syllable metrical pattern. Fully to appreciate the distortions and the comic punning some knowledge of the original *waka* was essential, and one has to assume a fairly high degree of literacy in the circle of those who wrote, or enjoyed reading, *kyōka*. Some of the loveliest of Hokusai's prints, but least known because they are so rare, occur in verse-books: books that in some instances appear to have survived in single copies only.

Before introducing some of these beautiful books, it is necessary, for reasons that will become apparent, to discuss Hokusai's frequent name-changes, and the problems they have occasioned. They are particularly significant in this mid-1790s period. Hokusai's name as a member of Shunshō's school had been Katsukawa Shunrō. In 1796 the name Hokusai first appears, coupled with Sōri and Kanchi, either separately or together. The name Sōri came from an earlier artist, Genchi or Tawaraya Sōri, who

長臂國

清葉泊連庵

had worked in the style of the Decorative, or Rimpa school. He is usually described as being active in the 1760s to 1780s period, though he may perhaps still have been at work in the early 1790s. Even so, it is not thought that Hokusai ever had direct contact with this master, and indeed, there is little relationship between the paintings of the early Sōri (no prints by him are known) and the work of Hokusai Sōri, except in so far as Hokusai shows a knowledge of and respect for Kōrin, one of the founding-fathers of the Decorative style, and in one book design (pl. 15) acknowledges that it is based on a Kōrin painting.

8 Men from the country of long-armed men as monkey-trainers.
From *Shiki-nami-gusa*, 1796

9 In the land of demons, treasures representing Momotarō's trophies. Signed Hyakurin Sōri.
From *Shiki-nami-gusa*, 1796

In that same year, 1796, appeared a *kyōka* book entitled *Shiki-nami-gusa*, one of the illustrations to which is signed Hyakurin Sōri, a name that had occurred earlier on a *surimono* dated 1795 and, for a few years after that date, appears on *surimono* and paintings. The title *Shiki-nami-gusa*, which Kenji Toda, the Japanese compiler of the Ryerson Catalogue (1931) mystifyingly translates 'Variety of the Layers of Wave', could only be understood after a disquisition on the use of Chinese characters to convey multiple meanings. In his text, Toda provides a paraphrase that is more explanatory of the contents of this curious book: 'Strange lands send their homage to Japan'. There are, for instance, pictures of the land of pygmies, with natives making their first calligraphy of the New Year; of the land of the long-eared men, one pictured at a window elongating his ear to listen to a Japanese nightingale (*uguisu*) on a plum tree; of the land of long-armed men, one with a performing monkey, the other beating a drum (pl. 8); and finally, of the land of demons, treasures on a stand representing the trophies of the fairy-tale hero Momotarō, this print bearing the signature Hyakurin Sōri (pl. 9).

Although neither the prints in this book, nor the paintings and *surimono* with the same signature, entirely satisfy us as being identical in style to works signed Hokusai Sōri, they are sufficiently related for most writers to have assumed Hyakurin to be another *gō* or art-name of Hokusai. Certainly, both names are sometimes accompanied by another *gō*, Kanchi, and on at least one painting Hokusai used a highly individualistic seal reading Kanchi, identical to one frequently accompanying the Hyakurin Sōri signature. Hokusai's style changed frequently throughout his long

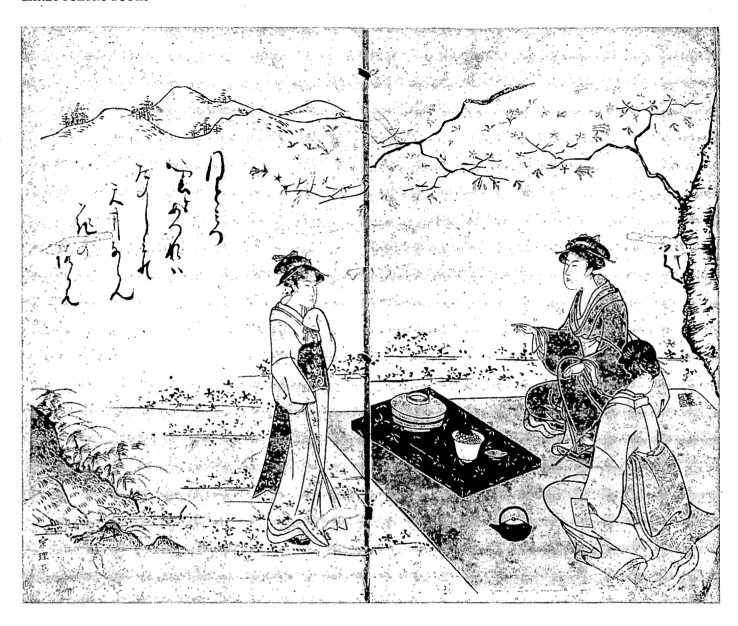

career, but one can only accept with some misgivings the notion that in this mid-1790s period he could have been employing two contrasting manners concurrently. Thus the *Shiki-nami-gusa*, and other works signed Hyakurin Sōri, whilst still included provisionally in the canon of Hokusai's works, have a question mark against them. Roger Keyes, on the basis of a study of the extant prints and paintings, has proposed (in an interesting paper communicated to the author and so far unpublished) that the name Hyakurin was first used by Hokusai and then taken over by his pupil Sōji about 1799 when Hokusai relinquished to him the *gō* Sōri. In his view, works with the Hyakurin Sōri signature dated, or datable to a period, before 1799, are by Hokusai himself; those from 1799 onwards are by the pupil who normally used the *gō* Hishikawa or Tawaraya Sōri. Additional problems arise when the signature is simply Sōri (as it quite often is) and a firm dating is not feasible. In such cases one has to fall back upon style as the final arbiter, and because the pupil's work often successfully imitates the master's, it is far from easy to make clear-cut decisions.

10 Young women picnicking under flowering cherry-trees. Signed Sōri.
From a *kyōka-bon* lacking title, *c.* 1794/95 (no. 55 in Appendix)

11 Peasants travelling on a riverbank with a view of Fuji. Signed Hokusai Sōri, seal Kanchi
From another *kyōka-bon* lacking title, 1796 (no. 64 in Appendix).

What may well be the earliest use of the name Sōri, since the time of the Sōri of the Rimpa school, occurs on a print in a small undated *kyōka* book that seems to have survived, without its title, in one copy only[1] (pl. 10). In this outdoor scene, the hair-styles of the three young women seem to belong to the period 1794/95, and possibly this print marks the point when Hokusai finally dropped the name Shunrō and assumed the *gō* Sōri. It is certainly an immense distance from the *kibyōshi* to the print just described, and it is even further to the small album of 1796 signed Hokusai Sōri to which I now come. (Only one copy of this too seems to be known, from which the title, as in the case of the other *kyōka-bon*, has disappeared.) Under the name Shunrō, it is true, Hokusai had been responsible for separate sheet prints and small books of erotica (see Chapter 13) that were much superior to the hackwork of the *kibyōshi*, but the influence of Shunshō, Kiyonaga and Shigemasa is all-pervasive, so that they lack real individuality. The three prints of this 1796 album are of a different order altogether. The first, in a sort of 'long *surimono*' format, unbroken over two successive 'openings' of the album, is a rustic idyll. Here the banks of the river, behind the massive foreground pines, are depicted in soft lines and two or three pale tones that evoke a quiet serenity, and the only movement is provided by the peasant family, of whom the farmer with his mattock stops to stare in wonder at the distant Fuji (pl. 11). This sheet is signed Hokusai Sōri, and the seal is a rather distorted Kanchi. The two other prints are single-page and represent further departures: one is of a peony, the other of the

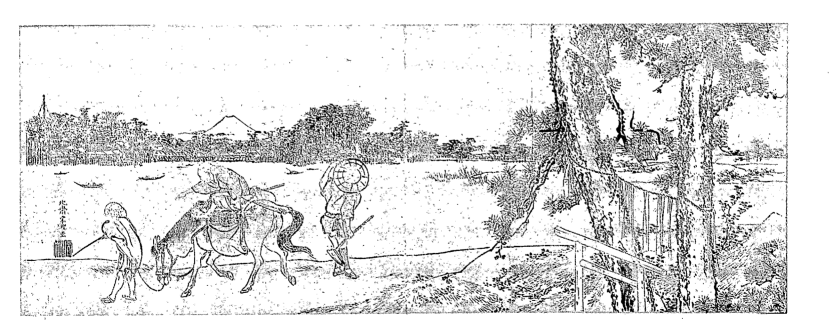

[1] From the Haviland Eighteenth sale, now in the Pulverer Collection, Cologne.

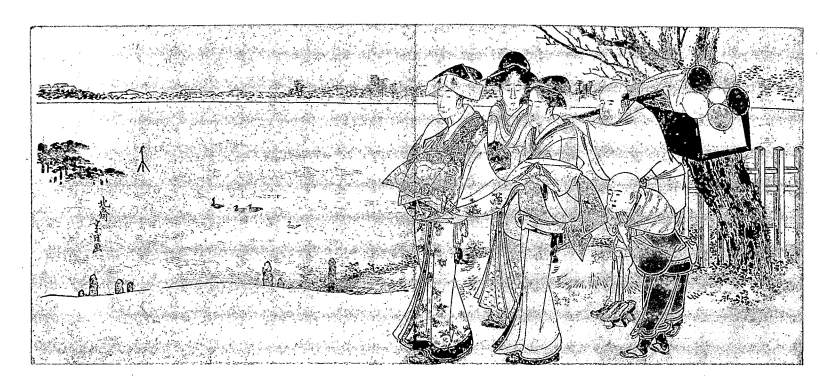

hototogisu, a harbinger of spring like the cuckoo, flying high over herbage half-hidden in bands of mist. The printing throughout is of a rare refinement, the covers are decorated with blind-printed white chrysanthemums on a pink ground, and there is an air of discreet *de luxe* about the production that is at the opposite end of the pole from the shoddy *kibyōshi*. The pictures do not illustrate ány particular poems, but the pastoral atmosphere and the quiet pastel shades tend to evoke a mood in which the verses, interleaved between the prints, can be more sympathetically read.

12 Courtesan and attendants on a river bank. Signed Hokusai Sōri. From *Haru-no-Miyabi*, *c.* 1798

Verse-writing was an activity more widespread in Japan than we can easily conceive. From classical times, however romantically recorded in such writings as the *Genji Monogatari*, it is clear that among the aristocracy it was a mandatory accomplishment to produce a verse to meet every occasion; normal conversation would involve a polite exchange of elegant poems, a capping of one couplet by another, and letters were full of verses apt for any topic. In the Edo period this familiarity and repartee in verse was no longer confined to the ruling classes. Quotes from the medieval anthologies were not the prerogative of men of letters only; and anyone with any pretensions to culture would be expected to compose a *haiku* at the slightest provocation, there being many accounts of meetings of literati who composed endless verses extempore. The *kyōka*, a rather lower-class form of verse and never so edifying as the *haiku*, grew in popularity in the eighteenth and nineteenth centuries. As Toda remarks 'They lack the philosophy of *haiku*, and the keen observation of humanity one finds in the *senryū*. Clever

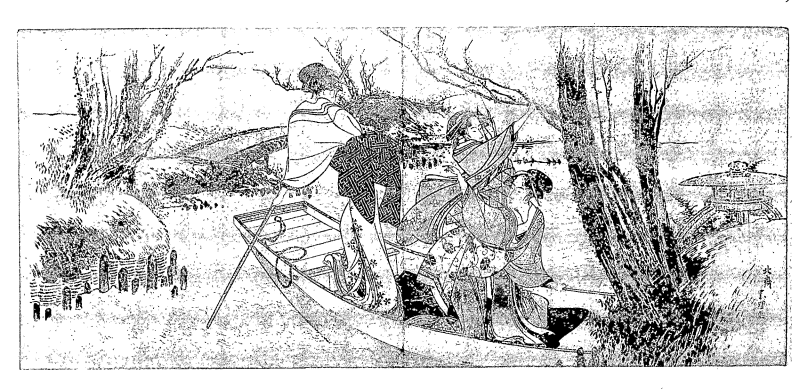

13 Young women in a punt.
Signed Hokusai Sōri.
From *Haru-no-Miyabi*, c. 1798

expressions in humour are all one can find in them, and yet the extent of popularity of this form of poetry in Japan in the late eighteenth and early nineteenth centuries was astonishing.'[2]

What was even more astonishing, bearing in mind the occasional, or ephemeral, nature of these verses, was the urge that consumed the versifiers to get into print, and to publish their work, often with a lavishness that is quite inappropriate to the triviality of the verses. But we should be forever grateful to the innumerable members of the *kyōka*-clubs for the conceit or foible that led them to publish their verses, either in print form, on the *surimono*, or, in greater quantities, in the albums and smaller *kyōka-bon*.

Societies were formed under the leadership of one or another of the acknowledged masters of the art of *kyōka*, and the *surimono* and the books were often published at the instigation of such clubs, sometimes, one feels, for distribution among members only. Occasionally such privately printed publications, called *kubarihon*, were accompanied by one or two colour-prints, often of an elaborateness in printing that vied with the most ornate of the separately published *surimono*. One of these anthologies has the title *Haru-no-Miyabi*, 'The Beauty and Elegance of Spring', and contains two very beautiful colour-prints, one of a courtesan and her attendants walking along a river bank (pl. 12), the other – among Hokusai's most graceful compositions – of a girl poling a shallow boat along a narrow stream, one of her two companions reaching up to break off a branch from a plum-tree leaning from the bank (pl. 13).

[2] See Bibliography.

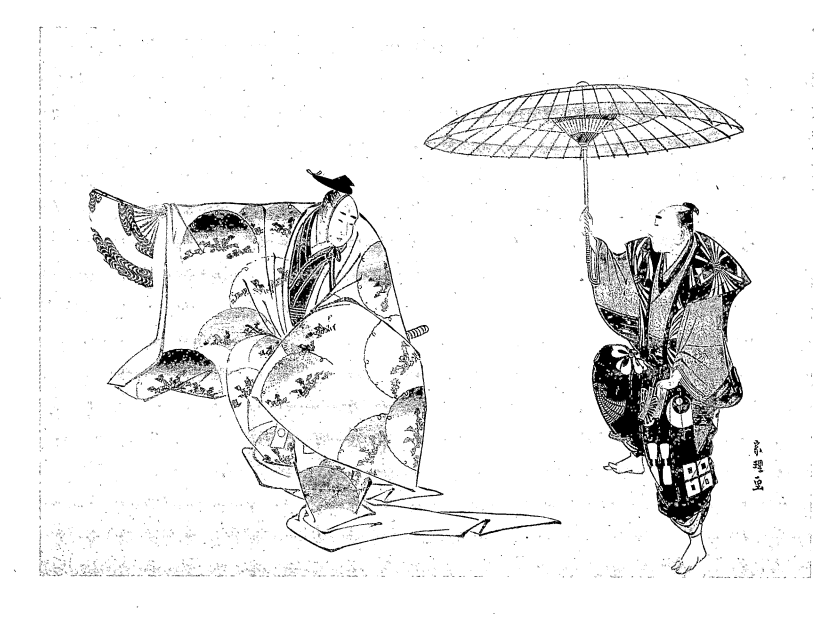

14 *Kyōgen* scene. Signed Sōri.
From *Tarōzuki, c.* 1797/98

Another print of the same order is better known than most because an impression, detached from the book in which it first appeared, came into the possession of Louis Ledoux, one of the most discerning of American collectors, and was reproduced in the handsome catalogue he produced of his prints. The picture (pl. 14) shows two actors in a *kyōgen*, the light relief of a *Nō* play. The title of the book is *Tarōzuki*, 'The Moon of Tarō', Tarō being a stock low-life comic in *kyōgen*. Ledoux suggested that perhaps the umbrella Tarō is holding is intended to represent the moon. It is an enchanting print, which makes memorable and coveted an otherwise featureless book of quite unmemorable verse.

Not all the pictures in these books were printed in colours. At the time, in the late 1790s, Hokusai was exploring the potentialities of several different schools of Japanese, Chinese and even European painting, and a number of extant works, as I mentioned earlier, show that he was aware of the genius of Kōrin, and of the Rimpa or

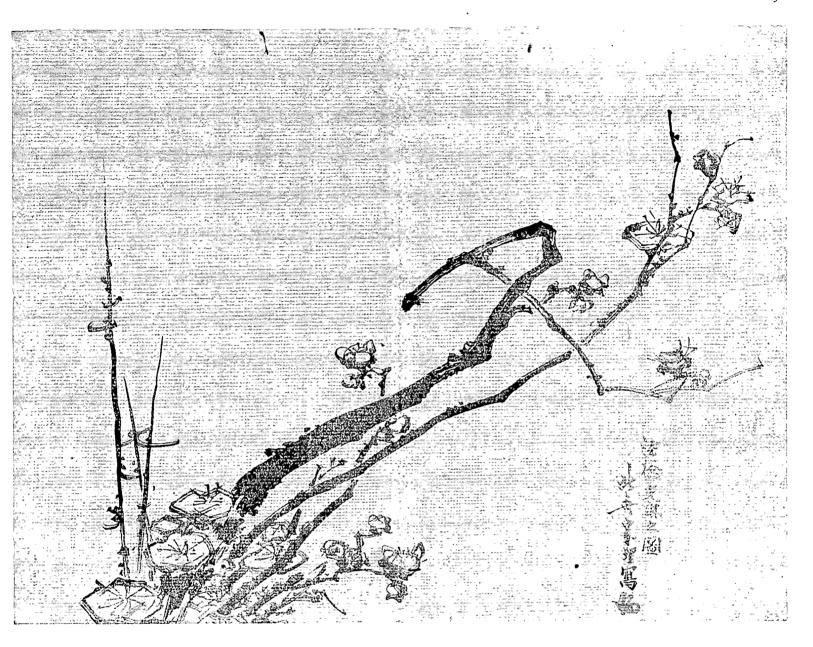

15 Plum-branch. Signed
Hokusai Sōri after a
painting by Hokkyō
Kōrin.
From *Miyama Uguisu*.
Preface 1798

Decorative style. In a poetry book of 1798, *Miyama Uguisu*, 'The Nightingale of
Miyama', he makes his indebtedness explicit: a sensitive ink-print of a plum-branch is
signed with the name Hokusai Sōri alongside an inscription acknowledging that it is
based on a drawing by Kōrin. A refinement of printing is noticeable even in this
seemingly simple page: the paper is pitted by blind-printing to simulate the appearance
of silk (pl. 15).

 Although comprising little more than a dozen sheets of verse, this little anthology is
embellished with two prints, the Hokusai plum-branch, and a colour-print of a
crowded ferry-boat by Shigemasa. It became normal practice about this time for more
than one artist to be enlisted for the pictorial accompaniment to these verse albums,
not, one imagines, to enhance the sales, since the *kyōka-bon* did not as a rule circulate
outside the members of the club, but simply because the versifiers were concerned to
give an attractive setting for their effusions.

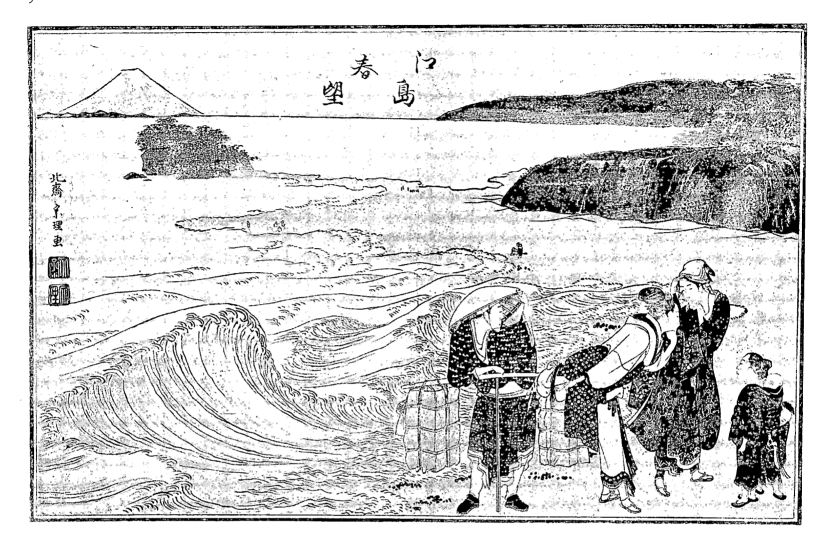

Some of the *kyōka* anthologies, however, are of a more sumptuous character and appear under the imprint of one or other of the more notable publishers of the day. In these cases, it is obvious that the books were directed at a wider and more general public. Among these albums, pride of place must go to those for which Utamaro was chosen as the sole artist in the wonderful series that began with the 'Insect Book' of 1788. Hokusai's prints appear in several somewhat later albums to which four or five other notable Ukiyo-e and Tsutsumi school artists contributed, Utamaro himself among them. For instance, *Yanagi-no-Ito*, 'Willow Silk', published in 1797, had prints by Shigemasa and Eishi, and in *Otoka-Dōka*, 'The Stamping Song of Men', he shared the illustration with Utamaro, Eishi, Shigemasa and others. Hokusai's print for the *Yanagi-no-Ito* (pl. 16) is one of the earliest versions of the theme 'Fuji above Waves' that recurs time and again in Hokusai's work, dating some twenty-five years before the best known in the 'Thirty-six Views of Fuji' set, and nearly forty years before another wonderful example in the 'One Hundred Views of Fuji' (pl. 1). For *Otoka-Dōka*, Hokusai designed a delightful village scene, centred around a small bridge over a stream (pl. 18).

16 Beach scene at Enoshima. Signed Hokusai Sōri, seals Hokusai and Sōri. From *Yanagi-no-Ito*, 1797

17 Peasants by a stream. Signed Hokusai Sōri. From *Sandara Kasumi*, 1798

18 Village scene by a bridge. Signed Hokusai Sōri. From *Otoka-Dōka*, 1798

正風古流花道の
自在軒宗近ら
列号を譲り交て
大サガミ
三代目
用捨菴
一樂
圖

Also in 1798, *Rakumon Binka-fu*, a book on flower-arrangement (*ikebana*) was published. Hokusai was one of a number of illustrators of this book and such a commission is further evidence of the cultured circle in which he moved at this time. It was his only venture into this rather specialist field, and his somewhat dry outlines of

19 Flower arrangement with Autumn *Kaidō* (*pyrus spectabilis*). Signed Hokusai Sōri, seal Kanchi.
From *Rakumon Binka-fu*, 1798

20 Flower arrangement with chrysanthemums, not signed, seal Kanchi.
From *Rakumon Binka-fu*, 1798

plants in pots and other vessels are in no way distinguished. Nevertheless, his thirteen drawings are signed with a variety of signatures and seals, so that the book has become, if nothing more, a document confirming his use of the *gō* Kanchi, which appears in combination with Sōri and Hokusai (pls. 19 & 20).

21 Couple walking by
pine-trees.
From *Itako Zekku*, 1802

22 Mother and son greeting the rising sun. Signed Sōri *aratame* (changing to) Hokusai, seal Sankei. From *Kyōka Hatsu Wakana*. Preface 1798

Although in this formative period Hokusai was open to a wide range of influences, native and foreign, the dominant style of these years emerged as what may be termed the Sōri style, from the art-name most frequently used then. The figures are of an unmistakable mould, with slim limbs and rather pinched faces; the clothes are prettily patterned, and the settings, whether landscape or interior, deftly suggested more than fully portrayed. The general effect is one of an elegant, well kept pleasure-garden with which the soft, printed colours are perfectly consonant, the whole projecting a kind of dream world quite the antithesis to the earthy realism of later years. Perhaps the last book fully to exemplify the Sōri style (when Hokusai had actually bestowed the name on his pupil Sōji) is *Itako Zekku*, 'Songs of Itako', of 1802 (pl. 21). It is a sample of the curious literary caprices in which the Edo wits indulged. Itako is a port on the eastern tip of Kasumi-ga-ura in Ibaki prefecture from whence it was possible to take a ship to three notable shrines. *Itako-bushi* were boatmen's songs, and the text of this strange compilation consists of such popular shanties and their five- or seven-character Chinese counterparts. Hokusai's pictures were hardly likely to be meant as a commentary on this outlandish whimsy, and instead, they depict the comings and goings in the prostitute district of the port.

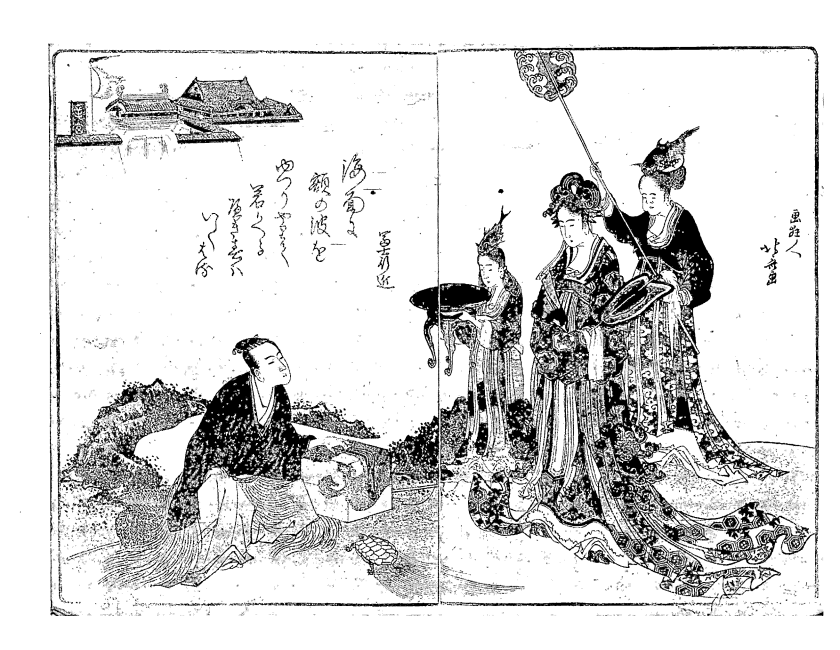

23 Urashima Tarō and
Otohime, the daughter of the
Dragon King, with two
attendants. Signed Gakyōjin
Hokusai.
From a *kyōka-bon* lacking
title, *c.* 1801 (no. 92 in
Appendix)

3 'The Story of the Forty-seven Rōnin'

No single story had a greater hold on the Japanese people than the *Chūshingura*, 'The Loyal League'. It paid homage with all the force of scriptural parable to the twin concepts that brought out the latent fanatacism in the nation's manhood: loyalty and revenge. It is so perfect an exemplification of the Confucian text 'Thou shalt not live under the same heaven nor tread the same earth with the enemy of thy father or lord' that it might easily be assumed that the *Chūshingura* was fictional, but in fact it is closely based on an historical event, and of the relatively recent past, at the beginning of the eighteenth century. Briefly, omitting the names of those concerned, an ambassador was due to come from the Emperor to the *Shōgun*, and two noblemen were to be instructed by a third in the elaborate etiquette the visit entailed. The instructor was avaricious, and as neither of his charges made any offers of money or other bribes, he was insufferably insulting to both. The more headstrong of the two threatened to kill his tormentor, but his chief retainer, aware of the penalty for such an act, himself bribed the instructor, who thereupon disarmed his would-be assailant with honeyed words. The other restrained himself for a time, but goaded by the ultimate in insults, finally drew his sword on his enemy, only to succeed in wounding him before being surrounded and arrested. For drawing his sword in the palace precincts there was only one sentence, *seppuku* or *harakiri*, and so he died, by his own hand. His property was confiscated and his forty-seven retainers turned adrift, becoming *rōnin*, 'wave men', tossed about like the waves of the sea.

The second part of the story is the revenge of the *rōnin* on the man who had caused their master's death. To disarm the suspicion that they were planning retribution, they scattered, and behaved in a manner least likely to suggest that they harboured any thoughts of revenge, their leader even going to the extreme of divorcing his wife, taking a concubine and generally seeming to live an utterly dissolute life. But, on an agreed day, when winter snow covered the country, they reassembled and made a surprise attack on the enemy lord's castle, capturing him and beheading him when he refused the more honourable alternative of *seppuku*, and later laying the head upon their lord's tomb. This took place in the twelfth month of the fifteenth year of Genroku era (1702).

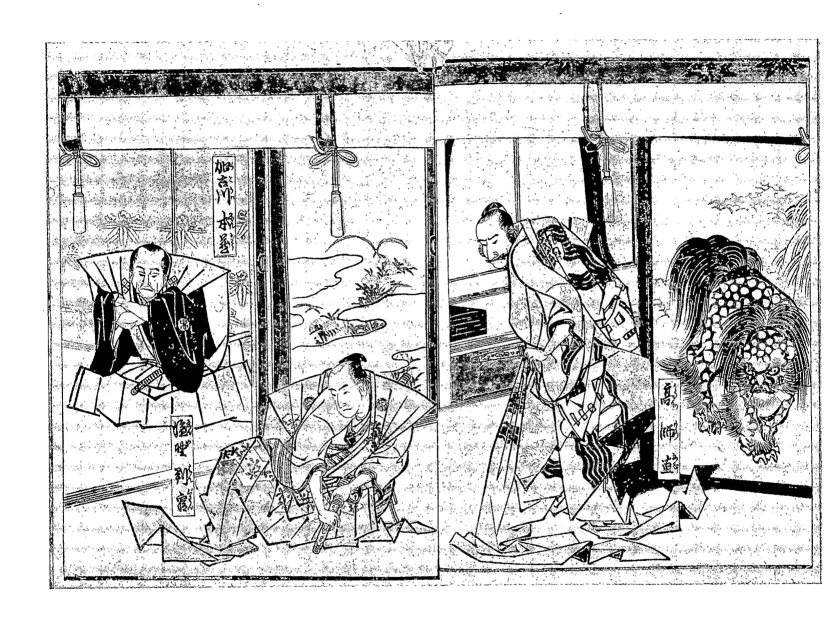

24 Moronao spurning
Enya, the watchful Honzō
nearby.
From *Ehon Chūshingura*, Act
III, 1802

And then, in the, to us, least comprehensible act of all, the forty-seven men gave themselves up to the authorities, and to a man, their mission performed, eagerly embraced death by *seppuku*.

Almost immediately, the events were seized upon by the dramatists of the puppet-theatre and Kabuki, and by the story-tellers. The first play, by the great Chikamatsu, was already being performed in 1706, and about the same time what is probably the earliest detailed account of the 'Forty-seven *Rōnin*' appeared under the title *Kōmyō Taiheiki*, with illustrations believed to be by the Kamigata artist, Yoshikiyo. From that time on there was a positive spate of literature and play performances, but because of a government interdiction against recounting the events of recent history, or identifying the participants, the names were completely changed and the scene of action transferred to different localities and a remote century. Moreover, in the plays especially, the action was extended by the writing-in of sub-plots involving a whole range of characters who had had no part in the actual affair. In the end, the surrogate figures ousted the memory of the originals; Yuranosuke became the name by which that paragon of loyalty, the leader of the forty-seven, is known, rather than Ōishi Yoshio as it was in reality; and the reviled name of the nobleman who insulted his master became Moronao, whilst that of Kira-no-Yoshinaka Kozuke-no-Suke, who was really guilty, is forgotten.

A story so universally known became the property of artists of every school, but it is the Ukiyo-e masters who are identified with it most. Not content with depicting the actual performances of Kabuki plays (of which forty or fifty were in the repertory by the nineteenth century), and designing sets of prints independently of stage performances though still as a rule conforming to the chronology of the eleven acts of the play, the Ukiyo-e artists made the *Chūshingura* their most frequent source for *mitate*, or parodies, in which the events of the play were distantly and often puzzlingly betokened by domestic squabbles, lovers' tiffs, or other equally unlikely analogues.

It was natural that Hokusai, aware of and responsive to every preoccupation of the people, should have been drawn to the *Chūshingura*, and apart from two complete series of broadsheets, one in *uki-e* or 'perspective' style, signed Kakō, of about 1798, and the other featuring landscape to a greater degree, unsigned, but with a seal-date corresponding to 1806, he was involved in illustrating one or two 'skits', and designed one *ehon* of considerable beauty. This is the *Ehon Chūshingura*, also known by its interior title to Volume 2, *Chūshingura Yakuwari Kyōka*. Published in 1802, exactly the same year as *Itako Zekku* (see p. 37) the designs are noticeably bolder than those in the poetry book, and of a more masculine character befitting the subject. The illustration to Act III (pl. 24), where Enya, viciously rebuked by the villain Moronao, is about to draw his sword on him, watched by Honzō, is a perfectly 'straight' interpretation of the scene and of considerable force. In the play, Wakasa-no-Suke is the second of the court nobles receiving tuition from Moronao; Honzō, his henchman, uses his guile to prevent his master assaulting Moronao. In Act II (pl. 25) he borrows his master's sword and cuts off a branch from a pine-tree with the words 'Thus let the enemies of my lord perish by this hand', though his real intent is to foul the blade with the resin of the

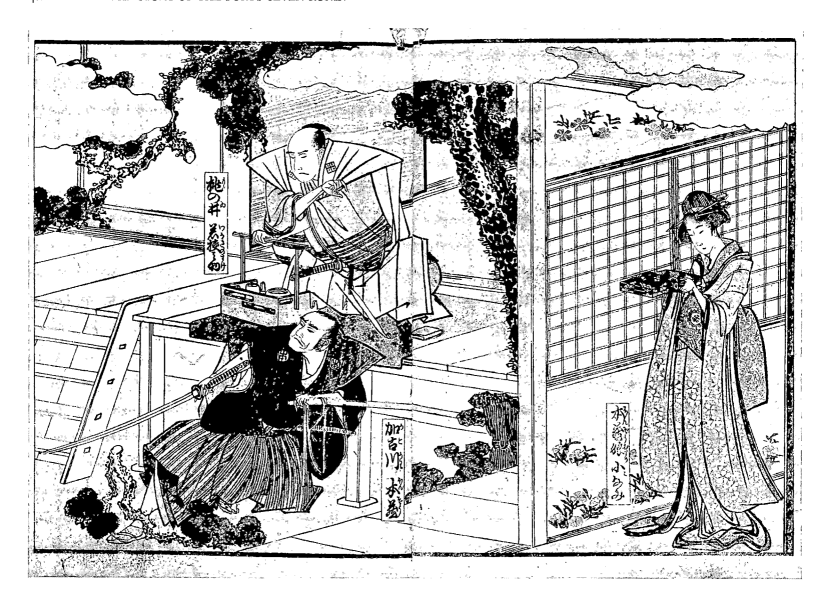

pine and render it useless. At this juncture, his daughter Konami (afterwards to play a large part in a sub-plot involving Rikiya, Yuranosuke's son) appears to the right, bearing gifts which Honzō will use to propitiate Moronao. In his illustration, Hokusai binds these elements in a finely balanced design which foreshadows the manner he adopted when grappling with the still more exacting texts of Bakin's novels a few years later.

Although primarily a book of pictures, the *Ehon Chūshingura* had the added attractions of a light-hearted text by Sakura Jihinari, and some *kyōka* by a number of writers. Jihinari (1762–1833) was one of those men who epitomize the Edo plebeian culture of his day. He was a man of diverse talents and activities, a writer of *kibyōshi* and other stories, a *kyōka* poet, an artist, a prompter of *surimono* artists, especially Toyohiro, a *bon viveur*, companion and friend to many of the famous in Ukiyo-e circles. This little book was produced with evident care, the colour-printing is of a high quality, and the covers are decorated with the *tomo-e-mon* of Yuranosuke in bold relief.

25 Honzō cutting the pine-branch watched by Wakasa-no-Suke, with Konami at right.
From *Ehon Chūshingura*, Act II, 1802

4 Poetic Topography

Several of the prints for the early *kyōka* albums convey scenes of such bucolic simplicity that one might gain the false impression that Hokusai had an intimate knowledge of the countryside and of peasant life. Yet his real milieu was Edo, that vast and teeming city of numberless low, wooden buildings. In the immediately post-Sōri period, when he was using, in addition to the name Hokusai, the art-names Tatsumasa and Gakyōjin ('the man mad about drawing'), he began a series of books of views of Edo that can be thought of almost as a separate genre, to which the term 'poetic topography' might be applied, in contradistinction to the prosaic *meisho-ki*, the stock 'guide books' to which Hokusai rarely contributed. In these albums, the roles of artist and *kyōka* writers were gradually reversed, for whereas in the books discussed in Chapter 2 Hokusai was embellishing publications that had the verses as their *raison d'être*, books like *Yama Mata Yama* and 'Both Banks of the Sumida River' were first and foremost series of views to which the *kyōka* were subsidiary.

The earliest, published in 1799, is called simply *Azuma Asobi*, 'Pleasures of the East', the East standing as always for Edo, and a literary flavour immediately detectable in that *Azuma Asobi* is also an old term for a *Shintō* ceremonial dance with songs. The first edition of this book is in ink only, but the rather meagre line seems to need the support of colour, and the landscapes in and around Edo are disappointing. Unfortunately, when colour was added, in new editions dated 1801 and 1802, it was crudely and unimaginatively superimposed. However, the street and interior scenes already show Hokusai's unusual capacity for seeming to draw from a viewpoint at the very centre of a crowd, so that we move shoulder to shoulder with the shoppers, sightseers and the rest as we might do today in the Ginza or in a Tokyo *departo*. Here, at random, is the Jikken doll shop (pl. 26), which reflects the widespread fashion, or fetish, for dolls and records the sort of jostling confusion that might have been witnessed on the eve of a doll festival. Throughout the book, single-page prints depict not only a variety of shops but also the premises of individual craftsmen and tradesmen, adding to that truly enormous corpus of views by Hokusai and many other artists, both before and after, that makes Edo as familiar to us as London or Paris at the same period. One print brings home the not always polite astonishment the Edoites expressed when

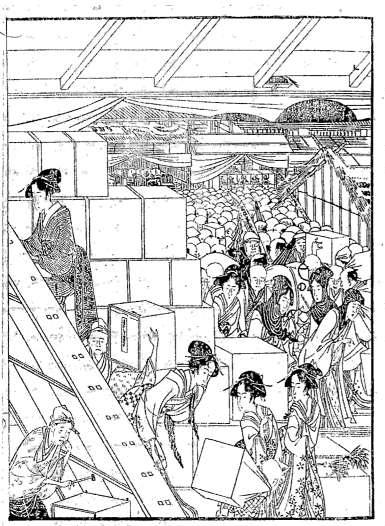

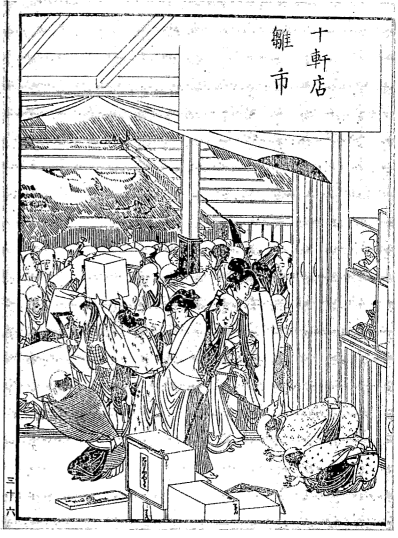

Dutchmen appeared, not in their midst for that would have been proscripted, but behind window-bars in their lodgings, where they endured virtual house-arrest during their rare visits from Deshima to the *Shōgun*'s capital. The outlandish clothes, the colour of hair and skin of these westerners were the objects of intense curiosity, amusement and derision (pl. 27). But quite the most interesting of these close-ups is the picture of the print and bookshop of Tsutaya Jūsaburō, whose imprint is on this very

26 Jikken doll shop.
From *Azuma Asobi*, 1799

27 Dutchmen in their lodgings quizzed by Edoites.
From *Azuma Asobi*, 1799

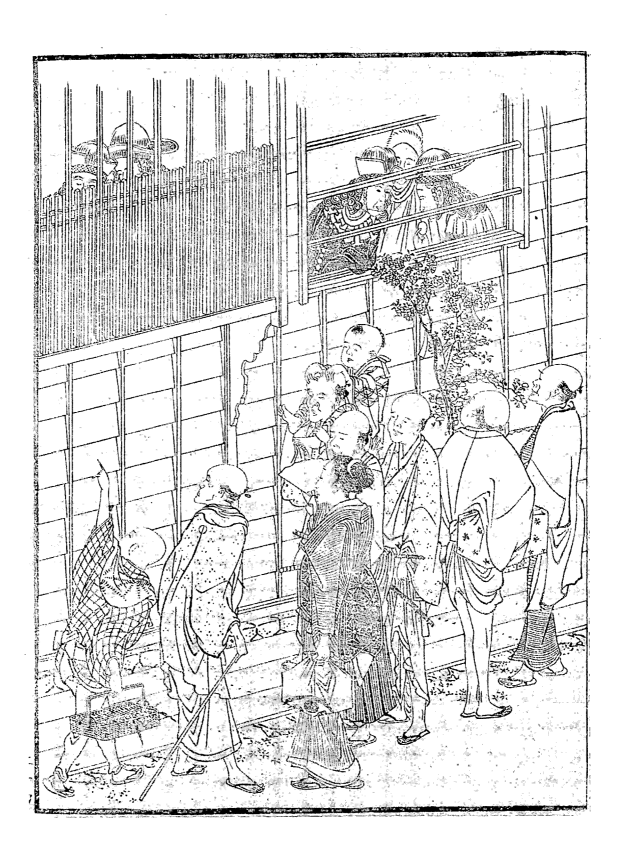

28 The print and
bookshop of Tsutaya
Jūsaburō in Edo.
From *Azuma Asobi*, 1799

book, and who was the most influential and successful publisher of the last quarter of
the eighteenth century (pl. 28). The illuminated sign outside the shop bears his name
and his *mon* or crest – the mark of ivy-leaves under a stylized Fuji that appeared on
many of the finest prints of Utamaro, Chōki and others, and on every print by Sharaku.
If, as has been suggested, the elderly man seen behind the racks of prints is meant to be
Tsutaya himself, then Hosukai's print was possibly intended as a tribute to the memory
of the great publisher, since he had died two years before the book came out.

29 The Eighth Month Festival in the Yoshiwara. From *Tōto Shōkei Ichiran*, 1800

The next of these picture books of Edo views shows a marked development in Hokusai's handling of 'figures in a landscape', or, as is more often in his case, 'in a townscape'. 'Fine Views of Edo at a Glance', *Tōto Shōkei Ichiran*, published in 1800, is a succession of largely outdoor views of favourite landmarks with the *kyōka* no longer on separate sheets but inscribed in the blank areas at the top of each print or in the sky. The places were all as familiar and as frequented as Piccadilly or St James's Park, and they recur time and time again in the paintings and prints of Hokusai and every other genre artist. Some locations were invariably depicted at the time of year, or the festival occasion, commonly associated with them: it is always the time of the blooming of the wisteria at the Tenjin Shrine of Kameido, and no artist ever thought of recording Asakuyama out of the cherry-blossom season, or the Shinobazu Pond at Ueno after the lotus flowers had died down. The ideal day for seeing the Yoshiwara was on the first day of the eighth month when the courtesans paraded in white apparel (pl. 29), and the temple at Asakusa was always most impressive when seen above the heads of the multitude attending the year-end fair in its grounds. In 'Fine Views of Edo', Hokusai recorded all the most popular places at their most notable times, and the book was clearly a huge success, several new editions being called for, the last as late as 1840, when the figures in the prints and the mannerisms of the artist must have seemed quite old-fashioned.

30 Sakai Street, the auditorium viewed from the stage.
From *Tōto Shōkei Ichiran*, 1800

But although Hokusai was following a traditional path in his tour of the sights of the town, he shows great charm and originality in some of the prints, especially in that of the theatre at Sakai Street (pl. 30) where we look towards the auditorium from a standpoint behind the players on the stage; and in the 'Sumidagawa' where the two girls (pl. 31), waving farewell from a jetty to men friends departing in boats, are among the most elegant of his creations. The complexities of the delicate colour-printing aid and abet the expressiveness of the lines of the windblown garments, and a twilight atmosphere and the sadness of parting are subtly evoked.

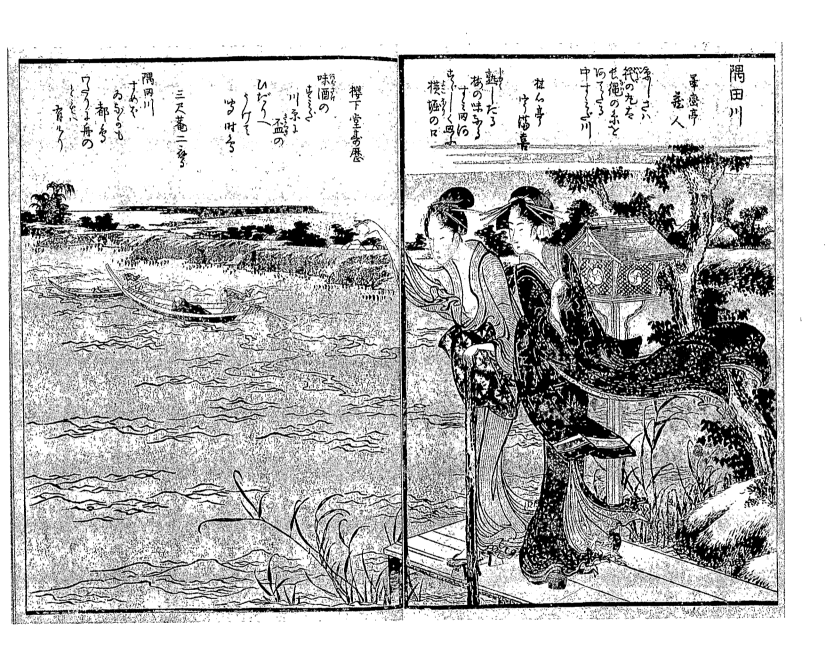

31 Sumida River, girls
bidding farewell to guests.
From *Tōto Shōkei Ichiran*,
1800

32 Balcony scene.
From *Miyako-dori*, 1802

33 Sekiya village.
From *Miyako-dori*, 1802

In 1802, Hokusai again collaborated with the *kyōka* versifiers in an album called 'The Bird of the Capital', *Miyako-dori*, (a title full of allusiveness, especially to the bird of the Sumida River made famous by the medieval poet Narihira). The illustrations, in a curiously subdued form of colour-printing, with verses running across the head of each, depict scenes in and around Edo (pls. 32 & 33). In the following year, another, smaller, album, embellished with three prints of a similarly precious nature, was published under the title 'Fuji in the Spring', *Haru-no-Fuji*. All three prints have a vernal freshness in spirit and in colour, the first of plum-blossom and moon (pl. 35), the second of Fuji from the sea-shore, and the last of girls gathering herbs in the fields (pl. 34).

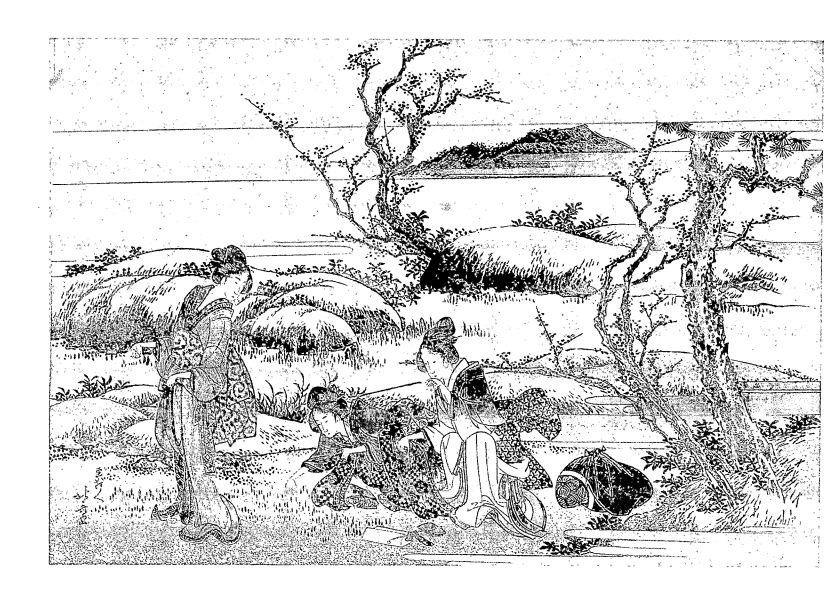

34 Girls gathering herbs in
early spring.
From *Haru-no-Fuji*, 1803

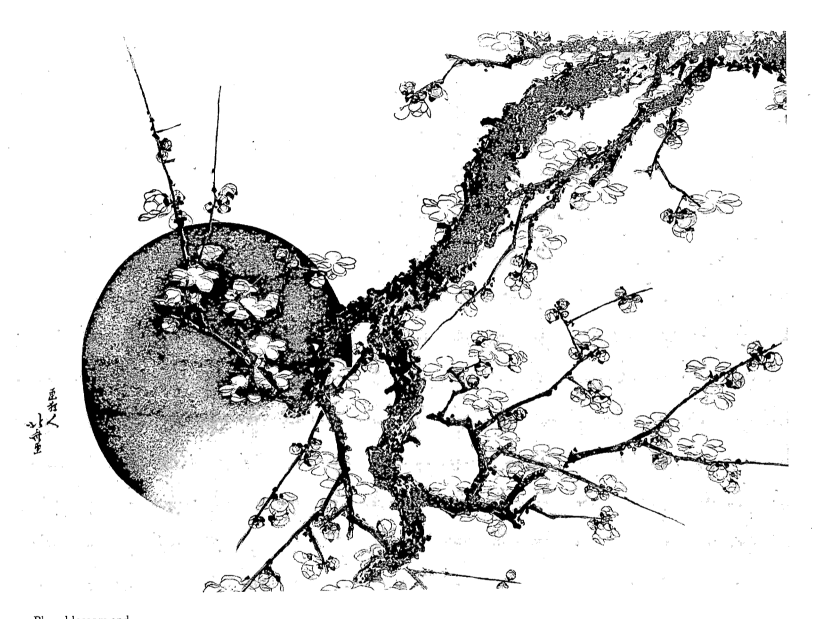

35 Plum-blossom and
moon.
From *Haru-no-Fuji*, 1803

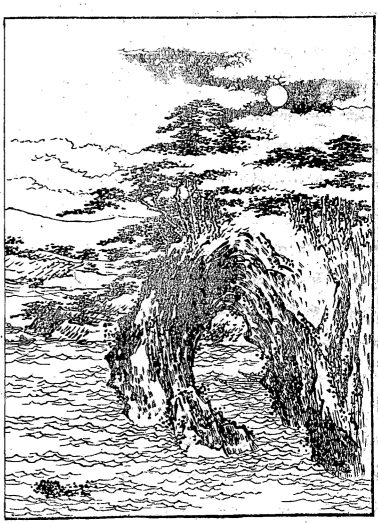

36 Matsushima.
From *(Hinauta) Tsuki*
Kuwashi, 1803

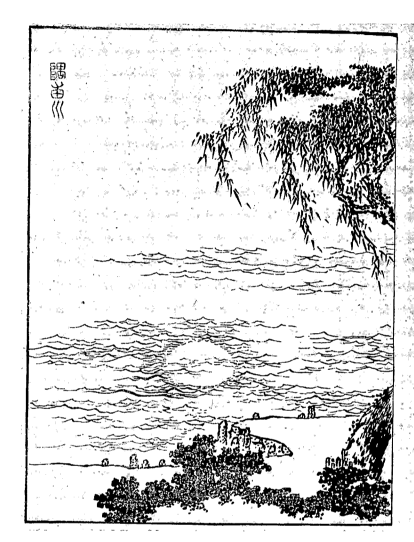

37 Sumida River. Signed
Gakyōjin Hokusai.
From *(Hinauta) Tsuki
Kuwashi*, 1803

Another small book of *kyōka*, with a title that may tentatively be translated
'Outlandish Verses on the Moon in all Aspects', and with a preface dated 1803,
contains three enchanting ink-printed landscapes, Mitsumata Bay, with Fuji under a
crescent moon; Matsushima (pl. 36); and Sumidagawa (Sumida River), which is signed
for all three prints, Gakyōjin ('man mad about drawing') Hokusai (pl. 37). This is an
extremely rare little book of which only one example seems to have been recorded.

Yama Mata Yama, published in 1804, means 'Range upon Range of Mountains', and refers, with the hyperbole typical of the *kyōka* set, to the slightly higher ground in the north and north-eastern parts of Edo, which by no stretch of the imagination could be called mountainous. Like the earlier books, it is full of enchanting views of the city and its environs, though figures still command the foreground and are the centre of interest. The places depicted are not named, though the accompanying verses usually give a hint as to the locality, but in fact, many are in the outlying countrified suburbs of the city and have no features that make them easily recognizable. But in a print like that

38 Picnic party at the Takeda racecourse. From *Ehon Kyōka Yama Mata Yama*, 1804

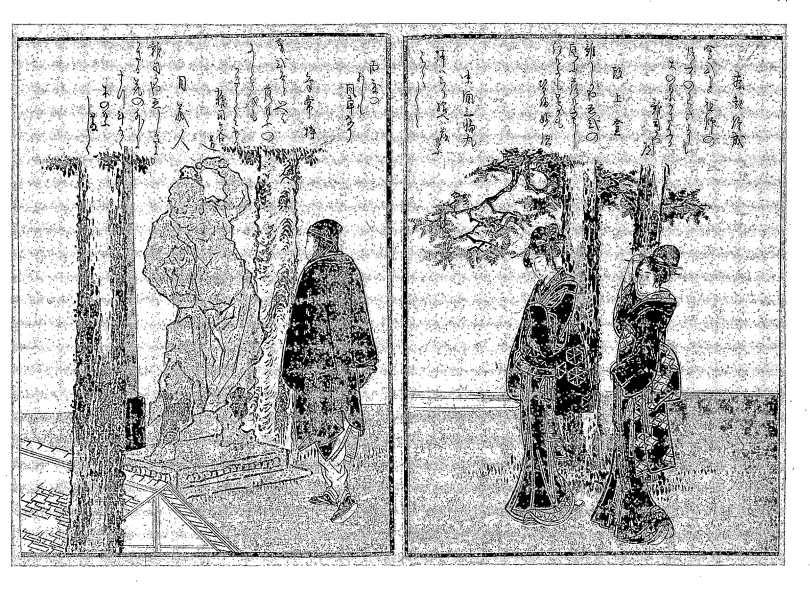

39 Visitors to Zōshigaya.
From *Ehon Kyōka Yama Mata Yama*, 1804

of the picnic party at the Takeda racecourse with Fuji in the distance (pl. 38), the actual locale is obviously less important than the handsome imported telescope. The third volume has a curiously static composition of two women and a man visiting the Zōshigaya and admiring one of the stone *Nio*, or guardians, of the shrine (pl. 39). The figures at this date show an elongation and a slimness which continues a trend set by Utamaro and Eishi in their broadsheets, though when scaled down to the format of the picture book and set against more naturalistically treated backgrounds the proportions are apt to strike us as ultra manneristic.

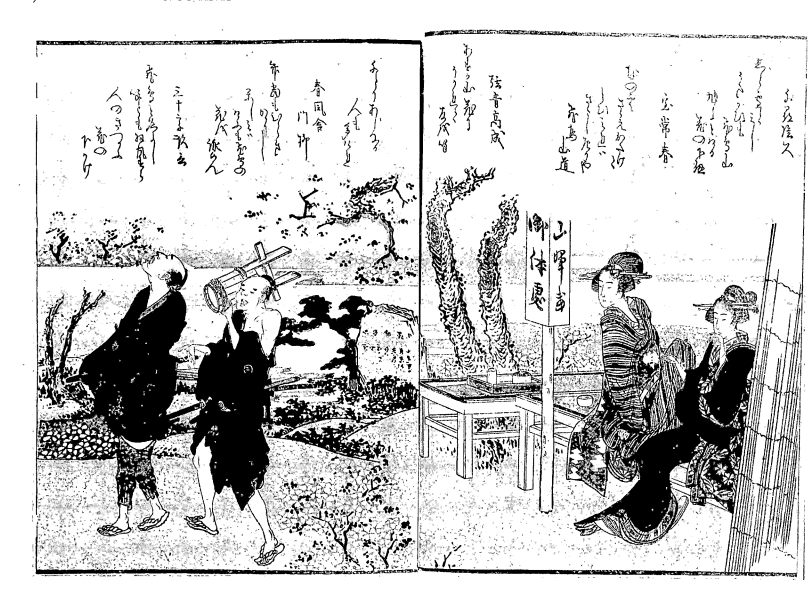

In referring in the Introduction to the make-up of a typical Japanese book, I did not mention that from the eighteenth century onwards – if not earlier – it was customary to sell sets in a wrapper, or *fukuro*. As the books were quite often issued in two or more volumes, the need for such a container was obvious, but even single volumes were usually provided with such a wrapper, which served the same purpose as our dust-jacket. Generally, these wrappers had some sort of pictorial decoration, and I deferred introducing them until this moment because, for *Yama Mata Yama*, Hokusai designed one of major artistic merit (pl. 41). Naturally, these wrappers were subject to the greatest wear and tear and few have survived: in fact, I have found record of only three copies of this *Yama Mata Yama fukuro*. The notion of associating Kintoki and Yama-uba with the book-title was presumably to underline the fantasy of situating Edo in a mountainous region such as Yama-uba lived in.

40 Cherry-viewing at Asukayama.
From *Ehon Kyōka Yama Mata Yama*, 1804

41 Yama-uba and Kintoki.
Fukuro (wrapper) for *Ehon Kyōka Yama Mata Yama*, 1804

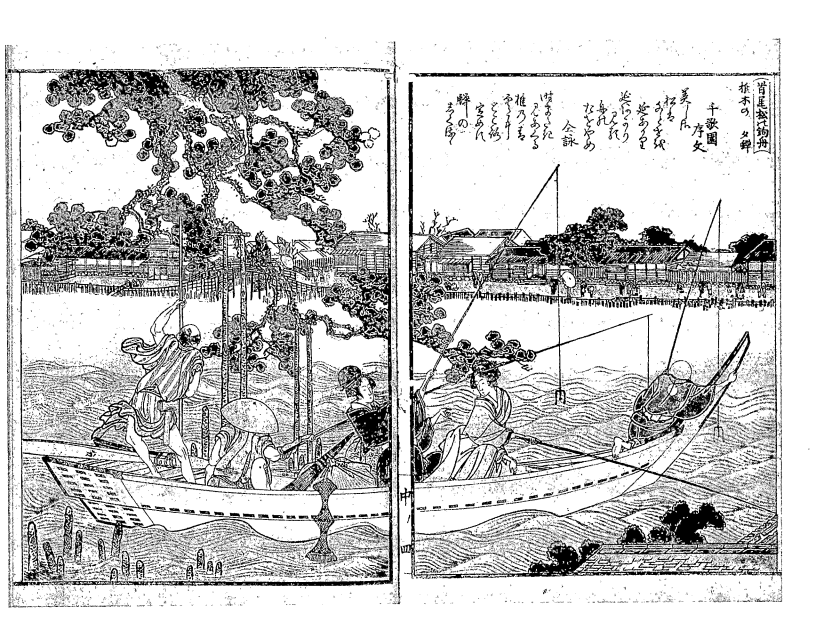

43 Angling from a boat, near the Shubi pine.
From *Ehon Sumidagawa Ryōgan Ichiran*, c. 1805

contriving nonetheless a topography whose lines follow the river banks continuously from one opening to the next.

The reproductions in pls. 42–44 here are from three successive openings. Plate 44 is entitled 'White Rain on New Willow Bridge' ('white rain' is a euphemism for a sudden sharp shower). We cannot fail to note the play Hokusai makes with the open or half-open umbrellas and the sense of squally, blustery weather that is created by the coolie's wind-blown coat. The next, which continues the line of the buildings on the far bank, transports us to a calm and rainless day for fishing, on a reach where a famous pine-tree, the Shubi-no-matsu, grew on the bank. Then follows the 'Ferry-boat passing the high lantern of the Kaya Temple', in which Hokusai, against all the conventions, has thrust the lantern through the border of the print to bring home to us its exceptional height.

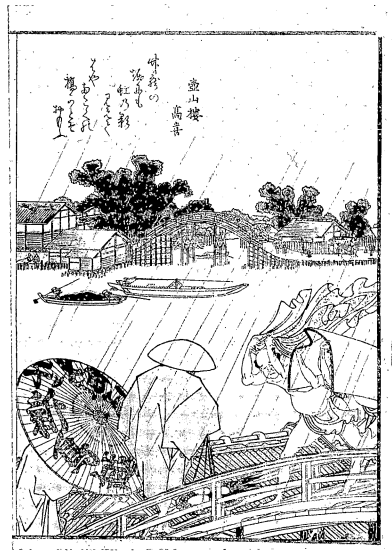
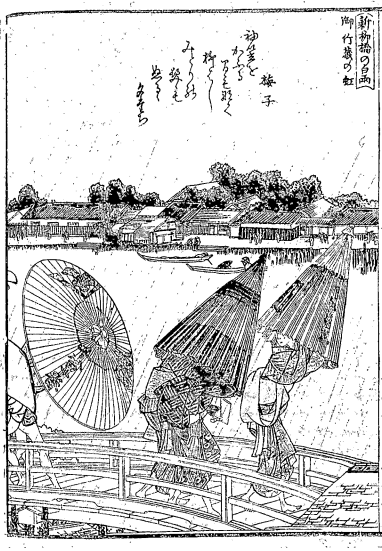

Hokusai revelled in the motley crowds thrown together on ferry-boats, and pl. 45 illustrates another print from the book, described as the 'First crossing of the Bay at sunrise'.

Although undated, the Sumida book is reliably placed about 1805/6. It shows a considerable advance in Hokusai's handling of the genre and complete assurance in conveying the river settings and in integrating groups of figures with them. From *Azuma Asobi* onwards, one can follow his steady progress in artistic power, so that the Sumida book can be seen as the summit of one phase of his career, and the development of the landscape print as his most positive and individualistic contribution to the contemporary illustrated book. It was no new thing, of course, for Ukiyo-e artists to depict their courtesans and paramours, actors, samurai, merchants and peasants in

44 White Rain on New Willow Bridge.
From *Ehon Sumidagawa Ryōgan Ichiran*, c. 1805

45 First crossing of the Bay at sunrise.
From *Ehon Sumidagawa Ryōgan Ichiran, c.* 1805

appropriate settings, and Kiyonaga, Shunchō and Utamaro excelled, especially in the triptych showing parties in the countryside around Edo, in the grounds of shrines, on the river or elsewhere. But although those artists had notable successes with landscape in album and picture-book form, none devoted himself so explicitly to books of landscapes, or evolved a style so immediately recognizable as his own as Hokusai did.

I mentioned earlier western topographical panoramas, but closer comparisons to the Hokusai prints described in this chapter can be found in European prints depicting manners and costume, social event and satire, by such artists as Rowlandson, Paul Sandby and Edward Dayes in Britain, or Moreau le Jeune and Debucourt in France. What those artists did for London and Paris, Hokusai did for Edo.

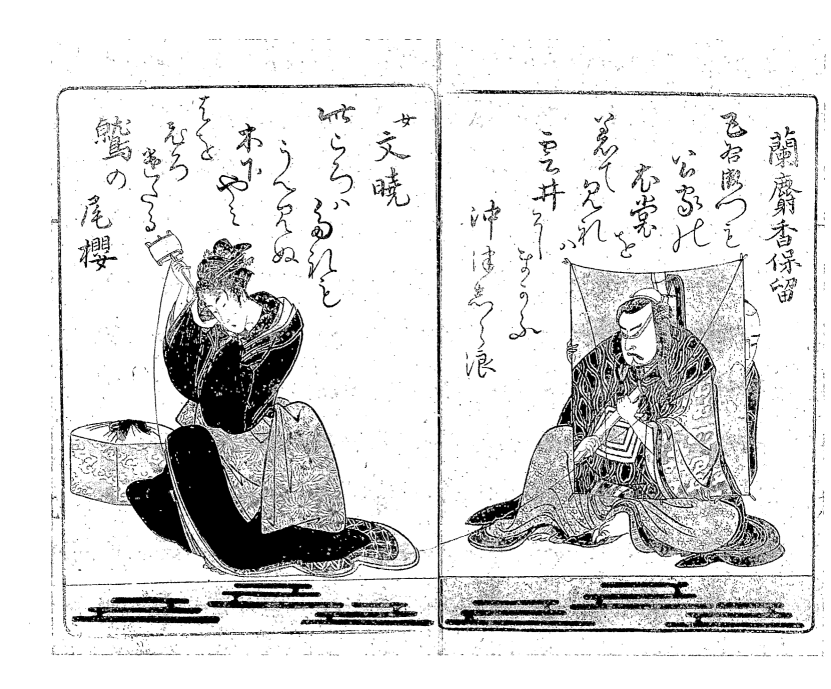

46 The poet Ranjakō Horyū holding a kite representing the actor Danjūrō VII, and Bunyo, a woman *kyōka*-writer, with a reel of twine. From *Kyōka Sanjū-rokkasen*, c. 1804/5

5 *Portraits of Poets*

Before moving forward from the period when Hokusai was so much in league with the *kyōka* writers, it is fitting to touch on the books of portraits, or imaginary portraits, of such poets. Fanciful depictions of the great poets of antiquity, in the canonical groupings of Six, Thirty-six or One Hundred, were stock subjects of Japanese painting from the earliest period, and from the seventeenth century onwards, of book-illustration. In the latter part of the seventeenth century, *haiku* composers were also sometimes depicted in books (as, for instance, in two works by Saikaku, *Kasen*: *Osaka Haikai-shi*, 'Immortal Poets: *Haikai* Masters of Osaka' of 1673, and *Haikai Onna Kasen* 'The Immortal Women of *Haikai*', of 1684). But in the eighteenth century, it became fashionable to provide pictures (whether actual portraits or not is open to doubt) of the celebrities of the *kyōka* societies, and it was natural that the portraitists should be drawn from the Ukiyo-e ranks. Among the best of the *kyōka-shi* portraits, and close enough in time for Hokusai to be familiar with them, were two books by the artist and writer Santō Kyōden (art-name, Kitao Masanobu), some of whose *kibyōshi* Hokusai illustrated in the early 1790s. The first of Masanobu's books, entitled 'A New Series of Fifty Poets' Stanzas of the Temmei Period, A Bookcase of Humorous Poems in the *Azuma* (i.e. Edo) Style' published in 1786, set the pattern for this kind of portrait gallery of the men and women members of the verse societies. They were, after all, comic poets, and the treatment in some cases is intended to underline that. Some are presented with mock solemnity in poses which recall those traditional to the 'Immortal Six'; others have silly objects on the head, one, for instance, a *makura* (the box-like pillow), another a pipe-case and tobacco pouch – to don such incongruous headgear was apparently considered the height of absurdity and certain to raise a laugh. Around and above each portrait is the name of the poet and a specimen of his verse. Occasionally, the features may seem sufficiently characterized to suggest that real portraiture is intended, but many of the faces are conventional and unparticularized. The second of Masanobu's books of this kind was even more extensive, comprising portraits of one hundred poets as well as several introductory genre pictures. It was entitled 'One Hundred Poems by One Hundred Poets: A Sack of Ancient and Modern Comic Verses' (*Hyakunin Isshu Kokon Kyōka Bukuro*), and although not actually dated, it

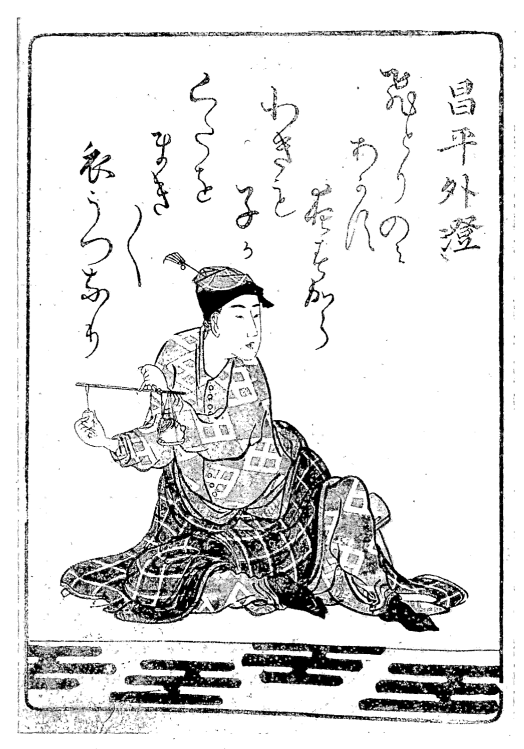

昌平外澄

花とちりの　わんにお花をかう　くくろを　せめきくくもあり　紙うつちあり

has been deduced that it appeared in 1787.

Hokusai made two series of portraits just after the turn of the century. One is dated 1802 and is probably the earlier. It has a title which employs the brand of facetiousness affected in such circles: 'A Wagon-load of *Kyōka* of Isuzugawa', the Isuzugawa being a river near to the Ise shrine renowned for its limpidity and frequently the inspiration of more serious poetry. This book is a charming specimen not only of this kind of literary joke, where the comic versifiers ape their classical betters, but also of extremely pretty colour-printing. Hokusai shows equal resource to Masanobu in varying the poses, and

47 The poet Shōhei
Sotozumi.
From *Isuzugawa Kyōka
Kuruma*, 1802

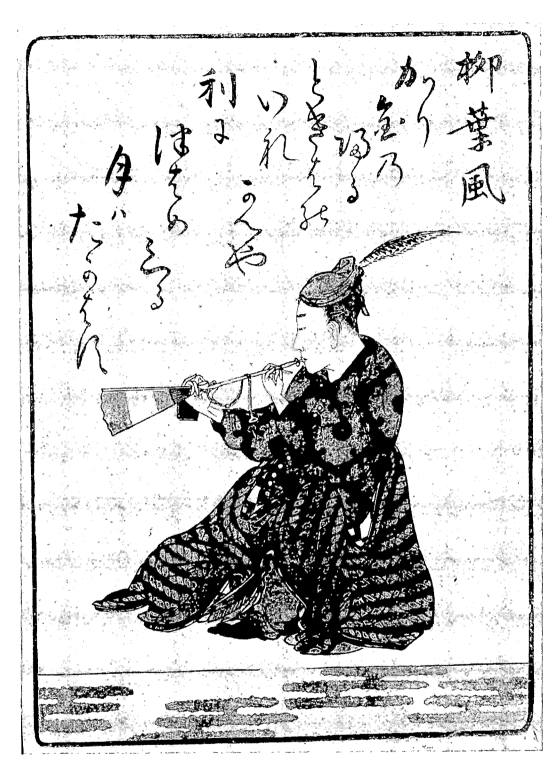

柳葉風

48 The poet Yanagi-no-
Hakaze.
From *Isuzugawa Kyōka
Kuruma*, 1802

the whimsical headgear, of the sitters, and the fifty portraits bear names which can be found repeatedly in *kyōka* books and on *surimono*. The last to figure in the book, Senshū-an Sandarahōshi, was also the compiler of the work, and below each of the portraits is a band or freize with a pattern formed of a stylized *san*, the first character of his name. This band is yet another take-off of classical practice, since painters of the great poets of antiquity always placed them on a low dais decorated with a recurrent geometric pattern (pls. 47 & 48).

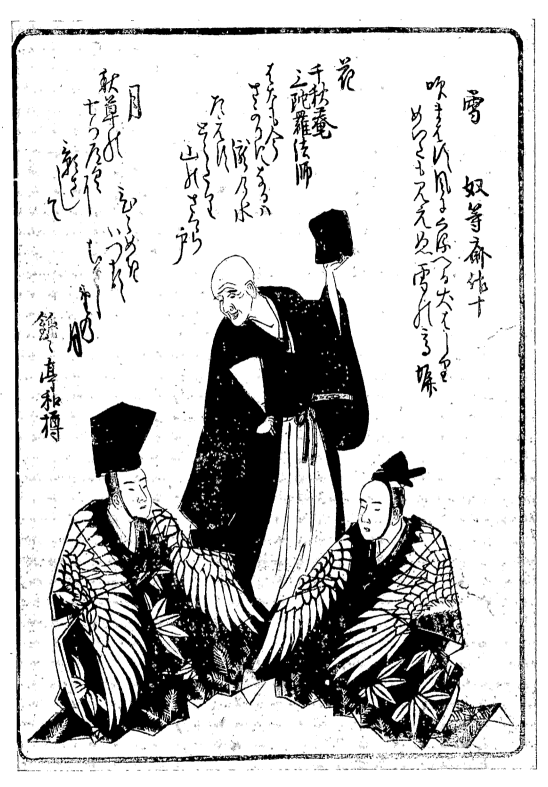

The other similar book of the period is called 'The Thirty-six Immortal Poets of *Kyōka*'. It is not dated but in style seems to be a few years later than the Isuzugawa collection. It was again compiled by Senshū-an Sandarahōshi and the poets appear above the same stylized *san* pattern that occurs in the earlier book. Without any obvious connection with the portraits, a splendid double-page print serves as frontispiece, a theatrical scene involving four actors, with verses above, one for each of

49 The poetry-master Senshū-an as a priest between two acolytes. From *Kyōka Sanjū-rokkasen*, *c.* 1804/5

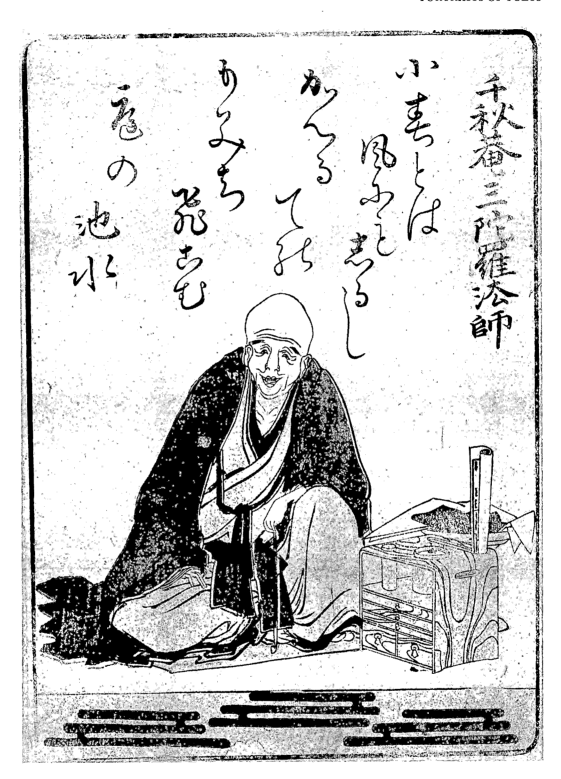

千秋菴三陰羅法師

小まとは
風心と
もるし
かへる
てふ
りゝち
花を
ひ
をの
池水

50 Senshū-an, with a poem
of his above.
From *Kyōka Sanjū-rokkasen*,
c. 1804/5

the four seasons (pl. 53), and the first of the single-page prints gives a picture of
Senshū-an as a priest standing between two kneeling acolytes in fancy dress, with
poems above on 'Snow, Moon and Flowers' (pl. 49). The compiler appears again as the
last portrait in the book. The colour-printing is once more of immense charm and
effectiveness.

51 The poets Shikin and
Shōhōjō.
From *Haikai Sanjū-rokkusen*,
1827

Presumably, books like these must have been subsidized by the verse-writers, each
of whom was no doubt prepared to make a greater outlay for the production of a book
that not only published his verse, but accompanied it with what purported to be a
portrait, however apocryphal the image. In these coteries there was no doubt a quite
competitive spirit – verse contests were frequently organized by the societies – and
there may well have been some jockeying for a place in a book coming out under
Hokusai's now well known name. This may explain the issue of two volumes within a
fairly short space of time, very few of the 'Thirty-six', apart from Sandara himself,
being among those who had already figured in the 'Fifty'.

52 The poets Kirei and
Shika-no-ko.
From *Haikai Sanjū-rokkusen*,
1827

Although it represents a break in the chronology so far observed, I think that the
other comparable book by Hokusai might be mentioned here. This is another series of
portraits of poets, but it differs from the two so far described in that the subjects are
haiku instead of *kyōka* composers. The title is 'The Thirty-six Immortals of *Haikai*',
and it was published in 1827, when Hokusai was using the *gō* Iitsu. The association
with a different circle of poets in what might be thought of as a superior stratum of
culture does not necessarily mean an apostasy on Hokusai's part from the *kyōka*
societies, though it is true that after 1827 he seems to have illustrated very little *kyōka*,
either in book or *surimono* form; but he was, by that date, in his late sixties, a recognized

53 Theatrical scene.
From *Kyōka Sanjū-rokkasen*,
c. 1804/5

master who might be expected to mix with the more intellectual groups on his own social level. Yet there is little difference in the portraits, and although the *haikai* writers do not emulate the antics of the comic poets, each occupies a single page and is surrounded by the calligraphy of his poem. Only in style is there a marked difference; and even allowing for the changed palette of the colour-printing, and granting the urbane competence of the *haikai* writers' portraits, one senses the loss, whatever the compensations of his maturer years, of a certain intangible quality that endues all Hokusai's earlier works with a winning geniality. Until middle age, he was humble enough to engender sympathy, but as he grew older, consciousness of his powers tended to make him magisterial and a little forbidding, always commanding respect, but checking what in relation to earlier works, would have been an immediate, affectionate response.

6 Illustrations
to Novels

By the early 1800s, Hokusai was a well known figure in literary circles and he soon began to be in demand not only by the verse-writers, but by the novelists. The *yomihon*, 'reading-books', that he was now called upon to illustrate were of a superior kind to the 'yellow-backs', and authors of the period, such as Bakin, Tanehiko, Emba, Rokujuen and Shigeyo, still have considerable reputations. Hokusai was most frequently employed on Bakin's immensely long and popular works, and that may simply reflect the prolific output of the author, or, more interestingly, a choice of an illustrator capable of interpreting the wilder flights of Bakin's fertile, not to say feverish, imagination. The accounts that survive of this collaboration between two proud, unbending men each at the top of his profession, suggest that the clash of temperaments led several times to a breakdown in what must always have been a stormy relationship. But Bakin recognized – indeed, he expressed himself to that effect on more than one occasion – that Hokusai was his greatest illustrator and ally, and the association at least survived thirteen novels, some of them running to many parts over long periods of years, despite intervals when one or other partner was sulking.

The first *yomihon* in which they collaborated was *Shōsetsu Hiyoku-mon* of 1804, but this marked a kind of halfway and as yet immature stage from the *kibyōshi*, though the illustrations were no longer invaded by the text. But in 1805 appeared the first part of *Shimpen Suiko Gaden*, and with that book Hokusai established new standards both in the artistry of his designs and the pertinence of his illustrations to the text. 'The Illustrated New Edition of Suikoden' is a translation, or rather, a free adaptation, of what is considered one of the greatest Chinese historical romances.[1] Earlier translations than Bakin's existed, but he was commissioned to produce a fresh and more popular version, and the first part comprised eleven volumes with seventy-seven double-page illustrations.

After their initially successful collaboration there was apparently a disagreement about the role of the illustrator, the outcome of which was Bakin's withdrawal from the enterprise and his place being taken by another translator, Takai Ranzan. It is perhaps indicative of the importance of the illustrations in a publication like this that it was the writer who was replaced, not the artist. Hokusai saw the novel through six parts, but

[1] *Shui-hu-chuan.* We have recently been enjoying the latest Japanese version in a television series under the title 'The Water Margin'.

一部水滸百幻其中施羅綠華奇天工堂堂逼天工者出藍譯之文雄神州不那蓑笠翁青洋馬昇贅園

from Volume 62 handed over the task to his pupil, Taito II, who completed it at Volume 91.

The story concerns a band of brigands who, because they operated, Robin-Hood-like, against corrupt rulers in the twelfth century, became known as 'The One Hundred and Eight Heroes'. The name Suikoden came from the name of their mountain hideout by a river. The novel is an almost unbroken sequence of bloody or supernatural events, combat, assassination, torture, abduction and ghostly visitation – the usual concomitants of favoured novels, but carried to a peak of sadistic violence. Hokusai revels in the universal mayhem. He seems to have gone to Chinese sources for circumstantial detail, and contrives consistently to give at least a foreign look to the

54 Fan simulating Chinese style, with *ishizuri* inscription recalling Chinese 'stone-rubbings'.
From *Shimpen Suiko Gaden*, Volume 6, 1805

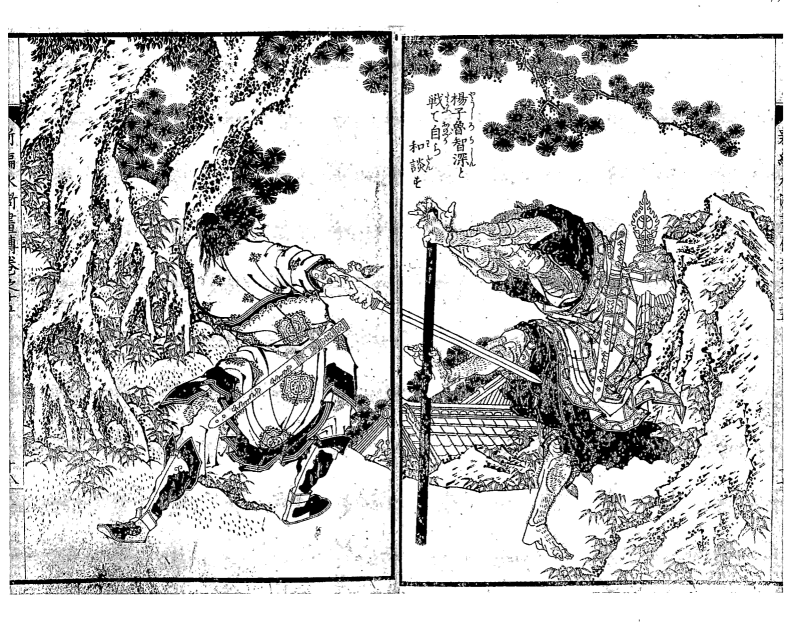

やりろうらん
楊子魯智深と
せんりてみつか
戦て自ら
わだんを
和談を

55 Rochishin defending
himself.
From *Shimpen Suiko Gaden*,
Volume 15, 1827

characters of the novel, though no one could closely relate the scenes to the Sung or
Yüan period when this anonymous novel was written. But Hokusai achieves a genre
quite different and separate from all his so to speak 'native works', and throughout
there is a conviction about his depictions of this imaginary Chinese world that must
have made it believable to the Japanese who read the book (pls. 55 & 56).

The volumes are full of virile and energetic compositions like that reproduced in
pl. 55. Rochishin, one of the most powerful of the one hundred and eight heroes, is
defending himself against an assailant with his monstrous *shakujō*, or priest's staff,
normally made of wood but in this case of iron, which with his superhuman strength he
wields with ease.

The next illustration (pl. 56) is of particular interest because Hokusai's first draft for the right-hand side has survived (pl. 57). The drawing, one of his finest, is one that came to Europe late in the nineteenth century and has always been admired in the West, partly, one feels, because it is not so far removed in its appeal from a western Old Master drawing. It presents an opportunity to touch here on the rather contentious subject of the translation of an artist's drawings into the published woodblock prints. It used to be accepted that the artist drew his design on very thin paper which was pasted, reverse side up, on to the plank of cherry-wood and was then destroyed under the block-cutter's knife. That this was often indeed the case there is little doubt: but certain drawings that have survived, prepared for the block-cutter but then rejected, suggest that it may have been Hokusai's practice, especially in his maturer years, to make a preparatory drawing which would be taken further, redrawn, with the detail required for the guidance of the block-cutter, by a pupil, or by an artist in the publisher's studio trained for just such work.

56 Sōkō about to rescue Lady Fujiyo.
From *Shimpen Suiko Gaden*, Volume 29, 1829

57 Preparatory drawing for the right-hand section of the Sōkō and Lady Fujiyo illustration.

58 Copyist's drawing for the block-cutter, based on an Hokusai original, for 'Newly-compiled Accounts of the *Shōguns* of Japan'.

In the Museum of Fine Arts, Boston, to instance a case in point, are five volumes of drawings ready for the block-cutter, but never transferred to the wood. The book was to have been entitled 'Newly-compiled Accounts of the *Shōguns* of Japan', and production must have reached an advanced stage since the drawings were made on sheets on which border lines and *hashira* title had already been printed from woodblocks. Possibly the censor vetoed publication, the Bakufu, the government of the day, always being sensitive to anything that might be written concerning even remote ancestors or forerunners of the Tokugawa line. But while Japan lost what would have been a splendid book of prints, posterity has been allowed to study drawings that otherwise would have fallen to the cutter's knife. From them we can conclude without hesitation that the conception was Hokusai's, but it is hard to believe that the actual

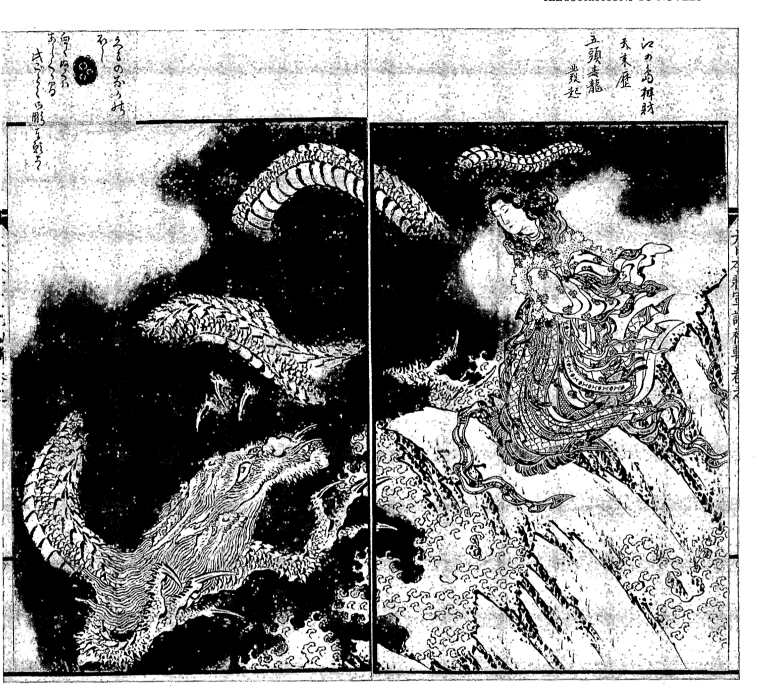

59 Another copyist's drawing for the same work.

execution of these meticulously finished brush-drawings is also his (pls. 58, 59). Marvellously controlled though the line may be, there is a sort of mechanical exactitude that is quite foreign to Hokusai's normal freedom, and it seems quite against his temperament for him to have worked minutely over the whole surface, servilely outlining every leaf, dotting the stonework, completing each intricate pattern of the clothes, not to mention the time that this would have taken him. It is far more likely that drawings such as these were based on original drafts of the master, drafts taken as far as he considered necessary bearing in mind the skill and resource, and the familiarity with Hokusai's style, of artists employed to finish them. Certain weaknesses of line here and there, quite uncharacteristic of Hokusai, strengthen that view.

元人豼耐菴水滸
一百二十四扁

The so-called 'Rape' is only a first sketch for a design that Hokusai no doubt took further before he passed it over to an assistant. Another set of drawings, this time in the British Museum, seems to be at the final stage at which Hokusai handed it over for translation into block-cutter's copies. As it happens, these drawings were made for another book devoted to the Suikoden heroes, a one-volume picture book entitled *Ehon Suikoden*, published in 1829. As can be seen from the drawing of Shin Nai-an (at one time thought to be the author of the book) (pl. 60) and the print based on it (pl. 61),

60 Preparatory drawing for the portrait of Shin Nai-an.

元人施耐菴水滸
一百二十回篇

61 Imaginary portrait of
Shin Nai-an.
From *Ehon Suikoden*, 1829

the drawing is quite close to the ultimate print, and it seems unlikely that Hokusai
would have patiently reworked his advanced draft simply to provide a guide for the
block-cutter. One corroborative detail is the crane ornament of Shin Nai-an's robe:
Hokusai in his drawing indicates what he intends, but only once, whereas in the
finished print the crane ornament has been completed all over the garment. This filling
out, given a hint by the artist, would be exactly within the competence of the skilled
copyists who abounded at the time. When we come to the *Manga*, the assistance of

62 The warrior Rōri
Hakuchō Chōjun.
From *Ehon Suikoden*, 1829

63 Suminawa's carving of a cockerel confronting a live bird.
From *Hida-no-Takumi*, 1809

named pupils is acknowledged in the colophon, and in what else could their work have consisted if it were not in preparing finished copies of Hokusai's sketches – many of which, incidentally, have survived (pl. 89).

From this digression we return to another typical novel, not this time by Bakin but by Rokujuen, entitled 'The Story of the Craftsman of Hida'. An English translation of this novel exists and enables us all to assess Hokusai's skill as an actual illustrator.

'The Craftsman of Hida', like so many novels of the period, is pure escapism, with the usual concomitants of thwarted love, oppressive villains, and a magician who usually, though not always, rescues hero or heroine when all seems lost. The craftsman of Hida, a carpenter called Suminawa (from the name used for the ink-rope with which guide-lines were made on timber), is a magician capable of producing carvings of a surpassing realism and with lifelike movement controlled by supernatural mechanism. Hokusai illustrated this faculty in Volume 1 with a picture of a live cock attacking Suminawa's wooden replica (pl. 63).

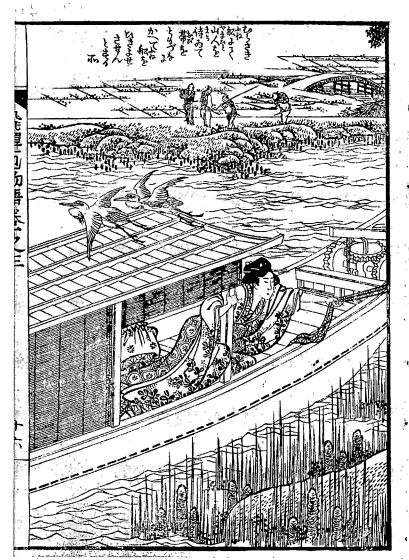
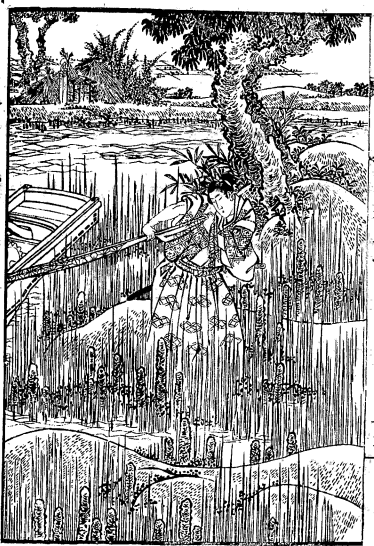

The love interest of the early part of the novel centres on Murasaki and Yamabito who are crossed at every turn in their endeavours to meet. Murasaki, with the contrivance of friends, is left alone in a boat near a reedy bank where Yamabito has concealed himself, and in the scene illustrated (pl. 64), Hokusai shows him trying to haul the boat inshore with the aid of Murasaki's sash. It breaks, inevitably, under the strain, leaving the girl at the mercy of the tide, which carries her to her destruction. Hokusai hints at the clandestine nature of the meeting by half hiding Yamabito in the spiky reeds, and by distancing the rest of the party far off on the opposite bank.

64 Yamabito trying to haul Murasaki ashore.
From *Hida-no-Takumi*, 1809

65 The ghost of Murasaki visiting her father Funanushi. From *Hida-no-Takumi*, 1809

No novel of this type was complete without its ghost, and Hokusai's most telling illustration in the six volumes of the book is of the spirit of Murasaki visiting her father, the old priest Funanushi, by night at a wayside shrine (pl. 65). One is conscious throughout the book not only of the vigour of Hokusai's line and the subtlety of his composition, but also of the point they give to his interpretations of the author's most crucial episodes. In this ghost scene, and in many others, Hokusai is aided by the superlative technique of the printers, three shades of *sumi* at least being provided from separate blocks to convey the unearthliness of this scene with a *revanant*.

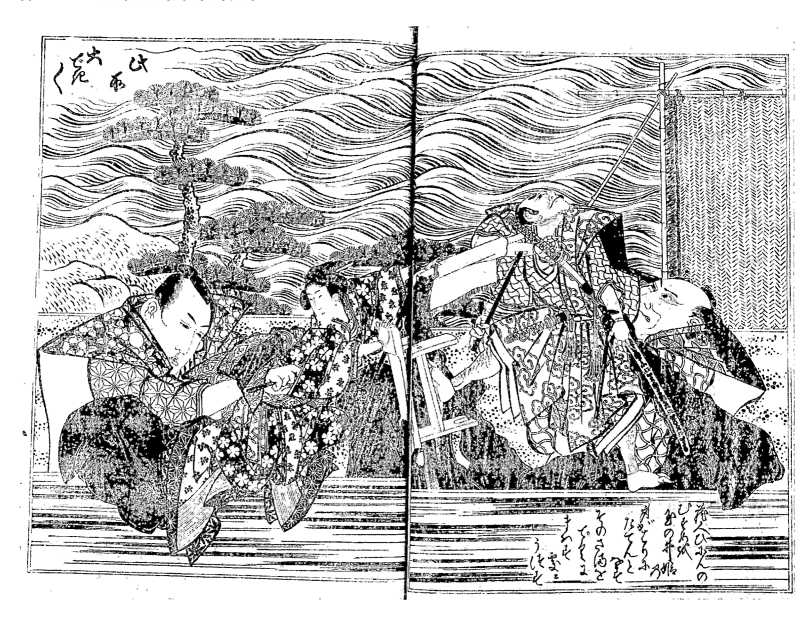

Another book for which Hokusai made some superb illustrations is Tanehiko's 'Jōruri for reading' *Seta-no-hashi Ryūnyō-no-Honji*, published in 1811, a story with a plot so involved that it defies analysis in a paragraph. Hokusai's illustration of a puppet scene (pl. 66) is masterly; and in another print (pl. 67), of the melancholy ritual of *kubi-jikken*, 'the inspection of the severed head', brought about by the father sacrificing his daughter's life in the cause of unswerving loyalty, the father's despair, and the whole *terribilità* of the harrowing event, are intensely moving.

It is tempting, where there are so few possibilities for direct comparison with western counterparts, to find an equivalent to Hokusai among the illustrators of western novels, like for instance, Hablot Browne and George Cruikshank, whose names are inseparably linked with Dickens. But such comparisons are prompted as much as anything by the use of the word 'novel' for the Japanese works, thus seeming to equate the Japanese fiction with the western, whereas there is a world of difference between the two species. Perhaps, from the point of view of illustration, the most

66 Puppet performance. From *Seta-no-hashi Ryūnyō-no-Honji*, 1811

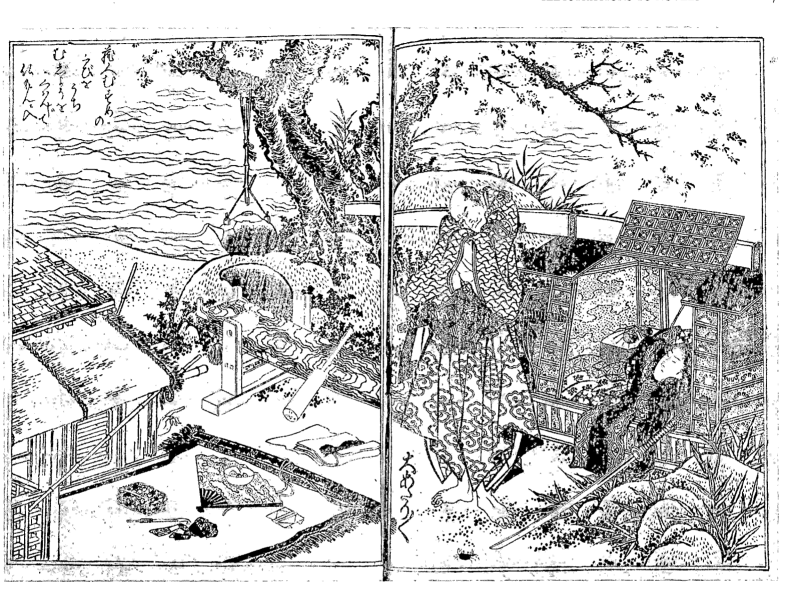

87 The tragedy of a father, forced to slay his own child. From *Seta-no-hashi Ryūnyō-no-Honji*, 1811

obvious contrast between the two lies in the western emphasis on characterization, the creation of identifiable individuals, the artist giving permanent and immediately recognizable form, features and clothes to Pickwick, Micawber, Squeers, Fagin and the rest, whereas the Japanese *yomihon* depended largely upon a succession of events, as in a *makimono*, a scroll that unfolds its story as it is unwound in the hand, with only a slight attempt to portray complex human beings. In our own literature, characters have been developed to a degree that we can anticipate how they will react to a given set of circumstances, and this has been a boon to illustrators. Hokusai, with no call or encouragement to focus upon individuals to that extent, conveys with immense drive and purpose the sweep of events, producing illustrations full of action and incident from margin to margin. It is a counterpart, in another form of literature, to the contrast between western drama and Kabuki, and between realistic prints and paintings of, say, Garrick and Kemble and the highly stylized colour-prints of Danjūrō and Iwai Hanshirō. Comparisons founder for want of a common conceptual plane.

Hokusai illustrated nearly forty novels of varying length containing in total over 1,500 prints, which thus constitute a major part of his lifework in all mediums. They certainly preoccupied him to the exclusion of much else in the years from 1804 to 1815 when the bulk of the *yomihon* with which he was concerned were published. Some, like the *Shimpen Suiko Gaden*, issued in parts though initiated in that period, were continued in sequels into succeeding decades, and a few, like the *Ehon Kanso Gundan* (see Chapter 17) were not begun until much later. But during that period 1804 to 1815, Hokusai's concentration on the illustration of novels was instrumental in causing the evolution of methods and mannerisms in handling certain classes of subject. These singularities were still further accentuated in books devoted later wholly to certain of those specific categories, those, for instance, with a pseudo-Chinese background, above all the *Tōshisen* books of 1833 and 1836 (see pls. 216, 219, 220), and the straightforward 'warrior' prints, the *musha-e*, particularly the trilogy described in Chapter 17 (pls. 209, 215, 217).

Clearly, in any account of Hokusai's book-illustrations, those in novels, because of their numbers, are inevitably given proportionally the least coverage. Fortunately, the greater part of them have now been reproduced in a comprehensive work called *Hokusai Yomihon Sashi-e Shūsei* 'A Compendium of Hokusai's Novel Illustrations', prepared under the main editorship of a leading Japanese authority on Hokusai, Jūzō Suzuki. A generous proportion of the illustrations of thirty-four novels are reproduced on a small scale, and more limited selections are reproduced full size in facsimile. Full bibliographical details are given of each book, as well as a synopsis of the text and a description of the scenes illustrated on the larger scale. No library in the world, it is safe to say, possesses good impressions of all these books, which are hard to locate in reasonable condition since they have invariably been well thumbed, and this new compendium is indispensable to every student of Hokusai and the Japanese illustrated book.

7 Hokusai's Album of Pictures from Nature

Towards the end of the period of the most intense activity in illustrating novels, while at the height of public acclaim and almost as if in response to it, Hokusai designed the series of fifteen prints which were published in album form under the title of *Hokusai Shashin Gafu*, 'Hokusai's Album of Pictures from Nature'. There is a short, eulogistic preface by one Taira-no-Yoshitaru dated 1814, and in the absence of a colophon, it has to be assumed that the album was published at about the same date.

The words *shashin* in the title are not capable of a simple translation: 'true picture' or 'realistic picture' are plausible, and the present-day usage of exactly the same characters for 'photograph' is some indication of the meaning conveyed in Hokusai's day. But the translations 'true' or 'realistic' do not at all describe Hokusai's quite stylized presentation of figures, birds, animals and flowers in this album, and 'pictures from nature' was no doubt in Hokusai's mind, not without, however, a hint of boastfulness at his ability to capture and portray the world and everything in it. In fact, Hokusai, who until then had been an illustrator of novels or a contributor to poetry anthologies, now for the first time gave his own name to the title of a book, and there is a kind of 'diploma-work' consequence and seriousness about the prints in *Shashin Gafu*.

He was, of course, by this time well known, even notorious. Ten years previously he had created a sensation by making a monster painting of Daruma some fifty feet high for public showing at the Otowa Gorokuji Temple in Edo, and in the same year he had been summoned before the *Shōgun* to pit his skills in a contest with the *Shōgun*'s favourite artist, Tani Bunchō. Pupils had flocked to him and, with all his eccentricities, he seems to have been a successful teacher, many of his pupils becoming leading masters in their own right, Hokkei, Shinsai, Taito II and Hokuba above all. Some idea of their numbers is revealed in a small *kyōka-bon* published around 1816 to which each of fifteen pupils contributed a print in addition to the frontispiece by Hokusai (pl. 68), and yet they comprised less than a quarter of the total number who received instruction from him.

His personal affairs in 1814 were in a far from tranquil state. He is thought to have married in his mid-twenties and to have had several children by this first wife. He remarried in 1797. His eldest son, by his first wife, died in 1812, and apart from a

faithful daughter, Ōi (Oei), who tended him in his old age, his children and grandchildren were a constant source of tribulation. His unconventiality, his disregard for personal comfort, his restlessness in constantly moving from one house to another, all seem to have become accentuated from about this time. Yet the prints in the *Shashin Gafu* belie this inner turmoil: however diverse the subject, they impress by their measured line and deliberate composition, and the album seems almost to have been conceived as a refutation of the pejorative term 'Ukiyo-e', with its connotations of transience, triviality and hedonism. The themes might almost be termed classical and

68 Actor making up before a mirror. Signed Hokusai. From *Kyōka Kunizukushi*, c. 1816

69 Shrine-guardian painting
a *torii* column.
From *Hokusai Shashin Gafu*.
Preface 1814

were currently in the repertoire of any Kanō or academic painter. But Hokusai's treatment, and the colour-print medium, resulted in prints without precedent in Japanese art, and the forerunners of the later sets of landscape and *kachō-e* published in broadsheet form on which Hokusai's fame principally rests.

Hokusai paraded his gifts in every sphere: sympathetic humour in his handling of people of the lower orders (the shrine guardian painting the *torii* column (pl. 69); awareness of the lore and philosophy of China (Sōshi dreaming of the butterflies); the composure and serenity of the religious icon painters (the Kannon on a dragon) (pl.

70 Kannon on a dragon.
From *Hokusai Shashin Gafu*
Preface 1814

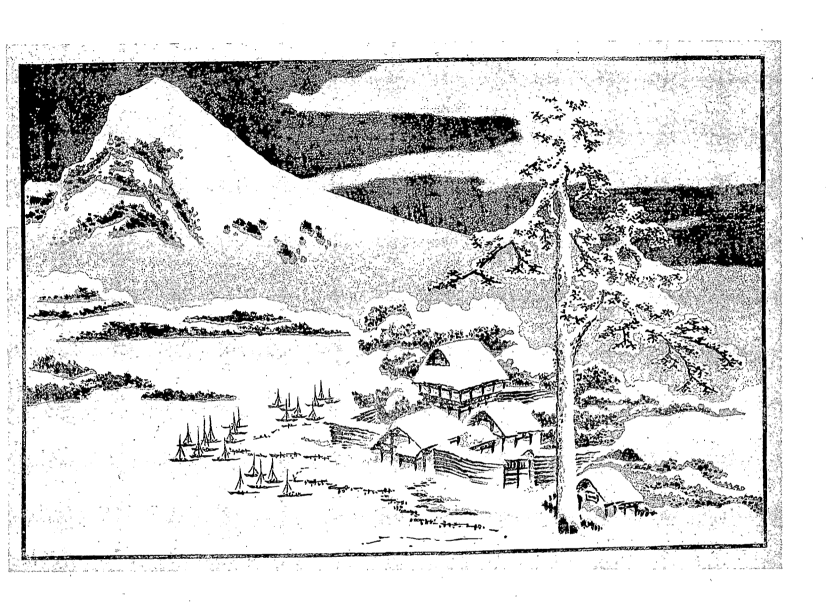

71 Landscape in snow.
From *Hokusai Shashin Gafu*.
Preface 1814

70); and newfound majesty in landscape and *kachō-e* (the snow scene already has the breadth of the finest of the 'Thirty-six Views of Fuji' (pl. 71)), and the prints of an eagle, a pheasant (pl. 72) of ducks (pl. 73), of plum, and of irises (pl. 74), foreshadow the *nobilemente* mood of the 'Large Flowers' series of prints. It is an astonishing series of prints, quite beyond the reach of any other Ukiyo-e artist of the period, presented without a word of text apart from the preface.

 We can conceive some notion of the richness of Japanese art in book form when it is realized that, splendid though it was, the *Shashin Gafu* was only one of a number of outstanding publications to appear on the bookstalls in that same *annus mirabilis*, 1814.

72 A pheasant.
From *Hokusai Shashin Gafu*.
Preface 1814

73 Duck and drake in the snow.
From *Hokusai Shashin Gafu*.
Preface 1814

74 Irises.
From *Hokusai Shashin Gafu*.
Preface 1814

Principal among the others were two great anthologies of Nanga and Shijō art, the *Meika Gafu* and *Keijō Gaen*; then there were the astonishing solo performances of three artists who gave their names to *Suiseki Gafu* (Series I), *Minwa Hyaku-jo* and *Fukuzensai Gafu* (Fukuzensai being an art-name of Niwa Kagen who had died in 1786); and among the Ukiyo-e contributions, an attractive series of *kyōka* poets' portraits by Shinsai, entitled *Kyōka Shusse Goi Gojūnin Isshu*, much on the lines of the two books by Hokusai referred to in Chapter 4. In addition to all those, and several worthy new editions of earlier publications, there was the first volume of the *Manga* which, far more than *Shashin Gafu*, established 1814 as a major landmark in Hokusai's career.

In fact, very few copies of *Shashin Gafu* have been recorded, another pointer to its comparative unpopularity at the time of issue. Among the great French collectors only Gonse appears to have possessed a copy,[1] though the Hayashi Sale Catalogue of 1902, No. 1719, describes a copy (for which a date of 1813 was given by mistake). Copies must be rare in Japan. It was omitted from the illustrations in Narazaki's *Hokusai Ron*, and the three copies listed in the recently compiled list of pre-1868 publications in Japan, *Kokusho Sōmokuroku*, are all cited as of the 1819 re-issue. The 1819 edition, which has a colophon naming the publisher as Tsuruya Kiemon, is inferior in printing and colour to the earlier, undated, edition.

[1] The Leiden 'Siebold' duplicate, now in the Chester Beatty Library of Oriental Art, Dublin.

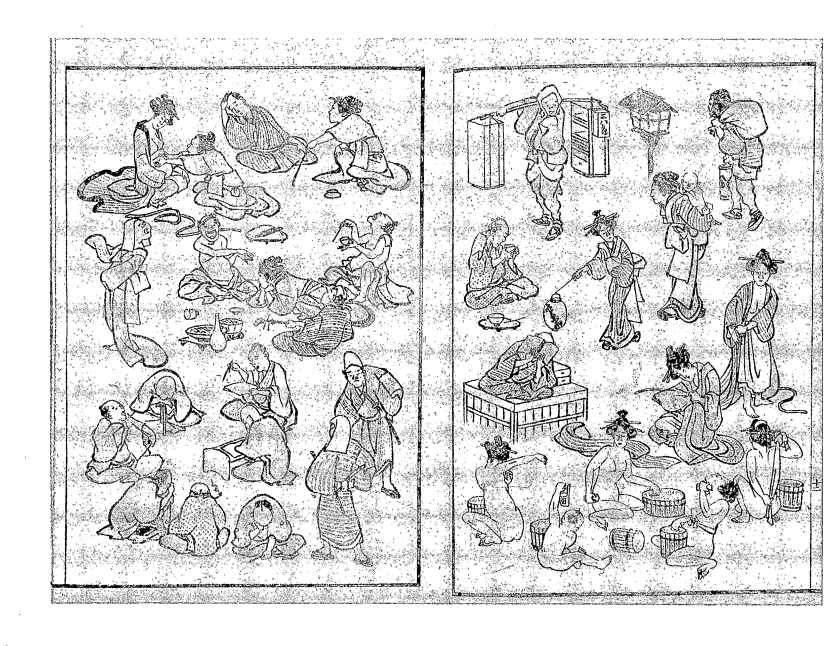

8 The 'Manga'

It is one of those paradoxes that abound in art history that the *Shashin Gafu*, on which Hokusai set so much store, had no more than a limited *succès d'estime*, whereas the first volume of the *Manga*, to all appearances an enterprising publisher's gamble, immediately achieved almost universal popularity, greater probably than any other Japanese picture book up to that time. And what is more extraordinary, as soon as it became known in the West, it rapidly became equally widely acclaimed there.

The preface to any Japanese book has to be read with scepticism. Traditionally, it was an occasion for literary spoof and rhodomontade, never to be taken too literally. But the foreword to Volume I of the *Manga*, whilst indulging in the customary high-flown verbiage, has one short passage that has the ring of truth. It reads: 'This autumn [the autumn of 1812, when Hanshū Sanjin, an obscure artist of Nagoya, wrote it], the master chanced to visit the Western Provinces, and stayed for a time in our city. There was a meeting at the house of Gekkōtei Bokusen and there over three hundred drawings of every kind were made' Bokusen, whose acquaintance Hokusai had made earlier in Nagoya, became a pupil of the artist and may possibly have proposed to the leading publisher in Nagoya, Eirakuya Tōshirō, that he should publish a volume of prints based on random sketches of the artist, and may even have agreed to make working versions of the drawings for the block-cutters. Certainly, his name is shown alongside Hokusai's in the colophon, where he, and another pupil named Tōnansai Hokuun, are described by the character *ko*, which has a variety of meanings but here is assumed to mean 'reviser', implying, it is plausible to accept, that the two pupils prepared Hokusai's impromptu sketches for publication. Eirakuya seems to have persuaded an Edo publisher to underwrite part of the venture, and the first edition appeared under the joint imprint of Eirakuya of Nagoya and Kadomaruya Jinsuke of Edo.

What made this picture-book so inordinately popular that it was followed by further volumes in quick succession, Parts 2 and 3 in 1815, Parts 4 and 5 in 1816, Parts 6, 7, 8 and 9 in 1817 and Part 10 in 1819, whilst reprints of Volumes 1–9 were being published during those years?

The contents of the first volume consist in the main of pages of disconnected drawings (pl. 75), roughly ten to a page, of figures from everyday life, from mythology,

75 All sorts and conditions of men and women. From *Hokusai Manga*, Volume 1, 1814

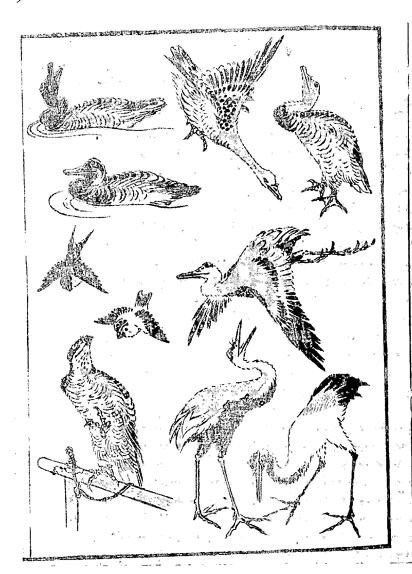
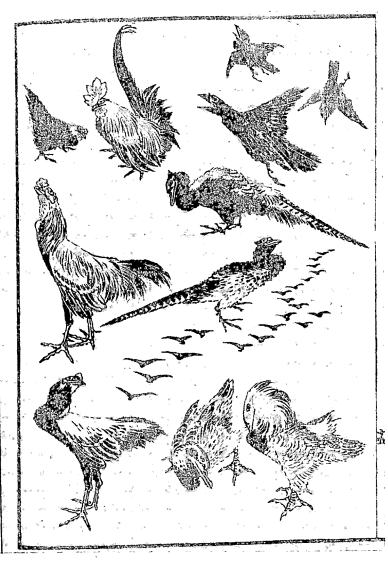

76 Varieties of birds.
From *Hokusai Manga*,
Volume 1, 1814

religion or legend, figures invariably in lively action captured unerringly in expressive brushlines that are translated into woodcuts printed in a light and a dark shade of ink and a pale rose tint: and in that translation given the kind of vouched-for authority that the printed word has over the haphazard inequalities of a manuscript. The human figures are followed by pages of animals, then birds (pl. 76), insects, flowers and fish, until, at last, two double-page prints are devoted to a mountainous landscape and a seascape with many ships and a raft. Then follow pages of trees, grasses, cottages, villages, bridges, rivers and waterfalls – it is almost as if there was an intention to provide a comprehensive range of models for a would-be painter, on the same lines as an explicit instructional manual. Such practical guides had been fairly common since the mid-eighteenth century, though in general they were intended for students of Chinese-based styles of painting, Nanga or Nagasaki (Shên Namp'in). Most recent, and no doubt familiar to Hokusai, were Bumpō's *Bumpō Kanga*, 'Bumpō's Drawings in the Chinese Style', of 1803, which was nothing more than pages of diminutive Chinese figures, singly or in groups, identified by names, and on a scale, at least, equivalent to

those in the *Manga*; and *Gentai Sensei Gafu* 'The Master Gentai's Drawing Book' of 1806, which was a manual of instruction in landscape painting in the Chinese style, with examples of the stock ingredients and of staffage figures, not too dissimilar from some of the *Manga* pages.

The *Manga* may not primarily have been intended to provide models for aspiring artists, but Saeda Shigeru (certain of whose novels Hokusai had illustrated a few years earlier) suggested on two occasions that the publications were intended for art students – in the preface to Volume 4 he spoke of the volumes being distributed among pupils and providing 'a ladder for beginners'; and in the preface to Volume 7 (1817), the gist of a typically high-flown eulogy is that Hokusai spent his spare time making model drawings for pupils to copy.

All sorts of translations of the two characters forming the word *Manga* are legitimate, but possibly 'Random Sketches' is nearest to the sense Hokusai, or his publishers, intended. Actually, the full title of the book, *Denshin Kaishu: Hokusai Manga*, is rarely quoted. The words *Denshin Kaishu* are no easier to translate than *Manga* itself, but one Japanese translation is 'The education of beginners by the spirit of things: Hokusai's random sketches'.[1] And so, in title at least, it might be argued that the book was presented as something rather more than a mere picture book.

But that would not have accounted for its instantaneous popularity. That arose because the public at large, not merely students of painting, enthused over it. It is difficult for us to comprehend why. The contents of the first volume of the *Manga*, a series of drawings of the utmost diversity, reproduced several to a page in woodcut, without a word of text, not even a caption, were devoured by the Japanese commoners with an avidity that seems to confirm that pictorial images meant a great deal to them, and that they 'read' the woodcuts as their western contemporaries would read popular literature. The small woodcut images were the characters of a language which they read with the same facility as the 'picturegraphs' or 'ideographs' of their own actual written language. Perhaps, for those of semi-literacy for whom the Chinese characters were an impediment to reading, they were a substitute for literature. As a species of art, or entertainment, or instruction, such books as the *Manga* and the *Gafu* lie outside our western experience and we can only partially grasp their appeal to the Japanese.

The fifteen volumes present complex bibliographical problems. Distinctions between the earliest and successive issues of each volume are indicated by a number of factors: gauffraged covers; the number of pages of publisher's announcements at the end of re-issued volumes; changes in the publishers named in the colophon; the omission of the publication date in the colophon, and, in some instances, an actual change of publication date. The first ten volumes were republished in a collected edition, undated but thought to be shortly after the appearance of Volume 10 in 1819. Then there was a lull of about fifteen years before Volume 11 came out, undated but before 1834; Volume 12 has a preface dated 1834; Volume 13 although it has a preface dated 1849, just before Hokusai's death in that year, probably did not appear until 1850; Volume 14 is undated but is certainly posthumous, and according to Goncourt, though on what authority he does not say, appeared in 1875; Volume 15 is dated 1878.

[1] *Naito*. See Javal Catalogue, First sale, p. 38.

 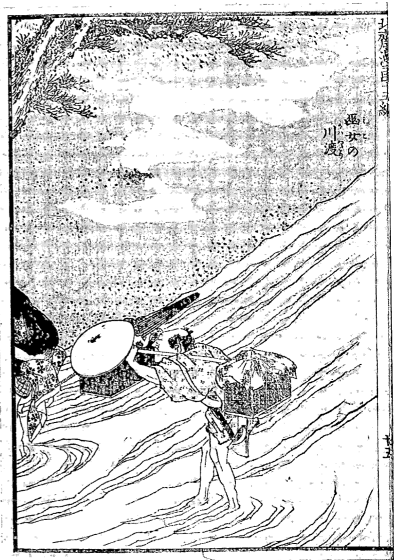

The last two volumes were brought out by the astute and less than scrupulous publishers under the *Manga* title but the contents have none of the validity of those put together during the artist's lifetime. Volume 14 contains drawings of a more finished, less spontaneous, nature than the typical *Manga* sketches, and though the drawings on which the woodcuts were based may have been considered authentic at the time we view them more critically today. Volume 15, on the other hand, was patently spurious since it consisted largely of designs worked up from those already printed in *Shūga Ichiran* (see Chapter 9) published in 1818, figures being lifted bodily from the earlier publication but transposed and placed in different relationships (pls. 77 & 97). Volume 15 was published by Katano Tōshiro, son of the Eirakuya Tōshirō who brought out the first *Manga* in 1814, and Katano was so confident that the public of 1878 would be ignorant of the *Shūga Ichiran*, published sixty years earlier, that he had the effrontery to write, in the preface, 'the illustrations were only half-completed and not yet published at the time of the master's death'. Thus, although Volumes 14 and 15 are not without points of interest, the *Manga* canon proper consists of Volumes 1 to 13 only.

Laurence Binyon and J. J. O'Brien Sexton, in their *Japanese Colour Prints* of 1923, were the first to impose some sort of guide to this bibliographical labyrinth. Later,

77 *Miko* (sorceress) borne across a river; and a *daikon-seller.*
From *Hokusai Manga,* Volume 15, 1878

78 'Sparrow dancers'.
From *Hokusai Manga*,
Volume 3, 1815

Charles Vignier, in the first Javal Sale Catalogue, of 1927, straightened the paths still further, and his account, while, on his own admission, provisional and only capable of completion in the light of study of a greater number of copies of the *Manga* than had come within his purview, remains the most solid and authoritative so far published. James Michener, in his splendid *The Hokusai Sketch Books*, performed the valuable service of reproducing extensive selections from all the *Manga* volumes, with an enthusiastic and enlightening text, which also provided translations (by Richard Lane) of all the prefaces to the volumes.

Even restricting myself to the first thirteen volumes, I can give no more than a few characteristic examples; and it cannot be claimed that from them a valid idea of the whole enormous corpus can be gained. For that, one would need the imagination of Hokusai himself: there is no way of appreciating what the *Manga* encompasses short of a study of the work as a whole, volume by volume, though Mr Michener's copious anthology is the next best thing.

The first few volumes rely a great deal on pages crowded with tiny figures. The 'Sparrow dancers' from Volume 3 (pl. 78) brings home the double pleasure such compositions give, first, from each figure viewed singly, the capture of fleeting

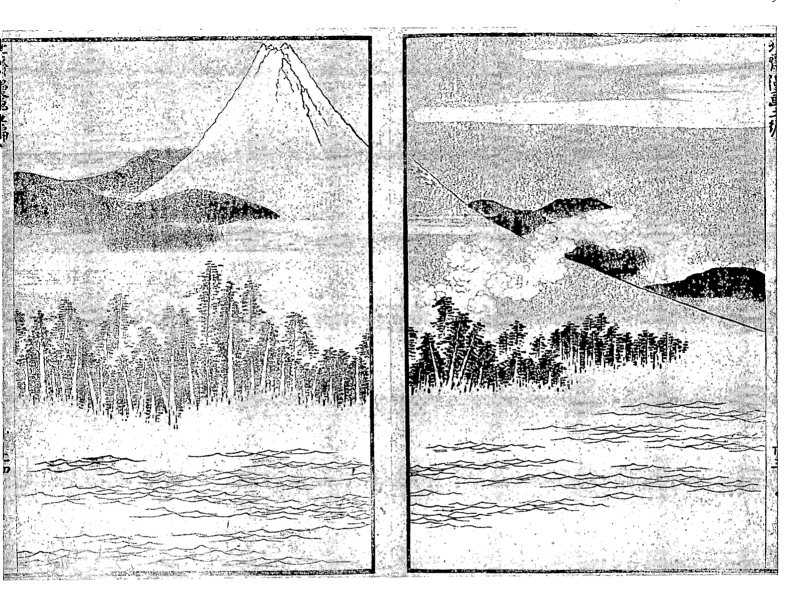

79 Tree forms. From *Hokusai Manga*, Volume 4, 1816

80 Mount Fuji. From *Hokusai Manga*, Volume 5, 1816

movement, the poise in motion, second, the pattern they make dotted about the page. In Volume 4 (which contains the often-reproduced page of fish-divers under water) a double-page of tree forms, with some attempt to distinguish species (pl. 79), shows how Hokusai's concern to instruct could still result in attractive compositions. Volume 5, devoted largely to shrine architecture, has one glorious print of Fuji (pl. 80). Horses (pl. 81), and men in *kendō* (pl. 82) and other contests, predominate in Volume 6, whilst Volume 7, one of the finest, is confined almost entirely to landscapes, several of which are of a nobility that fully demonstrates Hokusai's deepening powers (pls. 83 & 84). Volume 8 has about the widest variety of any volume, with drawings ranging from elephants to looms, from the 'Paragons of Filial Piety' to botanical diagrams, from

81 Horses.
From *Hokusai Manga*,
Volume 6, 1817

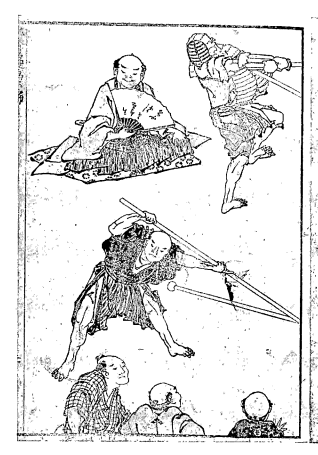
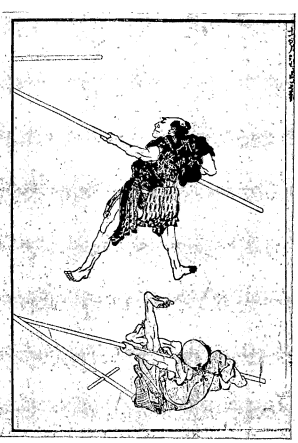

82 *Kendō* contests.
From *Hokusai Manga*,
Volume 6, 1817

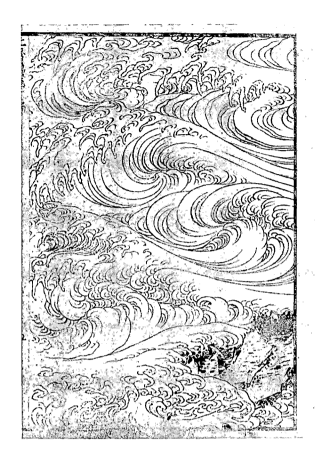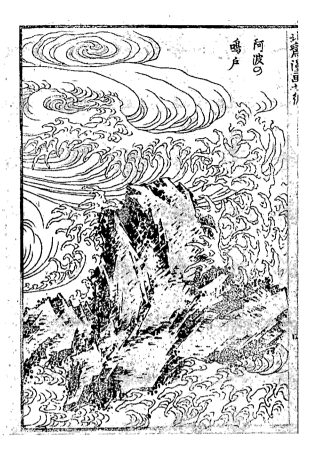

83 The Straits of Awa.
From *Hokusai Manga*,
Volume 7, 1817

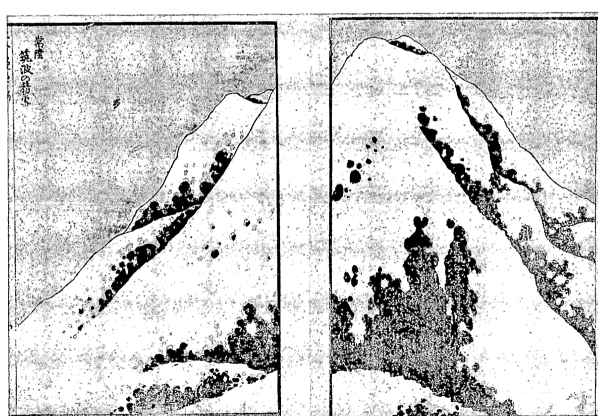

84 Snow on Mount Tsukura,
Hitachi (now Ibaragi).
From *Hokusai Manga*,
Volume 6, 1817

mountebanks (pl. 85) to anchorites and saints. But every volume has this kind of
inconsequential jumble: the later volumes may have fewer pages of tiny figures, there
are more double-page designs that point forward to the grand prints of *Hokusai Soga*
and *Hokusai Gashiki*, but there is still, in the first ten volumes more obviously than in
the later, a sense of random selection from the stream of drawings that came from
Hokusai's brush, incessantly, every day of his life. No single volume of the *Manga*
impresses us as a work of art as does, say, the *Shashin Gafu*, but the *Manga*, seen as a
whole, gives us an (almost) unedited Hokusai, demonstrating as nothing else does, his
response to Japan as a whole, its daily life, the town, the countryside, the people, all
trades, history, legend, mythology, with something gargantuan and indiscriminate in
the appetite revealed, and something almost superhuman in the constant striving to
record his vision. Michener wrote:

86 Blind men exploring an
elephant.
From *Hokusai Manga*,
Volume 8, 1817

'I have long been perplexed as to why it was the *Manga* that caught popular fancy –
and holds it still – since in so many respects the other series were superior; and I
have concluded that it is the *Manga's* simple honesty, its peasant force, its lack of
pretension that have kept it popular with artist and layman alike.'

The *Manga* reached the West ahead of other Japanese books partly because it had
been published in such numbers over the years that it was the most common, and odd
volumes if not sets were easily acquired; but partly, also, because the appeal of this
shorthand account of the newly encountered and still unknown Japan, in a racy style
and agreeable woodcut medium, was irresistible to the traveller or merchant or the art-
conscious public alike. Its earliest introduction to the western world was in the
lithographed paraphrases of some of the landscapes in van Siebold's account of Japan,

87 Ghost stories.
From *Hokusai Manga*,
Volume 10, 1819

88 Floating logs down a
torrent.
From *Hokusai Manga*,
Volume 11, *c.* 1834

89 A sheet of mounted
figure-drawings later used for
woodcuts in *Hokusai Manga*,
Volume 12, 1834

90 Two studies, one based
on the drawing described in
no. 89.
From *Hokusai Manga*,
Volume 12, 1834

Nippon Archiv zur Beschreibung von Japon, published in Leiden in 1831, and in France
under the title *Voyage au Japon*, while Hokusai was still alive. The reproduction of the
Siebold lithograph by L. Nadir (pl. 92) (Hokusai is acknowledged in miniscules as the
artist), after a woodcut in Volume 7 (pl. 91), reveals how the style of the original was
westernized. But actual volumes of the *Manga* were circulating in the West soon after
Perry's momentous entry into Japan in 1854, and there is a fairly reliable story that the
French etcher Félix Bracquemond was acquainted with the work by 1856. In any event,
he was adapting designs from the *Manga* for the decoration of ceramics in 1866–67.
Literature showing knowledge, if not a proper understanding, of the work began to be
published: Dickins, Duret, Gonse, Anderson, Ary Renan, Goncourt and all the other
earlier writers on Japanese art wrote more or less ecstatically concerning the
phenomenal *Manga*, and because of the initial furore, it has played a disproportionate
role in the creation of Hokusai's ranking and distinction as an artist in western eyes.
Without the slightest desire to depreciate this remarkable series of volumes, I think the
Manga should be viewed within the framework of Hokusai's work in book form as a
whole: in that context, it takes its place as one of the dozen or so achievements that
warrant his great reputation.

91 'Crag Bridge' (Iwahashi).
From *Hokusai Manga*,
Volume 7

KUMENO-IWAHASI.

SAGAMI HASIRIMITS

92 L. Nadir. Lithograph
after 'Crag Bridge' in
Hokusai Manga, Volume 7.
From *Nippon Archiv zur
Beschreibung von Japon*, Leiden
1831

93 A lively *tai*-fish, a group
of fish, *crustacea* and octopus.
From *Shūga Ichiran*, 1818

9 'Excellent Paintings at a Glance,' 1818

One might have thought that a book of the *Manga* type, after the issue of nine volumes, would have satisfied or even sated the public's appetite and dampened the publisher's, if not the artist's, ardour: but that was not the case. About 1818 a quite separate book was printed, rather larger and grander than the *Manga* volumes but basically of the same type, a hotch-potch of disconnected sketches, often several to a page, which could quite easily have provided the material for another *Manga* volume (pls. 93 & 94). But it appeared under a different title – *Shūga Ichiran*, 'Excellent Paintings at a Glance', or *Denshin Gakyō*, 'A Mirror of Paintings [transmitted] from Mind to Mind'. (*Denshin* in this instance is differently written from the word in the sub-title of the *Manga* books, but the import is not greatly dissimilar.) Moreover, one edition of the book was sumptuously printed in colour and in that form is rather more imposing than the *Manga*, with its limited and subdued colour-printing; so much so that Goncourt was moved to extravagant praise, writing 'This book . . . is, like the *Shashin Gafu*, an album where Katsushika Hokusai shows himself at his most magisterial, at the greatest command of his talent.'[1]

But although we may feel that, at best, *Shūga Ichiran* is just a superior kind of *Manga*, it is a book that raises so many issues, some peculiar to it but others referable also to other publications, that it is worth a little detailed consideration. Indeed, it has already been anatomized in depth by Cornelius Ouwehand, whose paper 'An Annotated Description of Hokusai's *Shūga Ichiran*'[2] is the most thoroughgoing critical study so far published on any Hokusai book, and upon which I have gratefully drawn for much which follows.

As I have hinted, there were two issues: one, in ink only, with the title *Denshin Gakyō*, and the other, colour-printed, and titled *Shūga Ichiran*. But all known copies of the colour-printed edition lack certain sheets that occur in the other (sheets numbered 18 to 21) and there is no obvious way of accounting for that. It may be argued that the ink-printed version was first, and that a group of blocks was damaged and not recut for the colour version; or that it was simply decided to reduce the number of prints in the colour version to cut costs. Neither of these alternatives is very convincing. The matter is further complicated by the possibility of yet another edition, which has been put

[1] 'Ce livre . . . est, avec le *Shashin gwafou*, l'album ou Katsoushika Hokusaï se montre le plus magistral, le plus en possession de tout son talent.' Edmond de Goncourt, *Hokousaï* (1896), p. 149.
[2] In *Mededelingen van het Rijksmuseum voor Volkenkunde, Leiden* (1962), No. 15.

94 Drunken *shōjō*, travellers
and ploughman in the rain.
From *Shūga Ichiran*, 1818

forward by one or two Japanese authorities. They talk of a *kyōka* edition, and postulate that it is the first, but give no details, nor indeed proof, of such a separate edition. The supposition they make is that the *kyōka* edition included sheets of poems (conceivably on the sheets numbered 18 to 21), but this kind of compilation of random sketches does not suggest a book instigated by a *kyōka* society, nor is there even an oblique reference in the preface that might support the supposition. Until an actual copy is located and described in detail, some scepticism must remain about the existence of a separate *kyōka* edition.

None of the copies of either of the two known editions has a dated colophon. The preface to both is dated Bunka 15 (1818) which must mean it was written in the early part of 1818, since on the twenty-second day of the fourth month of 1818 the era-name was changed to Bunsei. However, although an actual publication date is not given, the Leiden copy of *Shūga Ichiran* from which my colour illustrations are taken, came to Leiden from Jan Cock Blomhoff, who was 'Kapitan' of the Dutch Factory at Deshima from 1818 to 1823, and is known to have acquired his copy in 1819. Dr Ouwehand makes the point that the *'first edition* of the book was ready for publication or perhaps had already been published before or shortly after 22nd. April 1818', and later, he explains that the publisher's seal in the Blomhoff copy means 'the plum-tree covered with snow blossoms all at once' and is only likely to have been used at the New Year. That would have been the New Year of 1818 or 1819, but he inclines to the view that it was 1819. On the whole, there is stronger support for the ink-printed version being the first, though it is conceivable that the two versions were issued simultaneously, on a 'penny plain, tuppenny coloured' basis.

Throughout this study of Hokusai's illustrated books I have generally avoided bibliographical controversies, the arguments pro and con that absorb the specialists but bore the layman, but I have touched on them in relation to *Shūga Ichiran*, where they are particularly relevant, as an indication of the kind of problems that arise not merely in regard to Hokusai's books, but Japanese books as a whole. The Japanese have rarely, until recently, concerned themselves greatly with the kind of bibliographical minutiae on which we in the West have long made analyses and classifications, and as a consequence there are no handy Japanese repositories of data to turn to when the attempt is made to establish the credentials of a book like the *Shūga Ichiran*. Dr Ouwehand, in the preliminary remarks to his excellent paper, reviewed the situation, deploring the absence of any model, fully comprehensive, catalogue of Japanese books, in Japanese or any other language, and concludes, somewhat despairingly, '. . . even a catalogue limited to 200 choice books . . . would require years of work and travel'. Since he wrote, in 1962, Charles Mitchell has produced such a catalogue, relating to the illustrated books of certain schools of Japanese artists:[3] but much, indeed, the major part, still remains to be done in respect of Ukiyo-e and other schools not embraced in Mr Mitchell's survey.

Shūga Ichiran is, however, interesting for another, quite different reason. In the preface by Sekkyū Sanjin, of whom practically nothing is known, is a passage (translated in Dr Ouwehand's paper):

[3] *The Illustrated Books of the Nanga, Maruyama and Other Related Schools of Japan. A Biobibliography.* 1972.

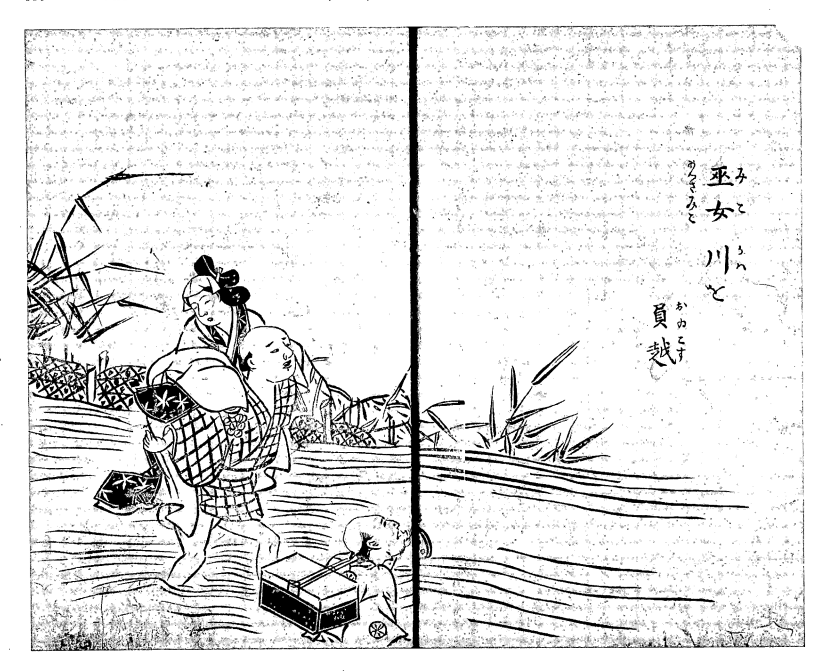

みこ
うらさみこ
巫女
ろん
川と
おゆこす
負越

95 Rinshō after Hanabusa
Itchō: Carrying a sorceress
over a stream (miko-kawa-
watari-o-oikosu).
From Eihitsu Hyakuga, 1773

'And so, last autumn, when the master took shelter from an unexpected shower
and rested somewhere in a house, this was immediately heard by people from the
book-trade circles and they came and asked him to follow the style called the
national style of painting as done in former times by some Hanabusa. Thereupon
he forthwith applied his skill to the designs of his taste and, delicately handling the
movements of the brush, he effortlessly rendered copies in a style which others
had not yet been able to paint.'

The 'Hanabusa' referred to was obviously intended for the great artist Hanabusa
Itcho (1652–1724), but bearing in mind the unreliable nature of prefaces in general, it
might have been thought a purely rhetorical invocation of a painter of legendary skill,
were it not for the fact that, according to Dr Ouwehand, certain copies of the ink-

蘿蔔賈

96 *Daikon*-seller.
From *Eihitsu Hyakuga*, 1773

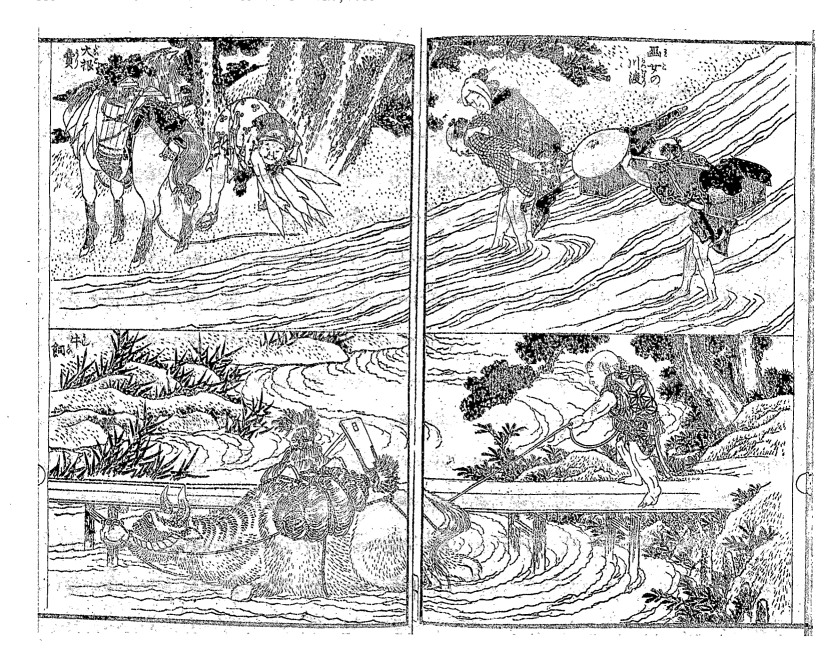

97 Carrying a sorceress over a stream (*miko-kawa-watari-o-oikosu*), and *daikon* seller and (below) boy oxherd. From *Shūga Ichiran*, 1818

printed *Denshin Gakyō* have a 'separate page inserted before the preface, giving both the names Katsushika Zen Hokusai Taito, and Suzuki Rinshō . . . with the supplementary indication *Eihitsu Hyakuga kōhen* (latter part of [sequel to] *Eihitsu Hyakuga*)'. Rinshō, it should be mentioned, was an artist better known not for his own original paintings but for his work in preparing drawings after Itchō for publication in the 1770s. *Eihitsu* was a book of Itchō designs published first in 1753 from versions of the originals by Itchō's pupil Ippō, but another version which came out in 1773 alludes only to Rinshō, and thus his name came to be linked with Hokusai's.

But the suggestion that *Denshin Gakyō* followed closely or relied heavily on *Eihitsu Hyakuga* of 1773 is quite misleading: three prints in the Hokusai book are related to

98 Man attacked by octopus.
From *Shūga Ichiran*, 1818

subjects in the *Eihitsu* but by no means closely, and it is only Hokusai's captions, echoing those of *Eihitsu*, which confirm his source (pls. 95, 97). But as can be seen in the two instances illustrated, Hokusai's drawings owe little to Itchō. On the other hand, the two artists have often been linked as possessing something of a common outlook, each with the faculty for recording the accidents and humour of people and gods with brushes that, however different stylistically, were handled with verve and mastery. And it could have been no accident that Hokusai came to repeat, in up-dated form, incidents depicted in the Itchō book. In a way, they were like disguised quotations, intended perhaps as homage to another artist whose kinship and greatness he recognized.

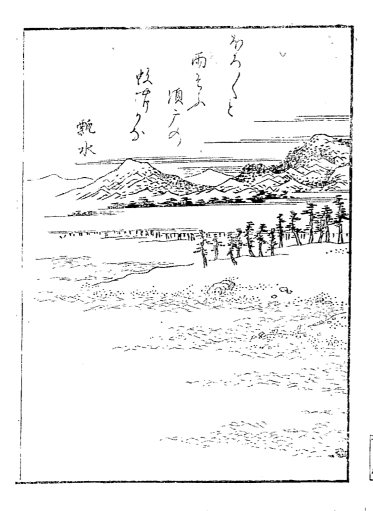

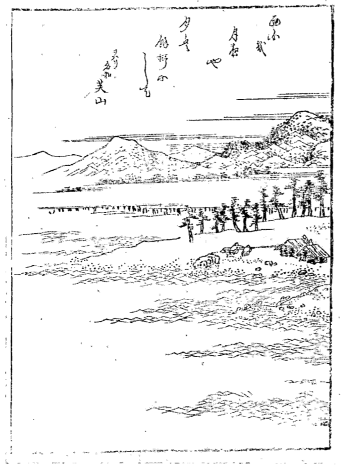

10 The Revamping of
a Book by Ryūkōsai

Hyōsui Kiga and *Ehon Ryōhitsu* represent one of the most intriguing episodes in Hokusai's career as an artist of the book. The affair began when, in 1818, for the *kyōka* book entitled *Hyōsui Kiga,* he adapted designs made originally by the Osaka artist Ryūkōsai for a book published in 1803 – an adaptation that involved the re-use of the existing blocks, suitably recut and plugged.

Ryūkōsai's book, *Gekijō Gashi,* of 1803, was a 'Pictorial History of the Theatre', intended to illustrate the real or imaginary locales of a number of well known plays. Similar books are known in the West, portraying, for instance, places where Shakespeare had set his plays – Elsinore, Verona, the Forest of Arden, and so on. In Ryūkōsai's book, actual events from the plays are projected into some of the landscapes, and thus, in a view of Ashigara-yama, illustrating *Komochi Yama Uba* (a play first performed, incidentally, in 1712), we see the minute figure of Kintarō tossing a black bear (pl. 104); and in the beach scene at Suma-no-Ura, illustrating the play *Ichi-no-tani Futaba Gunki,* there is a knot of fishermen and a *samurai* lying by a stone lantern (pl. 99): figures which were removed in Hokusai's adaptations, like the cut-out figures of a toy theatre which they resemble, to be replaced by others conceived by Hokusai (pls. 100 & 102). In fact, many of the designs give the impression that Ryūkōsai's figures were themselves afterthoughts, superimposed on landscape compositions that, artistically, were certainly not improved by the interpolations, and in some cases unquestionably weakened by them. The landscapes, quite the most memorable feature of the 1803 book, are in a strong *sumi* line in a *mélange* of styles in which both Nanga and Tosa elements can be detected. The text of the book, which deals with the plays, is interspersed by poems which also invade the upper part of some of the illustrations.

Ryūkōsai is best known for his theatrical prints, and occupies an important position as one of the founders of a separate Osaka school of actor-print artists whose style was pronouncedly different from that of the contemporary Edo masters. He studied under Shitomi Kangetsu (himself the son and pupil of the well known painter Tsukioka Settei) but none of his remaining works shows any particular traces of that training. His earliest known published work is the picture-book *Yakusha Sono Iwai* of 1784, and already the individualism of Ryūkōsai's theatrical design is evident. From that time

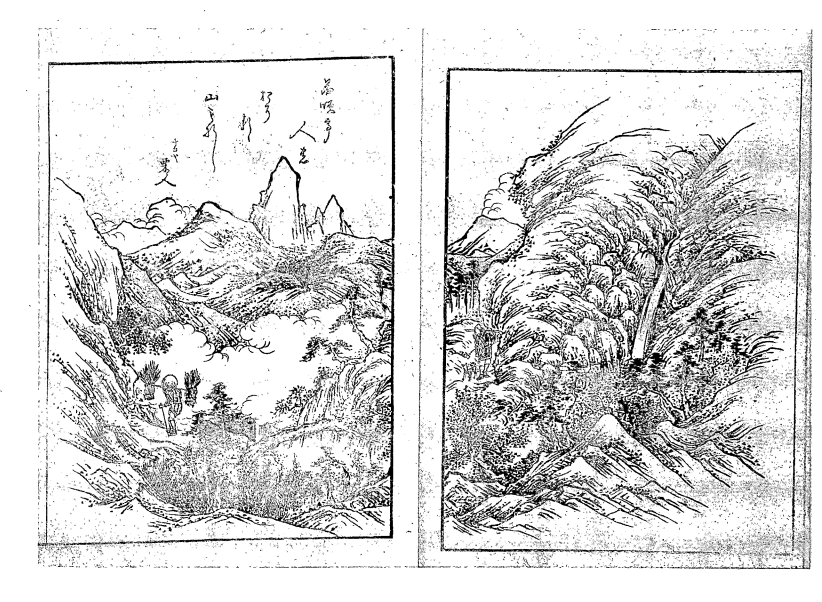

onwards, until 1809, when his activity ended (whether in death or not is not known), Ryūkōsai illustrated a number of similar books and designed several Kabuki broadsheets, usually in the *hosoban* triptych form. His actor-portrait style, though largely based on the Katsukawa prints of Edo, was also influenced by the Kamigata artist Suifutei whose *Suifutei Gigafu* appeared in 1782, but there is something indefinably corrosive in Ryūkōsai's depictions of the figures of the Osaka stage that has led to comparisons occasionally being made with Sharaku's prints. Today, the books and prints of Ryūkōsai are rare, and so far as that might be considered evidence, one could be led to believe that his work had a relatively small circulation and popularity, especially beyond the boundaries of Osaka.

101 Hokusai's adaptation of pl. 104, showing woodman substituted for Kintarō and the bear, and the verses changed.
From *Hyōsui Kiga*, 1818

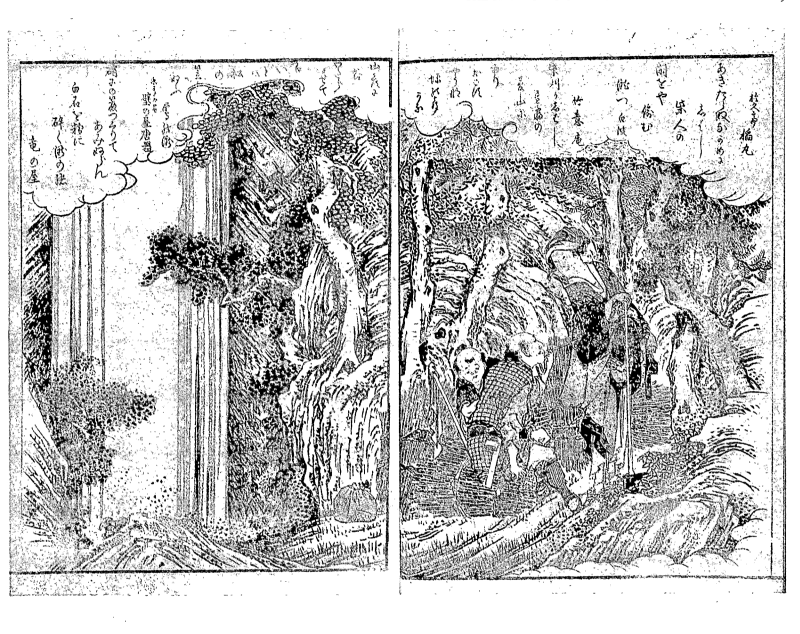

102 Hokusai/Ryūkōsai: A
woodcutter, his wife and
child take the place of the
hermit priest and the woman
in pl. 103.
From *Ehon Ryōhitsu*, before
1821

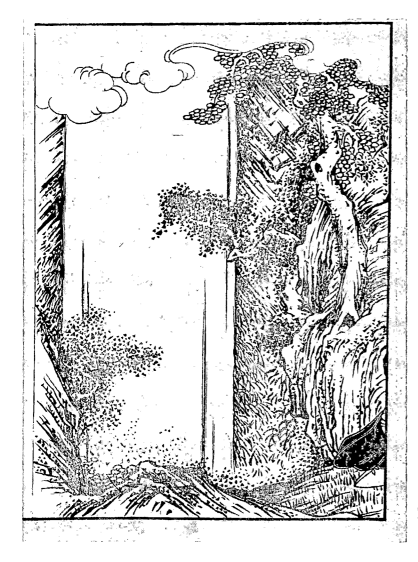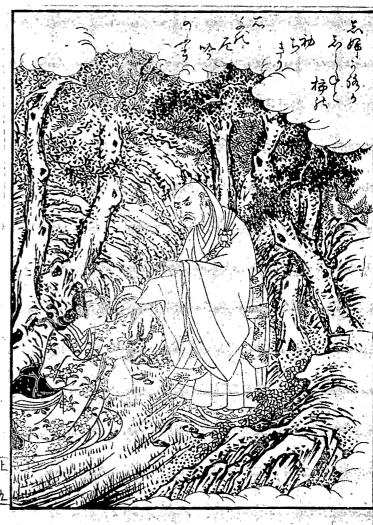

103 Ryūkōsai: Rakuhaku-
no-Yama, scene in the play
Sennin Yoshino Zakura.
From *Gekijō Gashi,* 1803

104 Ryūkōsai: Kintarō
tossing a black bear, an
incident at Ashigara-yama in
the play *Komochi Yama Uba*.
From *Gekijō Gashi*, 1803

I have given this resumé of what is known of Ryūkōsai since there is naturally speculation as to why Hokusai should have chosen, or been given, the *Gekijō Gashi* for conversion into an *ehon* with new figures of his own. *Hyōsui Kiga* was published in 1818. It is in two volumes, the illustrations printed in pale tints, blue, grey, yellow, pink and red, the last only sparingly used. The preface, from which one might have hoped to glean some explanation of the transformation, makes only the barest and quite unenlightening reference to the collaboration. It says:

> 'When it comes to the building of a house, the first thing to select is the right timber, and one should obviously leave this to the carpenter who knows the appropriate wood for particular parts, and is able to choose between bulky and slender, straight or curved timbers for beams and rafters. In the same way as the carpenter builds by careful selection, so the editor of the poems, Bouen Taibai-sō, has arranged elegant poems according to the places concerned. The same thing applies to the illustrations done by the two masters, Hokusai of the Eastern Capital [Edo] and Ryūkōsai of Naniwa [Osaka] in collaboration, the refined verses enriching the sights of the 'Snow-Moon-Flower' sequence in this small but beautiful book.
>
> Hearing about it from the publisher, I have made this preface to it.
>
> The day of the winter solstice, Bunka *hinoto-ushi* (1817) at Ganjirō in Mado-ura.
> (Signed) Ressai, sealed Raizan.'

Hyōsui Kiga consists of only sixteen prints, a single-page at the beginning and end of each volume, seven double-page in Volume 1, and five in Volume 2. The illustrations (pls. 99–102) show the nature of the changes effected by Hokusai in the original compositions. Some are more significant than others: the figures are larger, perhaps, or the action more concentrated (e.g. the beach scene, pls. 99, 100); or in others, the alteration of the figures has little bearing on the ultimate design but the colour-printing and the use of a fainter *sumi*, produce a quieter, softer, atmosphere. New poems accompany most of the designs, the upper lines of the original blocks needing to be recut in many instances to accommodate the calligraphy.

The colophon does not give the artists' names, but only the date and the names of the two publishers. Although the name Ryūkōsai is coupled with Hokusai's in the preface, the first two characters of the name differ from those used in the 1803 book, and in 1818 the connection with the artist of the 1803 book would probably have been recognized by very few.

The great problem posed is how and why did Hokusai become involved in this curious transformation? If a new book of this kind were in demand, he could very well have supplied the designs himself, and certainly had no need to rely upon another artist's work. Indeed, knowing his independence of mind, it is surprising to find him lending his talents to what, at best, looks like an unacknowledged revamp of another's book. One possible theory is that Hokusai may have been an intimate friend of Ryūkōsai at one time, and willingly agreed to collaborate with the publishers in a book that linked their names, perhaps intending it as a memorial to his friend: but in that case

we would have expected the preface to relate the circumstances. Although the date of Ryūkōsai's death is not known, the change in the characters forming his name suggests that he was dead by 1818, for it would be unlikely that even Eirakuya (not the most scrupulous of publishers) would have dishonoured a dead person by presenting him as though he were a living artist. A former association between Ryūkōsai and Hokusai would at least have given the publishers some chance of persuading Hokusai to revise the old illustrations and to introduce a new and livelier figure-interest.

Within quite a short space of time, a new edition was published, this time under the title of *Ehon Ryōhitsu*, 'Picture Book by Two Brushes'. This was in one volume, but contained more prints than the earlier edition, the additional illustrations being, with one exception to be mentioned later, further adaptations of blocks formerly used for *Gekijō Gashi*. The blocks already re-employed for *Hyōsui Kiga* were unaltered except that the poems were cut out and new ones plugged in, this sometimes necessitating alteration to the skyline and the tops of mountains and trees. These alterations are such that they give proof that *Hyōsui Kiga* preceded *Ryōhitsu*. *Ryōhitsu* is not dated, but in the colophon Hokusai's name is given as Tōto Hokusai Taito. In 1819 he relinquished the Taito name to his pupil Hokusen, and so *Ehon Ryōhitsu* should presumably be dated before the end of 1819.

The preface to this new edition is a little more enlightening than that of the earlier:

'On a rainy day in Spring, seated alone at my desk as I am sometimes in my old age and idly composing the *kyōka* "The only glimmer in the dark comes from my bald pate – result perhaps of my mother patting my hair too much" – the publisher Tohekidō [Eirakuya] came in and produced a work of *kyōka* by men of the two Provinces Mino and Owari, with pictures comprising figures by Hokusai of Musashi Province added to landscapes made earlier by Ryūkōsai of Naniwa [Osaka]. It immensely gladdened both eyes and mind. Indeed, this book enables me to view actual scenery of the four seasons instead of dreaming of fifty years of glorious days, and so, forgetting my years, I decided to write this preface.
[Signed] Dōrihō, who lives in Kyūkagai [a "frivolous town"]'

The colour-printing in this edition is in somewhat stronger colours than the *Hyōsui Kiga*, but it is still marked by considerable taste and refinement as can be seen from the waterfall scene (pl. 102) which also shows a decided improvement compositionally compared with the *Gekijō Gashi* print on which it is based (pl. 103). One curious feature is the additional complement of prints, or perhaps this would be better construed as the earlier edition's *lack* of certain prints. In point of fact, each of the two volumes of the 1818 edition ends with a single-page print which, in the *Ehon Ryōhitsu*, is seen to be one page only of a double-page print. (This is on the evidence of several copies of *Hyōsui Kiga*, including the Koishikawa copy from which my illustrations are taken.) One is left wondering why the earlier edition was curtailed, and why, so soon after it, another enlarged edition was called for. Could the demand have come from the *kyōka* writers who found the landscape settings of dramas ideal vehicles for their word-plays?

105 Ryūkōsai: Sano village,
setting for a scene in the play
Hojō Jirai-ki.
From *Gekijō Gashi*, 1803

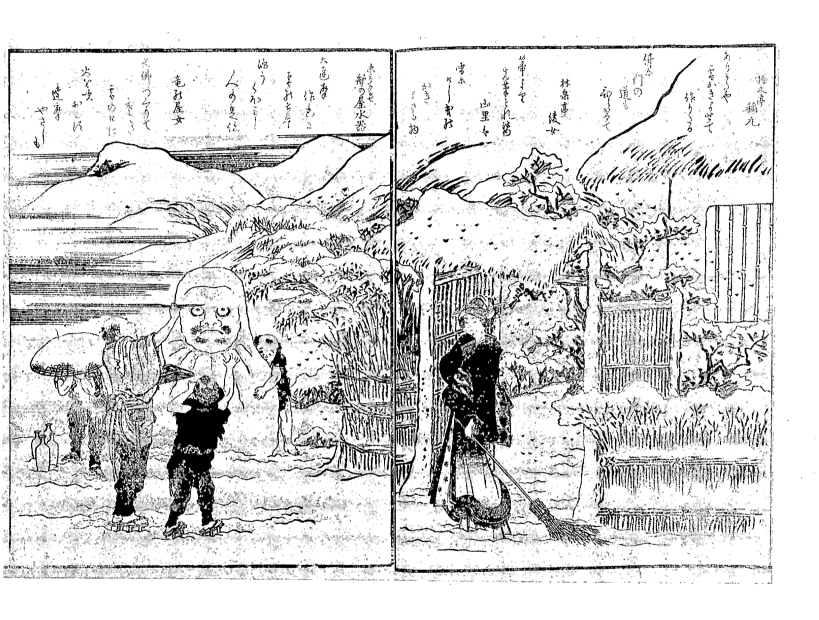

106 Hokusai/Ryūkōsai: The
characters in the play in pl. 105
give way to a snowman-
making scene.
From *Ehon Ryōhitsu*, before 1821

The last print in *Ehon Ryōhitsu*, the one not based on *Gekijō Gashi*, shows, within a circle superimposed on a landscape, two men kneeling opposite each other at a low writing table, a young man in Confucian garb, hands within his sleeves, and an older man with the top-knot of a *samurai*, moistening the tip of his brush with his lips (pl. 107). There is no clue to their identity, but the purchaser of the book was presumably meant to believe that the two men represented the 'two brushes' of the title. In this too, as in other respects, there is an element of hoax, for neither figure fits the facts: Ryūkōsai was probably dead, and Hokusai was neither a young, ascetic Confucian nor a literary *samurai*.

Finally, the colophon now plainly states (as does the preface) the division of work between the two collaborators: *Sansui Sōmoku* (landscapes and vegetation) by Ryūkōsai; *Jimbutsu Chōjū* (figures, birds and beasts) by Hokusai.

The popularity of *Ehon Ryōhitsu* was such that Eirakuya published two issues before 1821. The Leiden copy of the book, brought back from Japan by von Siebold in 1830, although identical in other respects, has a cover which differs from other known copies. It is possible that the whole edition may have been prepared at one printing and different covers used for two parts of the batch, but this is less likely than the other possibility that a first printing was exhausted and a new cover designed for the second printing. There is no positive way of deciding which of the two issues was first (assuming they *were* separate in time), but the supposition is that von Siebold would have been more likely to acquire a copy of the later re-issue which one would expect to have been more available than the other at the time.

The main features in the history of this curious changeling of a book have been described, but there were further editions which should be recorded. The next in time appears to be one published by Eirakuya in Nagoya in 1821 under the new title of (*Kyōka Gafu*) *Hakoya-no-Yama*. (The date in this volume makes it possible to assume a date prior to 1821 for the two editions of *Ehon Ryōhitsu*.) It is in one volume, with a title-page and twenty colour-prints (one less than in *Ehon Ryōhitsu*) and a colophon that shows that Eirakuya attributed a very short memory to the Nagoya public. It gives the names, first, of Rokujuen, the noted novelist and *kyōka* writer, as 'reader' of the poems, which are once more entirely new contributions; and then, of Zen Hokusai Sensei as the artist: Ryūkōsai's name has now completely dropped out. Perhaps in 1821 Hokusai's fame in Nagoya, especially after the success of the first *Manga* volumes, had made him a best-seller in that town, and Eirakuya, always with an eye to the main chance, felt the book would have more appeal as Hokusai's own than as one in which he had merely collaborated. Something similar we know happened when Eisen and Hiroshige collaborated in the Kisōkaidō set and Eisen's signature was removed when the second edition was published.

Yet another edition of the book, for which most of the blocks were recut, appeared at some later date, but the two copies I have seen were imperfect, and details of preface and colophon, if any exist, are lacking. In this edition, however, the poems have been completely eliminated and one assumes that it was published simply for the Hokusai interest and probably quite late in the nineteenth century.

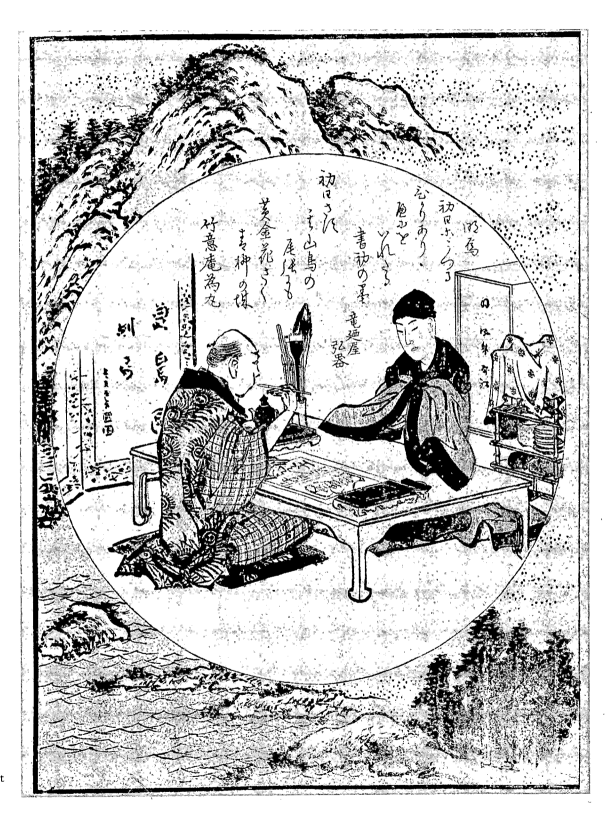

107 Hokusai: The last
page of *Ehon Ryōhitsu*

II *Miscellaneous Books,*
1808~1819

During the enormously creative period when the novels and the *Manga* were causing such a furore in Edo and Nagoya, Hokusai still found time to furnish designs for other books, either as sole illustrator or as one contributor among a group of artists. Some of his finest *shunga* also came out during these years, but they will be dealt with in a separate chapter. Here I want to give some idea of the astonishing variety of the other books with which Hokusai was associated, amplifying the evidence of the bare list of books given in the Appendix. The anthologies were as often as not of *haiku*, and the collaborating artists not members of the Ukiyo-e school. In *Hitori Hokku* 'Individual Verses', for instance, published about 1808, his fine print of a descending goose (pl. 108) is in the same volume as a landscape by the Nanga artist Gentai and a print of a fish by Masayoshi, the remaining artists being of 'classical' school allegiance. In *Taguri Bune* (*c.* 1813), an odd compilation, half guide-book, half *haiku* anthology, Hokusai again found himself in company with artists of a different background from his own, including the Nanga painter Tani Bunchō (with whom Hokusai had once had a contest before the *Shōgun*) and the wild expressionist Sōchō. His own ink-printed design is very much in the vein of his novel-illustrations (pl. 109).

One of Hokusai's rare excursions into the Kabuki sphere took place in 1808 when he designed a cover for a theatre booklet (pl. 110). The occasion was the performance of a dance-play in Osaka in the ninth month of 1808. The play is recorded under the title *Maiōgi Nanka Hanashi*, but the booklet bears the name *Kasa Tsukushi*, 'A Series of Bamboo Hats'. The names of Bakin and Hokusai are bracketed together on the cover, which states that the booklet is not for sale. The *mon* of the principal performers appear at the head.

Two books of unusual and vastly differing subject-matter came out in 1815. One was *Jōruri Zekku* 'Chinese Verses and *Jōruri*'; the other *Odori Hitori Geiko* 'Teach Yourself Solo Dancing'. We have already encountered one publication where Chinese verses were linked, inappropriately enough, with something peculiarly Japanese (boatmen's songs in *Itako Zekku*, see p. 37). *Jōruri* was a form of drama in which recitation was given with *samisen* accompaniment and often enacted by puppets, or less frequently, as part of Kabuki performances. In the *Jōruri Zekku*, Bokusen, one of Hokusai's Nagoya

108 Descending goose. Signed Gakyōrōjin Hokusai, seal Hokusai. From *Hitori Hokku, c.* 1808

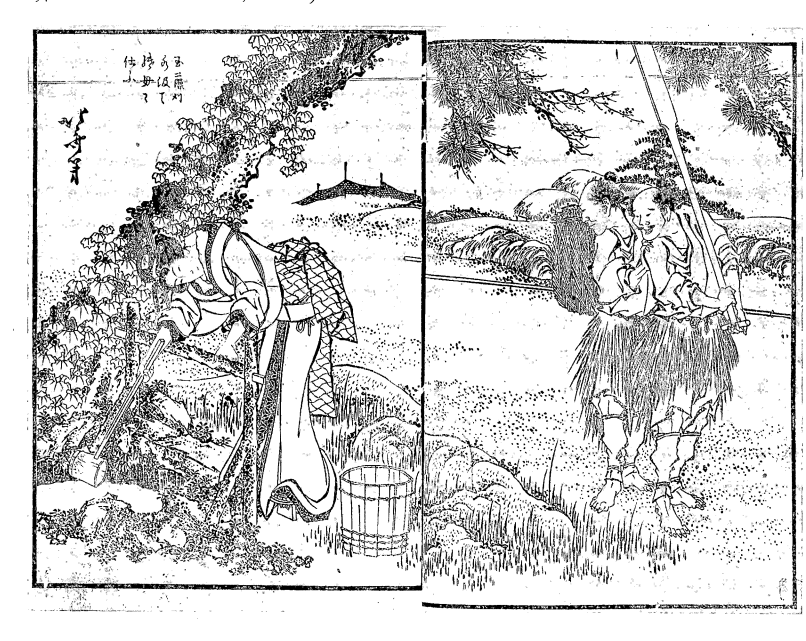

pupils and assistants, added Chinese verses to *jōruri* scenes which Hokusai had drawn at his behest. The first edition, published by Kadomaruya in Edo and Matsuya Biemon in Edo, was printed in shades of *sumi*.

 The relationship between Bokusen and Hokusai was a close and fruitful one. One suspects that this Nagoya artist, with whom Hokusai stayed when he came to that city in 1812, was on friendly terms with the prominent publisher there, Eirakuya, and that it was possibly through his instrumentation that the *Manga* and many other books were conceived and published. Hokusai was at his most creative, but all the evidence goes to prove that he was an erratic and self-willed genius who, like others of his rare type, was unable to cope with everyday, material matters, and it is here that his pupil and trusted friend Bokusen proved his worth as manager and entrepreneur on his behalf. Bokusen was no mean artist himself, and in the few books that he illustrated, such as *Bokusen Sōga* (1815), showed that in preparing Hokusai's drawings for publication he had acquired a great deal of his master's manner.

109 Two fishermen and a woman drawing water from a spring. Signed Hokusai. From *(Katsushika Zushi) Taguri Bune, c,* 1813

110 Cover design for the theatre booklet *Kasa Tsukushi,* 1808

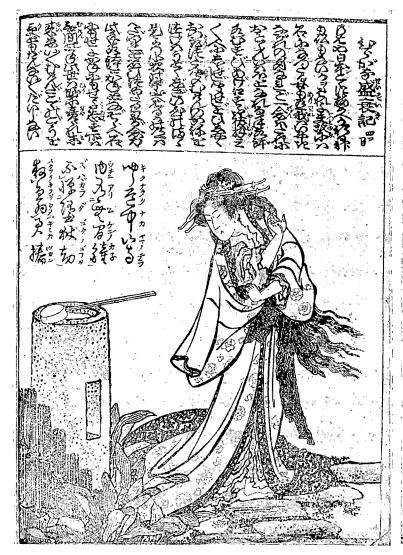
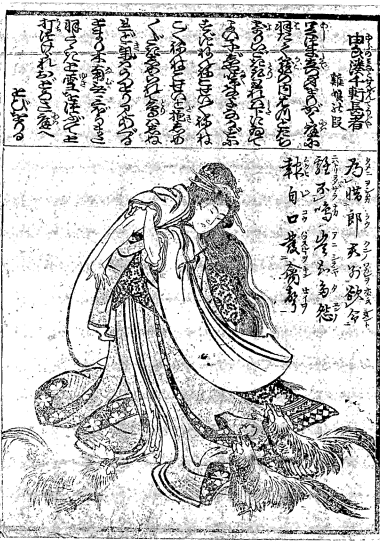

In *Jōruri Zekku*, the figures of the women show considerable changes from those of the poetry books illustrated by Hokusai in what we have called the 'Sōri period', at the latter end of the eighteenth and the beginning of the nineteenth century. In 1815, in what on the same basis, could be called the 'Taito period', from the name most commonly used at this time, the figures have become more robust, the line more sweeping though perhaps less graceful, and there is a sense of agitation, furthered by a zigzag, crinkly line in the draperies, most evident at the neck of the *kimono*. The block-cutters were to some extent no doubt responsible. They were no less skilful than those of fifteen or twenty years earlier, but there were styles in cutting as there were in painting, and imperceptibly as the century wore on, the interpretations of artists' drafts resulted in prints (and colours) that tended to make still more pronounced any changes in the artist's own mannerisms (pls. 111–113).

111 Two characters in *jōruri*. From *Jōruri Zekku*, 1815 (first coloured edition)

112 Two characters in *jōruri*. From a later *sumi* edition of *Jōruri Zekku*

113 Scenes from two *jōruri*. From *Jōruri Zekku*, 1815 (the later *sumi* edition)

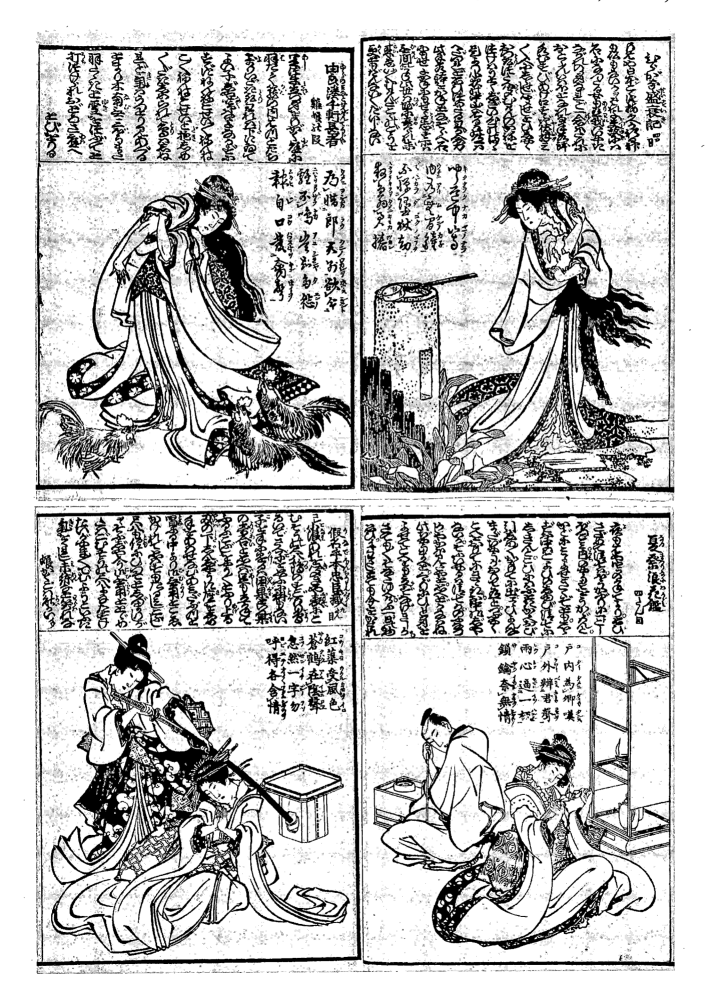

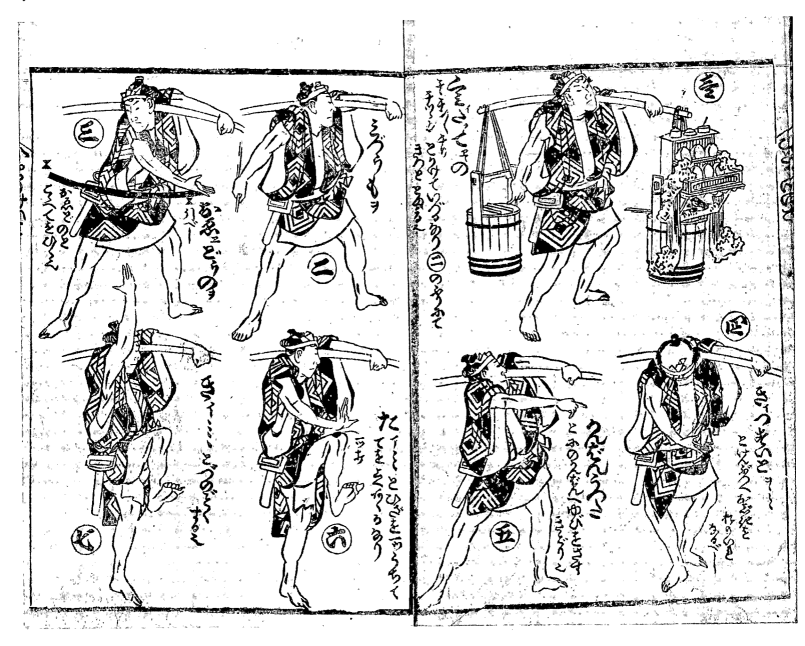

Although Hokusai made few theatrical prints after his debut as Shunrō when, as a junior in the Katsukawa school, he was very much pre-occupied with the stage, he continued to have close relationships with some of the leading players, and the book entitled 'Teach Yourself Solo Dancing' published in 1815, not only has a preface by the renowned Danjūrō VII, but the largest section of the four into which the book is divided consists of picture-sequences of the movements of one of Danjūrō's famous dance performances, *Hiyamizu-uri*, 'The Cold Water Seller'. The actor is depicted in an outer coat bearing the well known 'squares-within-squares' crest of the Ichikawa family, and begins the dance balancing the carrying-pole for his wares on his shoulder. This print shows the first seven movements (pl. 114). The other sections of the book

114 Danjūrō VII performing the opening movements of the 'water-seller's dance'. From *Odori Hitori Geiko*, 1815

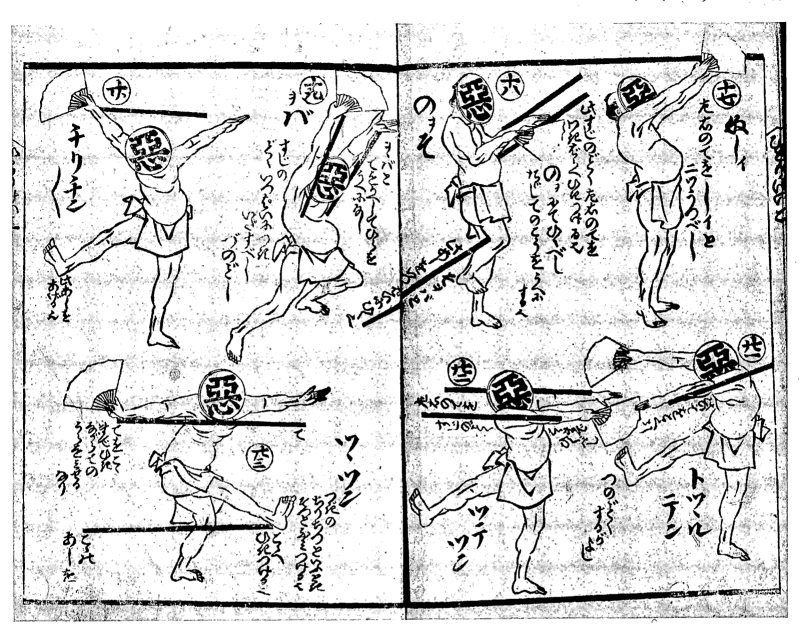

115 Movements in the dance of the 'evil spirit'.
From *Odori Hitori Geiko*, 1815

portray a boatman's dance, one for a master of ceremonies, and a third (pl. 115) for the grotesque caperings of an 'evil spirit', who covers his face with a disc bearing the sign for 'evil' (*aku*).

The other books of the period under discussion have a semi-educational intent, two being books that have a notional bearing on the arts of drawing and composition, and the third an elementary pictorial dictionary.

The 'Short Cuts to Painting' type of manual had been produced over the previous fifty years, mainly for the edification of those wishing to follow 'classical' styles, especially Nanga, either of Shên Namp'in or the native artists Taiga or Gentai and the like. Hokusai addressed himself to pupils of humbler aspirations, and the preface and

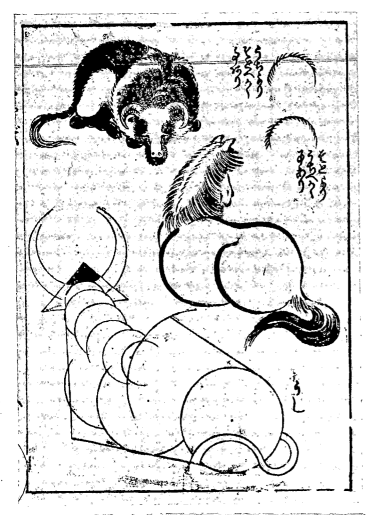

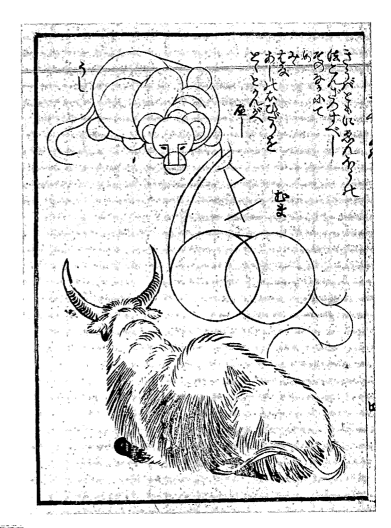

116 Oxen and horse reduced
to circles and straight lines.
From *Ryakuga Haya Oshie*,
Part I, 1812

117 A figure geometrically
analysed.
From *Ryakuga Haya Oshie*,
Part I, 1812

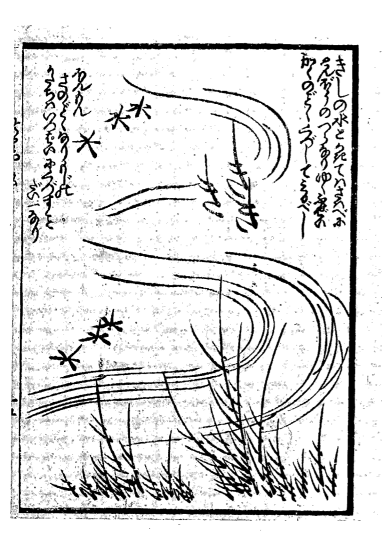

118 Two seated men and dragonflies over a stream, both reduced to *hiragana* and Chinese characters.
From *Ryakuga Haya Oshie* Part II, 1814

postscript to *Ryakuga Haya Oshie* 'Quick Lessons in Simplified Drawing' state that 'rules . . . for all kinds of painting originate from circles and squares . . . and based on this fact, Old Man Hokusai will instruct the basic rules for the composition of all sorts of drawing with rules and compass'. In an article in *Ukiyo-e Art*, Fumiko Tōgasaki discusses this book and its avowed objective in some depth, though possibly she takes it a little too seriously. It is just conceivable that Hokusai may have seen such Dutch publications as Van de Passe's encyclopedia *The Light of Painting and Drawing* (Amsterdam, 1643), Lairesse's encyclopedia *Groot Schilderboek*, 'The Comprehensive Painters' Book' (first published in Amsterdam in 1707) which would have given him hints; or if not from them, he could more easily have received ideas from Chūryō's *Kōmō Zatsuwa*, a miscellany of western-world matters, published in Edo in 1787. But Miss Tōgasaki makes too much of what has the aspect, to me, of an amusing book, no more profound than a modern 'paintings by numbers' manual (pls. 116 & 117). This is rather confirmed by the second volume, published in 1814, which is more obviously whimsical in that the diagrammatic simplifications this time ignore ruler and compass, but reveal chance resemblances to *hiragana*, and other calligraphic characters, in the outlines of figures and objects (pl. 118). The two volumes hardly seem to warrant the

Japanese writer's rather portentous arguments that *Kiku-hōen-no-hō* (the drawing method of circles and squares by ruler and compass) combined with the *Mitsuwari-no-hō* (the law of three divisions, another western concept, adumbrated in one of the *Manga* volumes) could be used to analyse Hokusai's composition at large.

Santei Gafu, 'Album of Drawings of Three Different Kinds', has even less claim to be considered instructional. It is simply another *Manga*-type compilation of miscellaneous sketches, but figures, landscapes, flowers, birds and insects are seen from three different aspects. The three forms are denoted by signs: a triangle, *gyō* (行); a square, *shin* (真); and a circle, *sō* (草). Each of these characters actually embraces a variety of meanings in the Japanese language, but the only clue to the sense Hokusai may have intended for them is their personification on the opening page where a Chinese *sennin* or *Lohan*

119 Swallows, kingfishers, *hototogisu* and ducks. From *Santei Gafu*, 1816

120 Iris flowers, water
spearwort, moths and
dragonflies.
From *Santei Gafu*, 1816

represents *gyō*, a Japanese nobleman, *shin*, and a Chinese warrior-sage, *sō*. But even if, allowing our imagination full scope, we deduced from this that *gyō* meant 'religious austerity'; *shin*, 'truth'; and *sō*, 'grass handwriting', how can these (or any other contrasting qualities) be attached to the three swallows, or the three kingfishers in the air (pl. 119) or iris flowers, or water spearwort, or dragonflies (pl. 120)! In the end, we are forced to conclude that Hokusai's Nagoya followers (they are again referred to as collaborators in the colophon), fired by the success of the books of random sketches, (the *Manga*), persuaded their idol to produce still more drawings, but with some quasi-linkage that would enable the publishers to present them as a different kind of book, under a specious title that would seem to offer something more planned than the unedited *Manga*, and vaguely instructional or educative.

121 Figures and objects beginning with *ko*.
From *Ehon Hayabiki*, Part II, 1819

Ehon Hayabiki, 'Quick-reference Pictorial Dictionary', the two parts of which came out in 1817 and 1819, really is what it purports to be, and must be one of the most curious examples of an artist of consequence turning his gifts to such menial miniscule hackwork. Yet the pages are undeniably attractive and as Duret wrote, 'One could say that this is a worm-sized *Manga*. The people, in fact, are given the dimensions of mere worms or of insects.'[1] It is yet another example of the Japanese people's ability, in whatever medium, to create art in miniaturistic form: in *netsuke*, in metal-work, in the illustrations for a dictionary. The entries appear under the signs for the *iroha* alphabet (but not in the order of that alphabet) and alongside each figure, or group, is the noun in Chinese characters, with the Japanese phonetic reading in *katakana* syllabary. On the page illustrated (pl. 121), under the heading *ko*, one sees the reduction to a few ultimate lines of such familiar figures and objects as *kochō* (butterfly dancer); *kotsu* (skeleton); *komusō* (outlaw or *rōnin*); *kozumi* (small hand-drum); *koto* (stringed instrument); and as many more as the small page could accommodate.

[1] 'On pourrait dire que c'est une Mangoua vermiculaire. Les personnages, en effet, sont tenus à la dimension de simples vers ou d'insectes.'

12 Major Drawing Books of 1819 and 1820

From the insect scale of *Ehon Hayabiki* to the drawings of *Hokusai Gashiki* (1819), which seem larger than life: it is almost typical of Hokusai that he could span the distance, so great in artistic and in psychological terms, in a single year. Throughout his life, his career was conducted on varying planes, catering for the needs of a semi-literate, artisan population, with books like the *kibyōshi* and the pictorial dictionary, and also illustrating novels or embellishing verse anthologies with serious intent and unsurpassable mastery. But from time to time he remembered his true dignity as a *grand-maître* and withdrew from the mundane crowd and from the demands of popular taste to design such masterworks as the *Shashin Gafu*, the *Gashiki* and the *Soga*, the 'One Hundred Views' and the other outstanding artistic successes that are described and illustrated in these pages.

The *Hokusai Gashiki*, 'Hokusai's Drawing Style', is yet another compilation of miscellaneous drawings, but they are like a gleaning from the *Manga* series of all the finest, more considered prints, they are no longer presented as a chance haul from the artist's studio, but as works he has produced best to display his talents in all spheres of composition. There are pages that show a desire to challenge the classical Kanō masters – a picture of Ebisu, the genial God angling for *tai*, and a group of *Lohan* admiring a dragon taking form in the smoke emitted from a perfume-burner – but the majority of the prints are of subjects we recognize as Hokusai's own choice, and in his own style carried to its ultimate in those features which stamp any drawing, print or painting as Hokusai's. His treatment, for example, of the peasants and woodmen is perfectly exemplified by the scenes illustrated. One senses the sympathy of the ageing artist with the humble labourers on whom the country depended for its well-being, and whose human lot he brings home, without bathos, by contrasting the carefreeness of children, much loved one senses, with the strained, overworked look of the parents whom they accompany (pl. 122), or by depicting a group of peasants (pl. 123), sitting at the roadside taking a rest from their toil, and drawing on their tobacco pipes. In each case, the country location is made plain, in the first, by the distant view of rice-fields below a mountain range, in the second, by the wayside rustic shrine, and the flock of birds careering over the narrow track. In a third print, (pl. 124), the play of a child again acts

122 Woodmen and boy.
From *Hokusai Gashiki*, 1819

as a foil to the unremitting labour of his elders, one of whom is shown working an
actual treadmill, so often the metaphor for drudgery. Hokusai's shorthand for the
human form and face is peculiar to him, and in a figure like the old man washing
potatoes in a tub reaches truly manneristic proportions, but he is unfailingly successful
in conveying movement and the relationship of figure to figure in a group.

123 Peasants resting.
From *Hokusai Gashiki*, 1819

124 Peasants by a stream,
one working a treadmill.
From *Hokusai Gashiki*, 1819

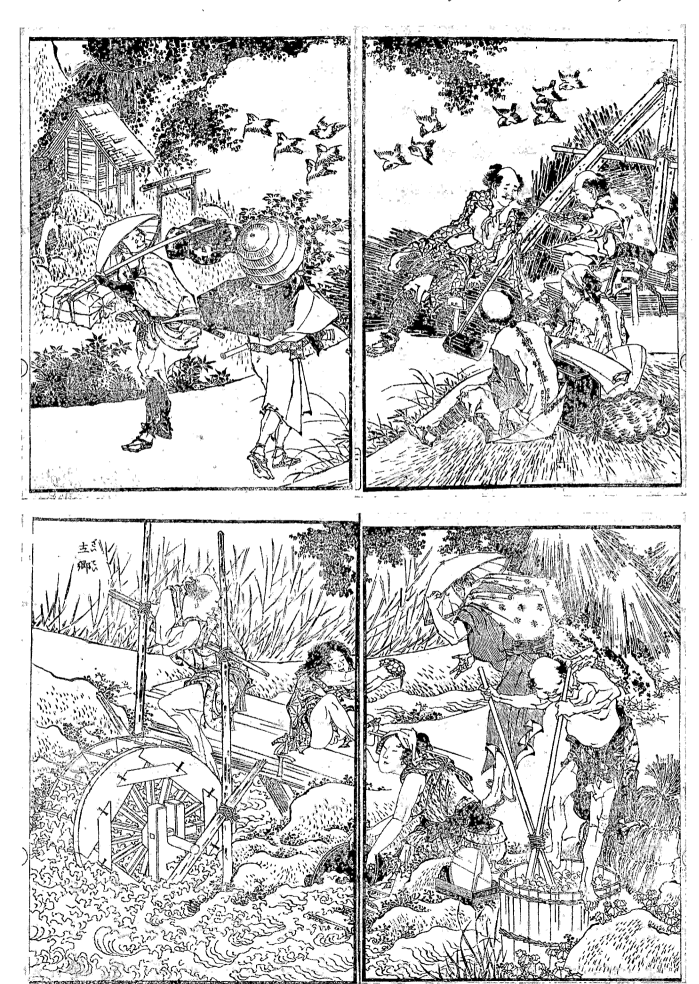

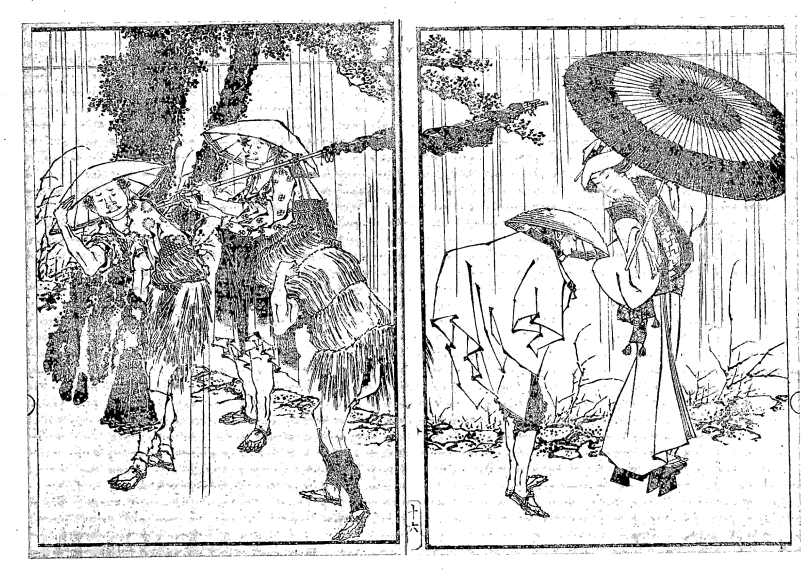

One print, a wonderful rain scene (pl. 125), suggests infinite distance beyond the foreground figures, the roadside stone and the tree, by reserving a blank area across which the rain falls in straight parallel lines. Here the composition is most telling, three peasants moving to the left in contrary motion to the woman sheltering her old father with an umbrella which, as so often in Japanese art, is made a great feature of the composition. Hokusai's effects are to some extent the result of the extreme variety of the brush strokes. Compare, for instance, the crinkled, interrupted lines of the *mino*, the

125 Rain scene.
From *Hokusai Gashiki*, 1819

126 Flowers in a basket.
From *Hokusai Gashiki*, 1819

straw coat that one peasant holds over his head, with the sharply-angled, incisive strokes of the cloak worn by the man at the right. It is touches of this kind that give the richness of effect to what is, in this case, an outline woodcut only.

There are several splendid landscapes, including one of mountains under a full moon, the human habitations, the small villages in the valleys, dwarfed by the immensity of the peaks. Great originality is shown in the 'Flowers in a basket' (pl. 126) thrust close to our eyes by its asymmetrical placement, and by the way the leaves and

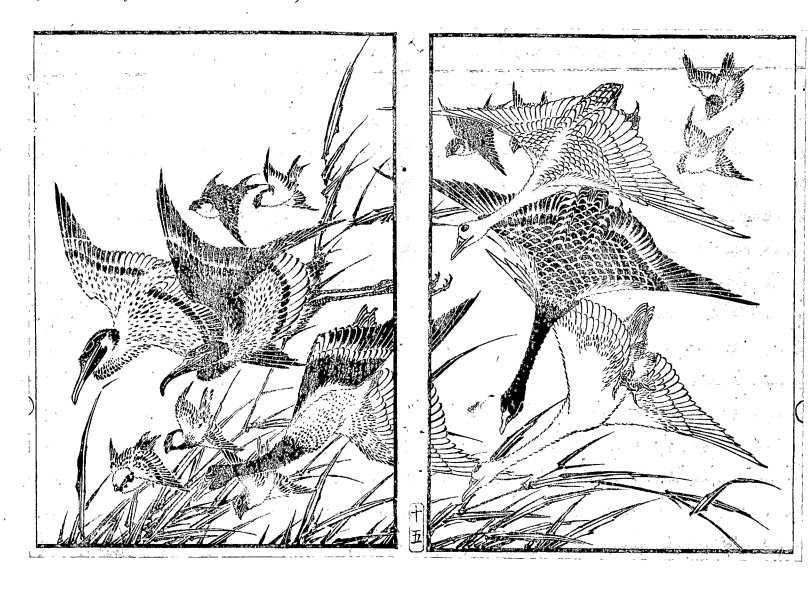

stems crowd to the borders of the design. The forceful bird piece (pl. 127), however
ornithologically improbable that so mixed a flock should hurtle suicidally into a reed-
bed, is a wonderfully decorative page with its exhilarating, diagonal sweep.

Perhaps emboldened by the success of the *Gashiki*, or, more likely, possessed by an
urge to create that overspilled from one volume to another, he designed the *Hokusai
Soga*, published in 1820. *Soga*, like so many of the words used in the titles of Hokusai's
books, is capable of all sorts of interpretations, but it seems as if it is another vague term
for 'Random Sketches', or to come closer to one of the literal meanings of *so*, 'Rough

127 Birds flying into reeds.
From *Hokusai Gashiki*, 1819

128 The wind on the heath.
From *Hokusai Soga*, 1820
(ink-printed version)

Sketches'. But, as in the *Gashiki*, there is very little that could be called random or rough about these remarkable compositions, and the volume contains some of Hokusai's finest prints in book form. 'The wind on the heath' is a famous design. The gale that lashes the clothes of the travellers and whips the plants into a frenzy is expressed in a whirling line that is positively breath-taking (pl. 128).

　　Both *Gashiki* and *Soga* were produced in two forms, probably at the same time, one in black outline only, the other with the addition of grey and pink blocks. 'The wind on the heath' is reproduced from the monochrome version since that best brings out the

telling brush-lines, but of the other illustrations from *Soga*, I have used the coloured
version which in some instances is immeasurably more effective than the other. To
enable the comparison to be made, I am reproducing both versions of the landscape
entitled 'Snow at daybreak'. The addition of the two tone-blocks transforms the
austere, diagrammatic outline into a landscape in which the forms are established in
space and given a majestic presence (pls. 129 & 130).

129 Snow at daybreak.
From *Hokusai Soga*, 1820
(ink-printed version)

雪の曙

130 Snow at daybreak.
From *Hokusai Soga*, 1820
(colour-printed version)

Among the fine figure prints in the *Soga* is the 'Comings and goings in the spring rain' (pl. 131) and the oxherds fording a stream caused by a snow-thaw (pl. 134). Another entitled 'Comings and goings under the moon' has a strangely brooding, even surrealistic atmosphere, and though the parties afoot at the late hour have nothing sinister about them and individually seem quite normal, the glare of a moon that throws no shadows bathes them all in an eerie light (pl. 132).

The *kachō-e* remind us of the two broadsheet series of 'Birds' and 'Large Flowers' that were soon to follow, and in fact, 1820 was the year when Hokusai assumed the name Iitsu with which, during the next decade or so, he signed what are arguably his greatest print series, the 'Thirty-six Views of Fuji', the 'Bridges', the 'Waterfalls' and the two sets of *kachō-e* already mentioned. The *Gashiki* and *Soga* show the artist on the threshold of new departures, and both volumes seem almost preparatory to the masterly series of prints that were perhaps already formulating in his mind. Certainly, before the *Gashiki* and *Soga*, it is difficult to find figures, landscape or *kachō-e* in broadsheet form with the amplitude, the grasp of telling composition and the gripping human interest that are possessed by the prints in these two books. The figures are projected with what, in comparison with the frail forms depicted in the early *kyōka-bon*,

131 Comings and goings in the spring rain.
From *Hokusai Soga*, 1820

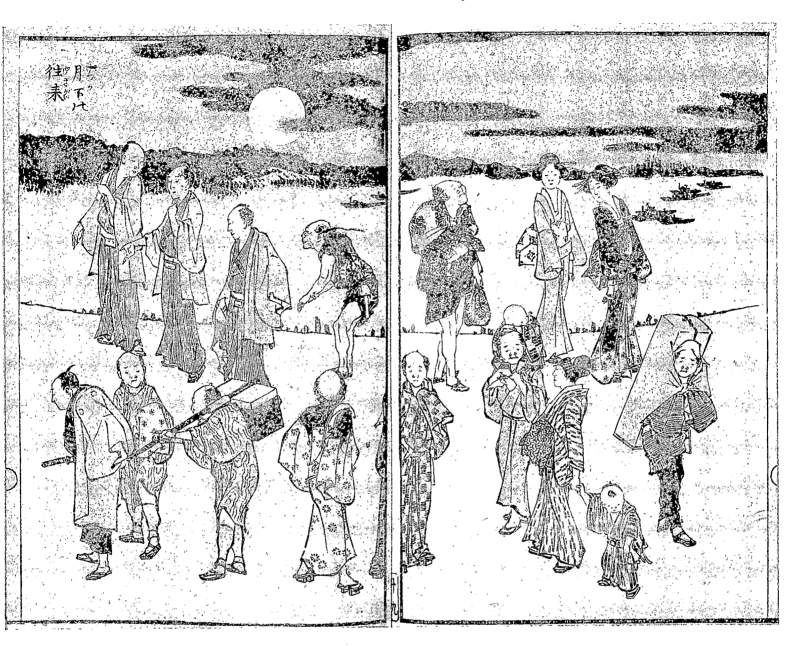

132 Comings and goings
under the moon.
From *Hokusai Soga*, 1820

can only be described as a new realism and which represents something closer to the
world as it actually was in place of what had been a poetically realized dream-world. I
can think of the works of no western artist, however long-lived, in which the women
so utterly change their form and mien as they do in Hokusai's: the diminutive, slim
creatures that people his early topographical illustrations belong to a different species
from the plump, naturalistic peasants and courtesans of the *Gashiki* and *Soga*. This is a
phenomenon that is not exceptional in the work of Japanese artists – Koryūsai, for
example, began by imitating Harunobu's *petite* and in later years veered almost to an
opposite extreme of Junoesque stature – but it is seen at its most remarkable in
Hokusai's *oeuvre* and will be discussed further in relation to his erotic prints in the next
chapter.

133 Summer
chrysanthemums, the
'Chinese' pink, and bees.
From *Hokusai Soga*, 1820

134 Snow-thaw stream.
From *Hokusai Soga*, 1820

135 Making *mochi* (rice-
dumplings).
From *Hokusai Soga*, 1820

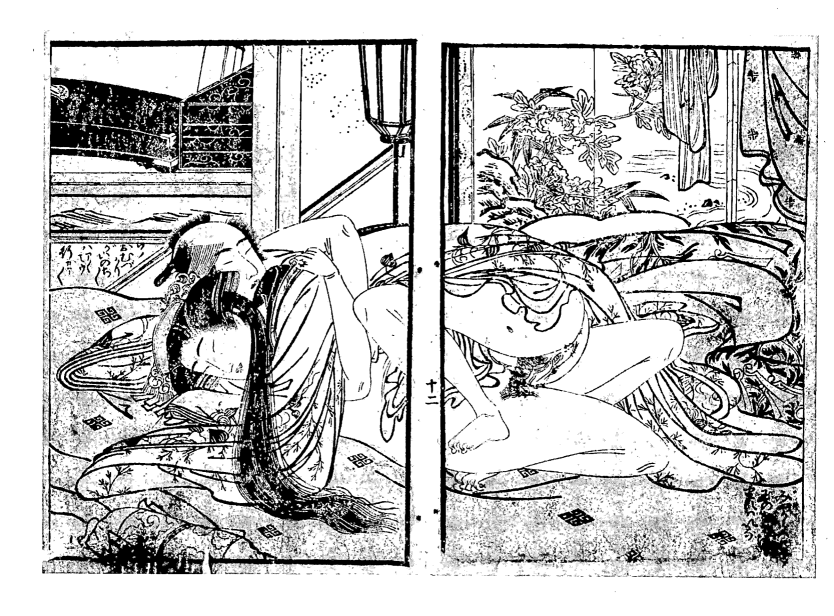

13 *Albums and Books*
of Erotic Prints

One of the undeniable gains of the present-day permissiveness in regard to sex – an emancipation that has greatly advanced even in the last decade – is that we no longer have to be on the defensive when illustrating the erotic art of the world. Since the fall of what might have been thought the last bastion of Victorianism – the Victoria and Albert Museum itself – which opened its rooms in 1973 to an exhibition of Japanese prints that included *shunga* ('spring pictures', erotica) unexpurgated and unashamed (published, equally openly, by Her Majesty's Stationery Office in the Catalogue), a number of books have appeared in Britain and other parts of the world with reproductions of prints and paintings that could only have been seen, in the past, in such specialist books as Poncetton's and Densmore's,[1] issued in limited and expensive editions. Ironically, in Japan itself the taboo against reproducing *shunga* continues to exist and they are published with the pubic areas masked or blanked out, an expedient by which these often great works of art are not only disfigured but violated, importing an obscenity and a prurience which is lacking in the untouched print or painting.

For the first time since these prints became known outside Japan it has been possible to see them, or reproductions of them, in sufficient numbers to allow us to formulate ideas of the social significance, the psychological attitudes, the artistic conventions of *shunga* and the development of style in individual artists within those terms. It may be to some purpose to review the literature through which this new liberality has been attained. One matter on which all western writers of today are agreed is the need to view *shunga* in the context of Japanese society and culture and to disregard the age-old prejudices of our own race and religion which would condemn Japanese erotica as pornography out-of-hand. Previous generations of writers either ignored *shunga* altogether as unfit even for mention, or stigmatized them, as did an earlier official of the Victoria and Albert Museum, Edward Strange, as 'quite beyond all European canons of good taste'. Museums, often reluctantly, became guardians of these scandalous sheets, and would-be students were rigorously screened before they were allowed access to them. Fortunately, there were collectors, in France especially, who frankly admired the erotica, and we have to commend François Poncetton, who was one of them, for introducing a fine series of reproductions published in 1925 under the title

136 From *Ehon Kuragari-zōshi* (preface dated 1782)

[1] See Bibliography.

L'Estampe Érotique du Japon. We forgive him his gratuitous Gallic slap at foreigners: 'The peoples of the Atlantic assume that sexual caresses must necessarily be obscene. I will say nothing of the anglo-saxon, who is unable to imagine physical love without a notion of the scandalous, which excites in him the most lively moral reactions;'[2] as we do also for innocently including as 'among the most ancient examples of wood-engraving in Japan',[3] some modern lithographs after seventeenth-century paintings! But certainly, Philippe Berthelot, Henri Vever, Charles Vignier, Georges Barbier, G. Marteau and François Poncetton himself, who lent their prints for reproduction, were all recognized as major collectors, and *L'Estampe Érotique du Japon* helped to establish *shunga* as a serious art-form. Before that, it is true, two books had been published in Germany as early as 1907. They were *Japanische Erotik, Sechsunddreisig Holzschnitts von Moronobu, Harunobu, Utamaro* with an anonymous text, and *Das Geschlechtleben in Glauben, Sitte, Brauch und Gewohnheitrecht der Japaner* by Dr Friedrich S. Krauss, a second edition of which was produced in 1911. However suspect the intentions behind the first of these two, it undoubtedly had the more artistic illustrations; Dr Krauss was more concerned, with the anthropological, ethnic considerations of *shunga* than the artistic, and most of his plates are from repulsive, late nineteenth-century specimens.

The publication of Kiyoshi Shibui's *Estampes Érotiques Primitives du Japon* in two volumes in 1926 and 1928, despite the fact that the text was largely in Japanese and the illustrations confined to 'cover-sheets' (relatively innocuous prints that were included in most *shunga* albums) and other unexceptional pictures, did much to strengthen the view in the West that some of the finest prints of the Primitive period in Ukiyo-e (*c.* 1660–1765) were erotic. And the same author's *Ukiyo-e Naisi* of 1932 and 1933, again mainly in Japanese but with the rather coy sub-title 'Old Documents concerning human life instincts and emotions interpreted by Japanese artists in the Eighteenth and earlier part of the Nineteenth century', and albeit illustrated only to the extent permitted by the Japanese censors, gave the western world at least some notion of the immense quantity of such books and albums relative to the total publications of all kinds – a far higher proportion than in any western country.

Even by 1954, however, not everyone approved. Chapter 20, in James A. Michener's *The Floating World* of that year, is entitled 'The Other Books', which seems a return to the reticence of the nineteenth century. He makes his condemnation quite plain.

> 'Of a given hundred erotic books, selected at random, at least ninety are pure junk and have almost no claim to artistic merit, not even when definitely attributable to Kiyonaga, Shunshō or Utamaro. The drawing is very bad, the coloring unreasonable, the engraving sloppy and the printing wretched.'

He selected his examples badly. A few late Utamaro books might qualify for his vilification, but the greater part of Utamaro's, and the whole of Kiyonaga's and Shunshō's, are splendidly drawn and the block-cutting and printing invariably of equal excellence. Mr Michener does, however, make reservations about certain artists,

[2] 'Les peuples atlantiques contemporains sous-entendent aux caresses sexuelles une nécessaire obscenité. Je ne parle pas d'un anglo-saxon, qui ne saurait imaginer l'amour physique sans une idée de scandale, laquelle excite en lui les plus vives réactions morale.'
[3] 'Parmi les plus anciens témoins de la gravure sur bois au Japon.'

Hokusai particularly, and I will return to his assessment a little later.

Support from a wholly unexpected quarter came in 1961, when Mlle Marianne Densmore, at that time the highly respected *doyenne* of the Parisian dealers, wrote a commentary and critical notes to another series of fine reproductions, *Les Estampes Érotiques Japonaises*. In her interesting introduction, refreshingly free from any attempt to justify the publication, Mlle Densmore makes a telling contrast between the Chinese and Japanese artists' treatment of identical scenes, concerning which, as she dryly remarks, 'there is nothing left to invent . . . The Chinese make pictures of expressionless gymnasts: the Japanese are all beautiful gesture and wild expressiveness.'

Dr Richard Lane, now recognized as a notable scholar in the field, was still handicapped by censorship in 1962 when his *Masters of the Japanese Print* appeared, and perhaps a little under the influence of the puritanical Michener. Discussing a famous early Ukiyo-e printed scroll of about 1660 and reproducing the first, harmless, section, he writes: 'After the first plate, the scenes are unprintable; they defy description, even if we cared to provide it'; and later, charmed by the face of a girl in the 'cover sheet' of one of Moronobu's albums, he continues 'we can only wonder how the same artist could, in the following plates, subject such girls to all kinds of indecent exposure.' By 1973, however, the restraints alike on reproduction and description of *shunga* had been lifted, and in his section on Japan in *Erotic Art of the East* published that year, he presents his maturer thoughts on the subject, reiterating a theme which is something of a *leit-motif* in his writings 'that a good part of the intrinsic interest of Japanese art is quite lost to the connoisseur, collector or scholar who has little intimacy with the language and customs of Old Japan'. But Dr Lane's essay is a serious and viable study, by an expert with wider acquaintance than most with the erotic paintings, prints and books in Japan. He was a leading contributor, too, to another book of illustrated essays entitled *Le Chant de L'Oreiller, L'Art d'Aimer au Japon* (1973), in which the text and illustrations are wide-ranging and of a high standard. Finally, Tom and Mary Evans express the viewpoint of the emancipated young men and women of the present generation in *Shunga: The Art of Love in Japan* (1975), situating the pictures 'within the context of the society from which they grew' and providing in those illustrations a demonstration of the progress of *shunga* as an art-form. The book is sound and non-sensational, written with a total disregard for former taboos, and has probably the most readable text that has so far appeared on the subject.

Having thus sketched the background to western tolerance with regard to Japanese erotica and their acceptance as works of art, we can turn to Hokusai's *shunga*. In this sphere, as in so many others, Hokusai's work is supremely important. In these prints more than any others, the distance between the figures, especially the nude figures, of the early Shunrō and Sōri periods and those of his maturity is most markedly brought out. The Shunrō prints illustrated (pls. 136–138) datable to 1782 and the Sōri *surimono* (detail, pl. 142) belong to a different world, a society with another life-style, and to an artist conforming to its conventions, in comparison with the astonishing prints of 1816 to 1822. The earlier have something of the gentleness and amiability of the artist's

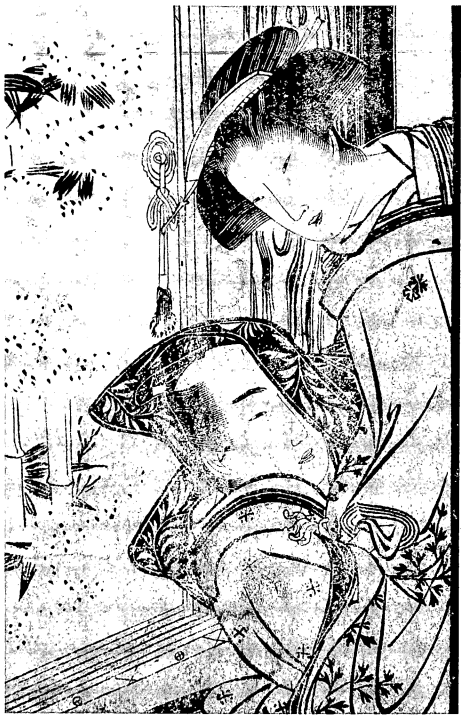

contributions to the poetry albums of the late eighteenth century: even when depicting couples in coitus there is an elegance, a calculated arrangement of the *kimono* folds to show the patterns at their prettiest. The figures of the later prints are not only on a larger scale, they are palpably heavy and voluptuous and the bodies somehow bestial in their utter abandonment to the sexual act, completely oblivious of their gross exposure. This change from an idealization to something which seems positively to debase woman has been noted before as a phenomenon that occurred at the turn of the eighteenth century, and it was a malaise which infected all artists, though it is archetypal in Utamaro who died in 1806 and whose *bijin-ga* in the last year or two of his

137 Detail from *Ehon Kuragari-zōshi*

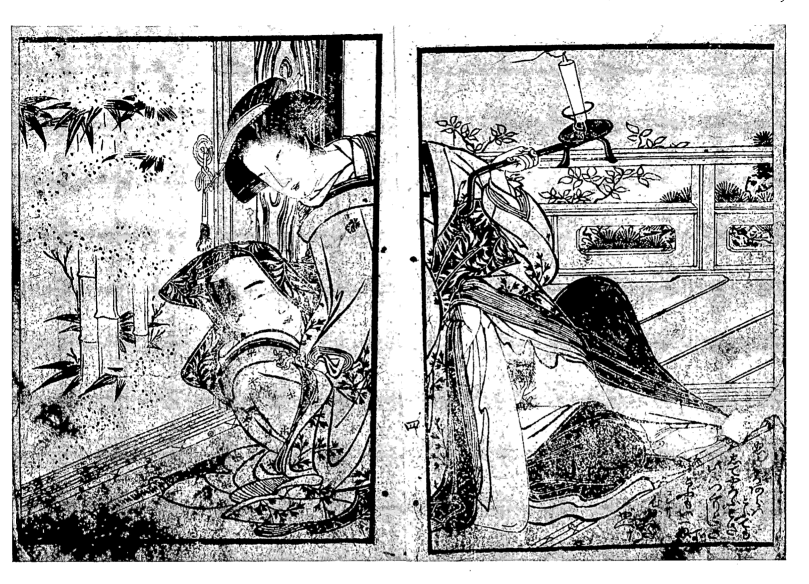

138 From *Ehon Kuragari-zōshi*

life portrayed sluts compared with the fastidious courtesans of the early 1790s. With Utamaro, it is a case of behaviour and expression, a depravity that is conveyed by vapid face and graceless carriage; with Hokusai, it is more a physical change, the slight immature forms being superseded by creatures of large limb and solid bodies, more realistic than the earlier types, and often frenetic or sadistic in the sexual act.

There are two valuable studies of Hokusai's *shunga*: that by Yoshikazu Hayashi, published in 1968 in the *Empon Kenkyū* series, and the other by Richard Lane that appeared first in the magazine *Ukiyo-e*, second month, 1977, and later in a separate book, *Hokusai and Hiroshige*, in the same year.[4] In both of those, published in Japan, the

[4] See Bibliography.

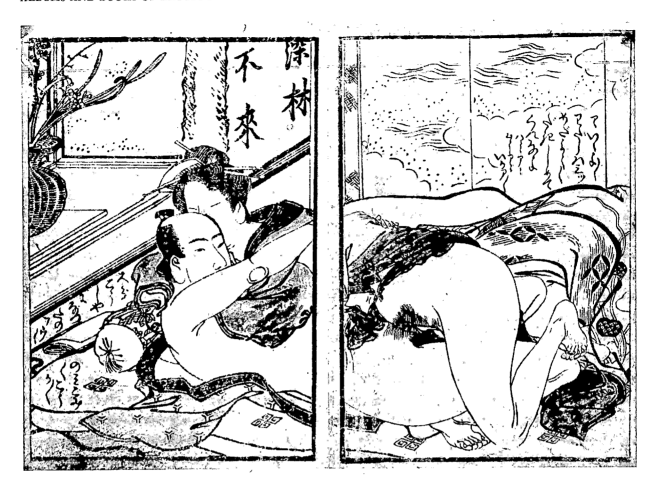

illustrations suffer from the customary censorship. Lane's chronological list shows that the *shunga* belong to two distinct phases: the first five books cover the years from 1782 to about 1794/95, in the Shunrō or Sōri style, the remainder from about 1811 to 1822, when the main names used were Hokusai, Taito and Iitsu.

 The first to appear, *Ehon Kuragari-zōshi*, has a preface datable to 1782 and two of the prints bear the Shunrō signature. The book belongs to the period dominated by Kiyonaga, but Hokusai's earliest *shunga* contains some enchanting prints, superior to the *kibyōshi* illustrations of the same time, and also to the majority of the actor-prints that he was principally engaged on at that period. The reproductions are given here, for the first time in a western publication, through the courtesy of Hayashi Yoshikazu (pls. 136–138). Then there was apparently a break until about 1792 when the next, entitled *Mame-batake*, appeared (though it is conceivable that other books were published in the ten years from 1782 of which no copies have survived). The fragments of *Mame-batake* (pl. 139) and of *Ehon Matsu-no-Uchi*, a book of about 1794, reproduced in Hayashi's book, are distinctly Shunrō in style and the figures comparable to those shown in the small print illustrated here (pl. 141) which is actually a pictorial calendar (*e-goyomi*) for 1792.

139 From *Mame-batake*. Signed Shunrō. C. 1792

140 From *Mame-batake*. Signed Shunrō

141 Calligraphy lesson, a pictorial calendar (*e-goyomi*) for 1792, the 'long and short' months indicated by the different thickness of line for the character *ne* (rat, the zodiacal animal for 1792). Signed Shunrō

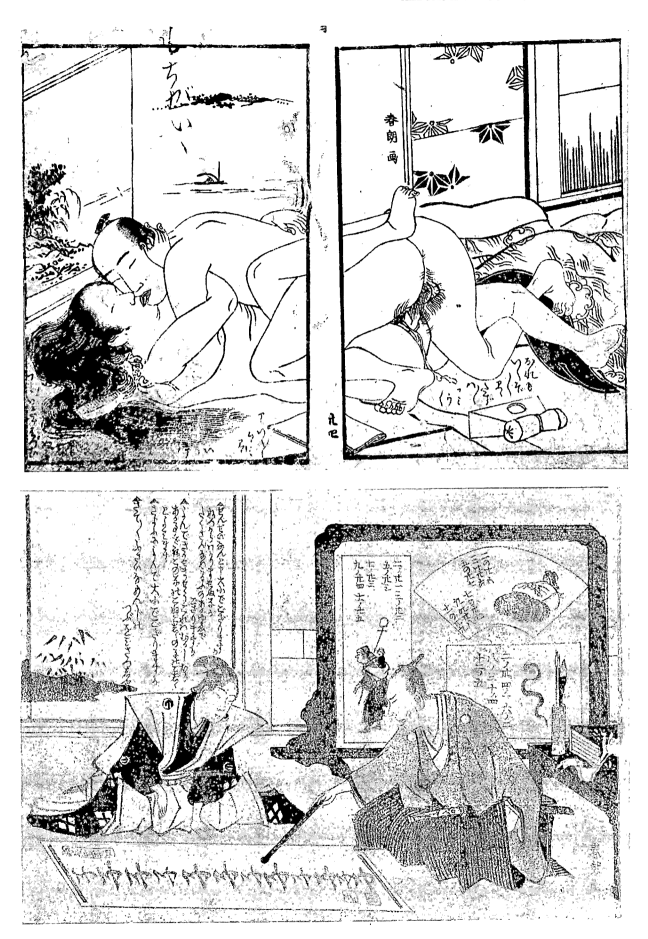

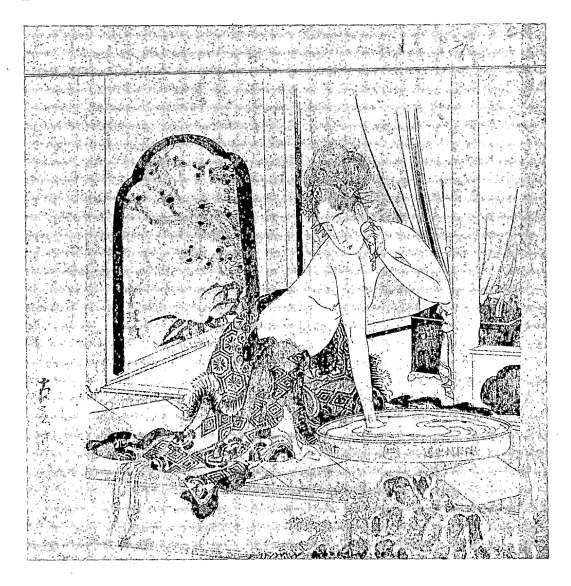

After these small, ink-printed books, Hokusai seems to have designed no *shunga*, except a number of miniature colour-prints, mostly pictorial calendars, until something like fifteen or sixteen years later, when two masterly colour-printed albums were published, the *Ehon Tsuhi-no-Hinagata*, and another lacking title (both extensively illustrated by Lane, pls.143–146).

Tsuhi-no-Hinagata, which like most *shunga* is not signed, has become the centre of a controversy. Hayashi Yoshikazu[4] has made the startling proposition that, contrary to the hitherto unchallenged tradition, the artist is not Hokusai, but his daughter, Oei. Hayashi was first disturbed by what seemed to him oddities of form, facial expression and line, and then found an inscription on the cover of a book depicted in one of the illustrations which he felt pointed towards Oei. Richard Lane takes an entirely

142 Woman washing at a shallow bowl. Detail of an *e-goyomi* for 1798 (the numbers of the 'long and short' months are on the side of the bowl). Signed Sōri

143 From *Ehon Tsuhi-no-Hinagata*

144 From *Ehon Tsuhi-no-Hinagata*

[4] *Empon Kenkyū: Eisen.*

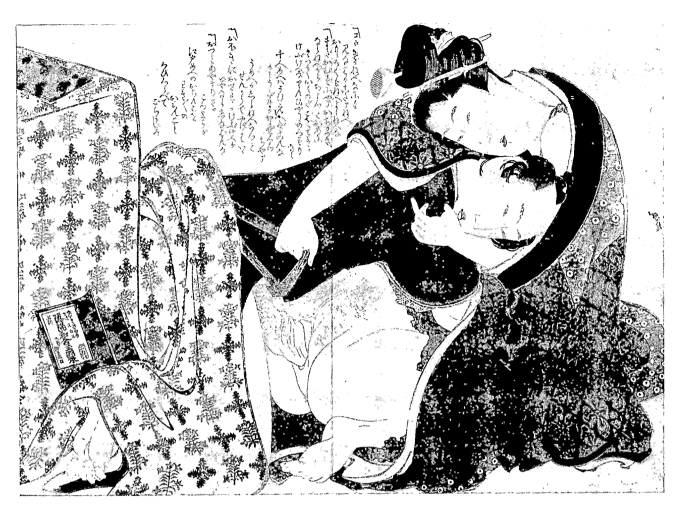

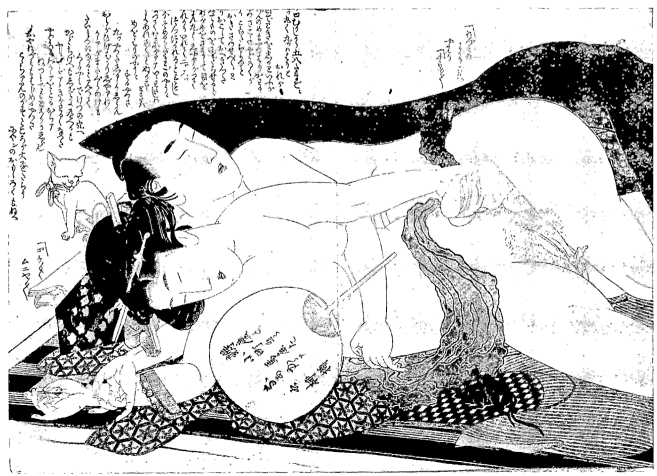

145 From a *shunga* album without title.

opposite view. 'Recent research in Japan', he writes, 'has helped distinguish the numerous works in Hokusai style by Eisen and other imitators, but has also confused the issue seeking to find the hand of assistants in such masterpieces as *Ehon Tsuhi-no-Hinagata* based on very dubious, textual grounds.' For my part, while not disputing Hokusai's authorship, I would demur at the dating of the book, usually given as 1811, and based upon what seems (in the absence of any date printed in the book itself) the unimpeachable evidence of an inscription by the first owner of the copy in the Shibui Collection to the effect that it was acquired in the winter of 1811. There seems no likelihood that anyone should make such a declaration simply to confuse aftercomers and yet, accepting it, we have also to accept the fact that Hokusai created *shunga* showing an entirely different handling of the human form from that in other works datable to the same time. For example, there are the ink-prints in the novel *Seta-no-hashi Ryūnyo-no-Honji* of the year 1811 (see pls. 66, 67) and the print in the miscellany *Taguri Bune* of about 1813 (pl. 109), which seem stilted by comparison; and of the same order

146 From *Ehon Tsuhi-no-Hinagata*

are the drawings in the so-called 'Occupations Album' in the Harari Collection,[5] one of which bears a date corresponding to 1811. In the erotic prints the men and women have an amplitude and a vigour that are the outcome of an entirely new, and I would have thought, masculine conception. They are in the same vein, after all, as the prints in the most famous *shunga* album, the *Nami Chidori*, universally accepted as Hokusai's work (pls. 149–153); and there is no evidence that Oei, certainly as early as 1811, was capable of such a masterly series of prints as *Tsuhi-no-Hinagata*. Keisai Eisen, who under a pseudonym is believed to have written the preface to *Tsuhi-no-Hinagata*, has also been put forward as the artist, but on the basis of the *shunga* generally agreed to be his, and indeed, on the lack of evidence of any output of consequence up to 1811, when he had made no mark as an artist, his candidature cannot be supported. However, on stylistic grounds one has to conclude that the date of *Tsuhi-no-Hinagata* can hardly be earlier than 1816, and that the entry of the former owner in the copy referred to by Shibui was incorrectly dated, but even so, the case for Hokusai being the artist is very strong.

[5] Illustrated in J. Hillier, *The Harari Collection of Japanese Paintings & Drawings*. See Bibliography.

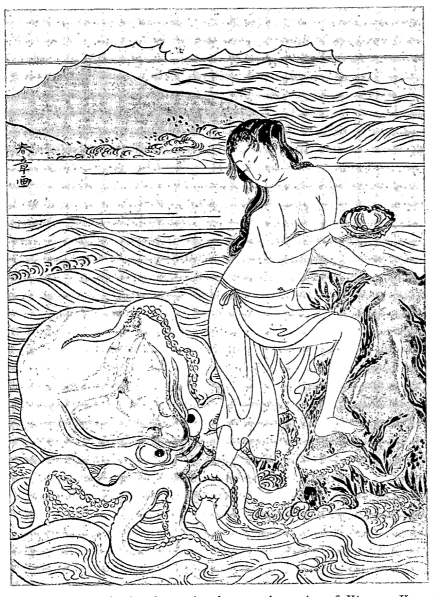

There is no doubt about the date or the artist of *Kinoe-no-Komatsu*, which has a preface datable to 1814, and has become one of the better known of Hokusai's *shunga*, mainly because of the ghoulish print of a young woman being violated by an octopus (pl. 148). The amorous octopus was not uncommon in Japanese art and it is revealing to compare the Hokusai print with one by Shunshō of the early 1770s, several years before. Hokusai was enrolled as his pupil. Nothing could bring home more clearly the distance opened up between these artists, in feeling and in treatment, over the forty years separating the two versions. In Shunshō's print (pl. 147), the *awabi*, diving girl, still belongs to the world of artificially frail beauties exemplified by Harunobu, and the attack of the octopus is seen as something amusing, not threatening and macabre as it becomes in Hokusai's print. Hokusai's is a nightmare fantasy which Goncourt called 'a terrible plate: on rocks green with marine plants is the naked body of a woman, swooning with gratification, *sicut cadaver*, to such a degree that one cannot tell whether she is drowned or alive, and of which an immense octopus, with frightening eye-pupils in the shape of black moon-segments, sucks the lower part of the body, while a small octopus greedily battens on the mouth.'[6]

147 Katsukawa Shunshō. Colour-print of *awabi* diving girl and amorous octopus. Signed Shunshō, *c.* 1773/74

[6] 'Une terrible planche: sur des rochers verdes par des herbes marines, un corps nu de femme, évanoui dans le plaisir, *sicut cadaver*, à tel point qu'on ne sait pas, si c'est une noyée ou une vivante, et dont une immense pieuvre, avec ses effrayantes prunelles, en forme de noirs quartiers de lune, aspire le bas du corps, tandis qu'une petite pieuvre lui mange goulûment la bouche.'

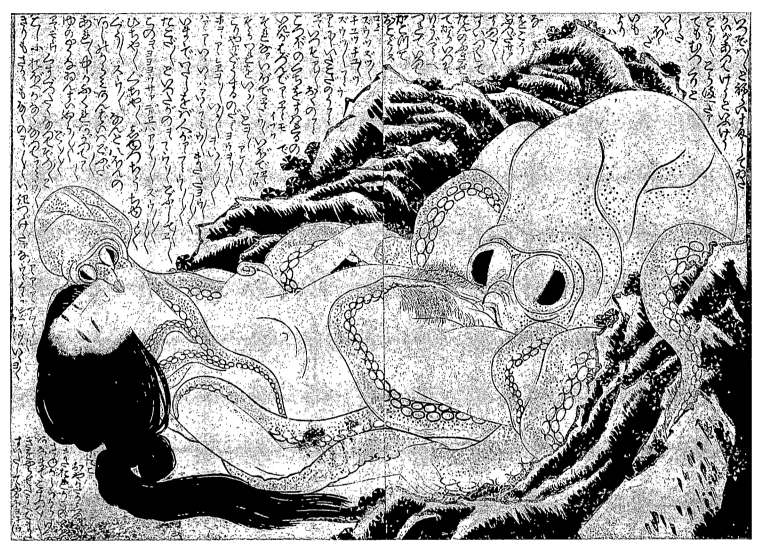

148 From *Kinoe-no-Komatsu*,
preface 1814

The remaining prints in this book present the most extreme development of Hokusai's use, in depicting clothes, of an agitated, fluttering line which, with complicated dress-patterns and the distracting text filling the background above the figures, results in a seething swirl of line and colour that is positively vertiginous.

The later *shunga* form a difficult group bibliographically. Several of them exist in two or more versions, evidence of a demand that led to re-issues, but because of the inaccessibility and the rarity of extant specimens there is a lack of opportunity to make adequate comparisons of copy with copy. These problems are particularly acute in relation to what is considered Hokusai's greatest colour-printed *shunga*, known generally as *Nami Chidori* (from the 'waves and plovers' design on the covers) but perhaps first issued under the title *Fukujusō*, 'The Adonis Plant', and also known under a further title *Ehon Sasemo-ga-tsuyu* 'Dew on Love's Grasses'. Briefly, in *Fukujusō*, text is

149 From *Nami Chidori* (*Fukujusō*), *c.* 1818

150 From *Nami Chidori*
(Fukujusō), *c.* 1818

inscribed above the figures; in *Nami Chidori*, printed from variant blocks, the text is
omitted, a mica-ground substituted and hand-colouring employed on some copies;
and *Sasemo-ga-tsuyu* more or less follows *Nami Chidori*, though the mica is over a pink
ground. However, as I have mentioned, no definitive detailed bibliographical analyses
have been published.

 This book is central to any consideration of Hokusai's work as a *shunga* artist: the
prints in it relegate such questions as priority of edition or variations in blocks to
irrelevances; they are outstanding proof of Hokusai's genius in this, as in every other
sphere in which he was involved (pls. 149–153). It must have been among those albums
that wrung from Michener, almost in spite of himself, the tribute to which I referred
earlier:

'I speak of a handful of contorted and harrowing sheets in which the old man set down scores of agonizing human beings caught up in the *reductio ad adsurdum* of sex. Here, in these demonic sheets . . . one sees the ultimate in human experience: the longing, the savagery, the bitterness, the joy, the ridiculousness and the unsatiated hunger of sex . . . It is a great pity that they cannot be exhibited, for until one has seen their mocking faces and their contorted bodies, one can have no final image of Katsushika Hokusai.'

But now they can be, and have been, exhibited. Despite himself, Michener recognizes that to omit the *shunga* from any exposition of Hokusai's works is to present an incomplete picture of the man and his art; indeed, it is worse, for it is a distorted,

151 From *Nami Chidori* (*Fukujusō*), c. 1818

152 From *Nami Chidori* (*Fukujusō*), c. 1818

153 From *Nami Chidori* (*Fukujusō*), c. 1818

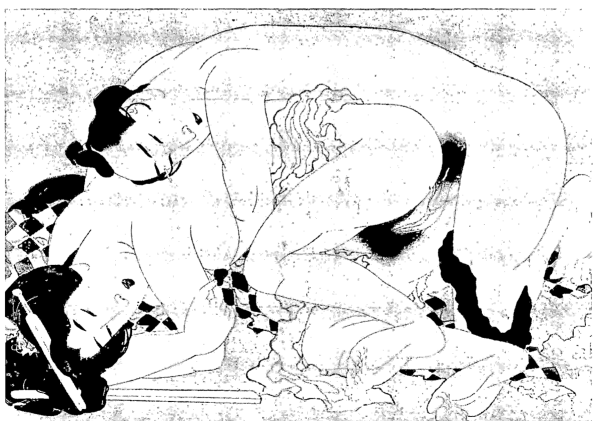

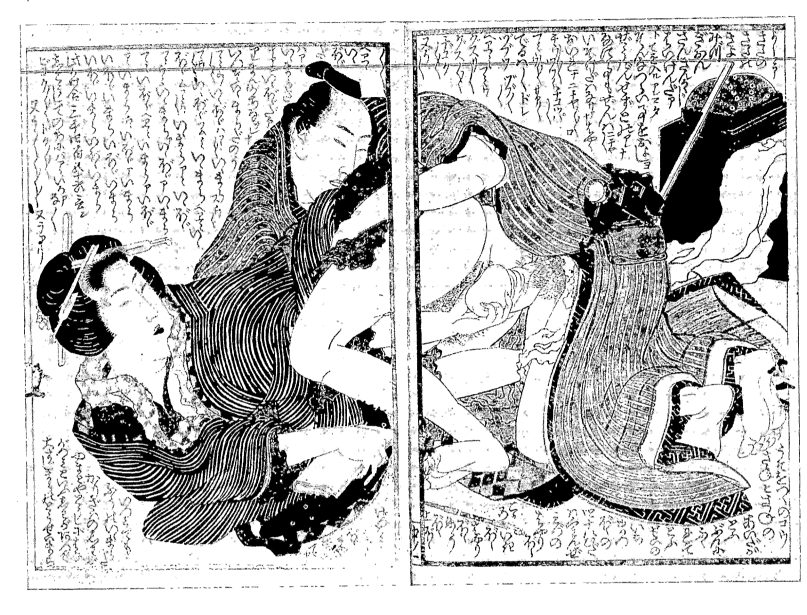

154 From *Tsuma-gasane*, c. 1818

because an emasculated, picture. The recognition by the western world that Hokusai's landscape prints are among the supreme artistic triumphs of Japanese art – 'The wave' and 'Fuji in clear weather' have come to symbolize not merely Hokusai but the colour woodcut medium itself – has led to his equally astonishing gifts in depicting human beings, whether in painting, print or book, being overshadowed. The virtual suppression of the great corpus of works in the *shunga* albums and books has still further stood in the way of a just appraisal of his stature in art involving the figure.

Fukujusō, though undated, has usually been ascribed to around 1818. Like the *Kinoe-no-Komatsu*, it coincides in time with the opulent *bijin-ga* paintings that are overpoweringly rich in colour, thickness and opacity of pigment and, coupled with the restless line in the draperies already alluded to, resulting in what, to western taste, is an excessive exuberance and turbulence. In the printed *shunga* these excesses are to some

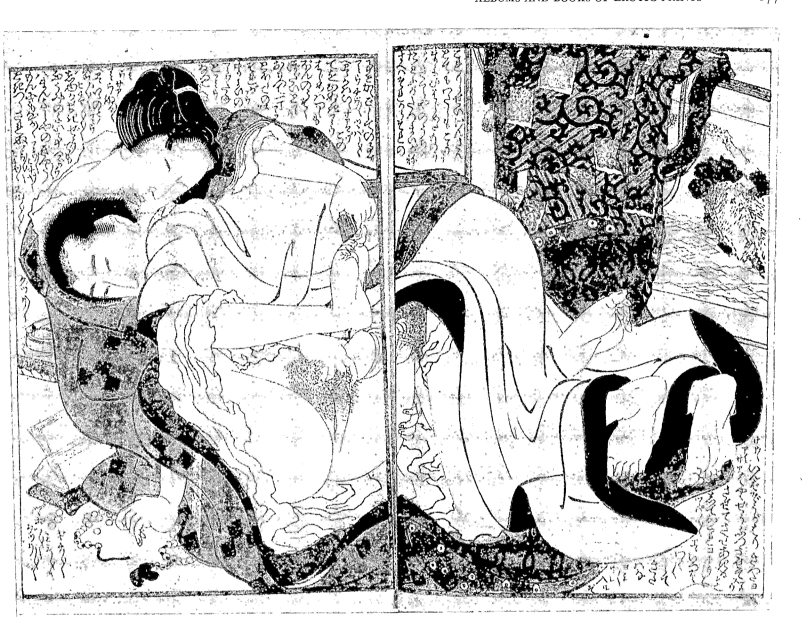

155 From *Tsuma-gasane*,
c. 1818

extent neutralized by the woodblock technique, and Hokusai is able, by the very nature
of *shunga*, to make greater play with the contrast of naked limbs and flesh against the
boldly patterned dress materials, uncompromisingly printed in flat tones: the figures
are very rarely portrayed completely nude, even the couple in the 'soixante-neuf'
position, perhaps the most monumentally sculpturesque group of his whole *shunga
oeuvre*, have their stark nakedness relieved by a flutter of draperies beneath them. The
version illustrated is from the first edition, with text filling the space above the figures.
In the later, recut, versions, the lines of text and the objects shown beyond the bodies
(the *makura*, pillow, and the corner of the rug) are taken out. Every distraction from
the outline of the two figures, except the rippling lines of the discarded dress, is
removed, the backgrounds covered with mica, silver in one issue, pink in another, and
hand-painted colour applied to the pudenda and to the lips of the man and woman.

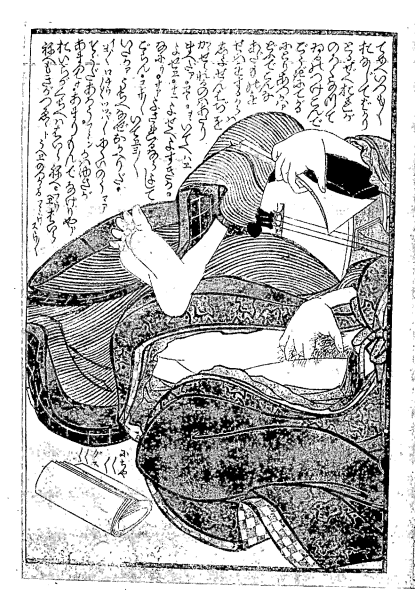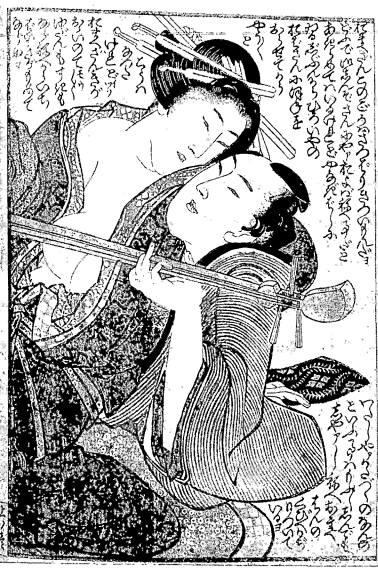

Plate 151 is of another scarcely less magnificent design, taken from the later edition with pink mica ground, in which the kind of limited hand-tinting I have mentioned can be seen. Neither Hokusai's oriental linear method, nor the woodcut medium, accepted *chiaroscuro* as a means of emphasizing bulk or volume, but with what expressive precision Hokusai has drawn the lines of the man's pomaded hair and with that detail not only given shape to the head, but a three-dimensional illusion to the whole design of these two, clasped in so contorted an embrace.

Several other books of *shunga* by Hokusai were published, one, *Tsuma-gasane* (pls. 154, 155) at about the same time as *Fukujusō*, followed a little later by two books in *ehon*

156 From *Tama-kazura*, c. 1820

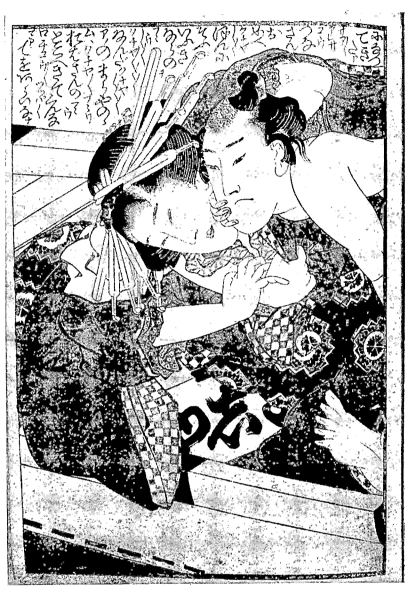
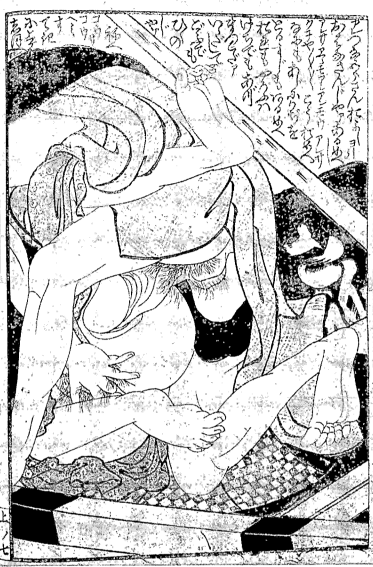

157 From *Tama-kazura*,
c. 1820

style and a final album, namely: *Tama-kazura* (assumed title), *c*. 1820 (pls. 156, 157);
Manpuku Wagō-jin, postface datable to 1821 (pl. 158); and *Enmushi Izumo-no-Sugi*
(assumed title), preface datable to 1822.

In all these books, Hokusai continued to display astonishing creative powers and a
realism that tends to make us feel close voyeurs of the most intimate scenes between
men and women, or of women in lesbian acts, or masturbating alone. The illustrations
can be taken as representative of the contents as a whole, it is impossible to give more
than a print or two from each and there is no point in attempting descriptions of
individual prints: to quote Marianne Densmore again 'there is nothing left to invent'.

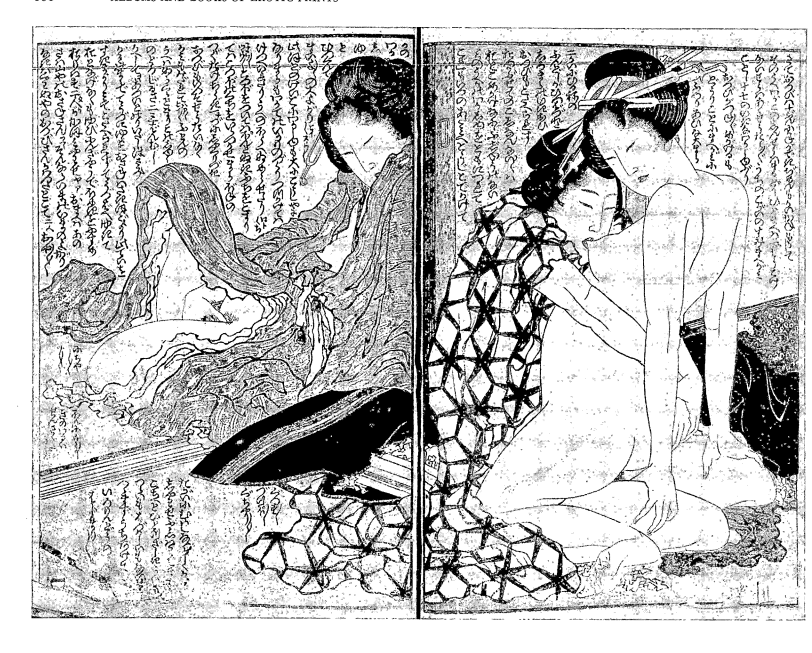

On the whole, Hokusai's later sex pictures only rarely evoke an image of romantic love: there is too often an element of stark brutality, or the viciousness of despair, that reminds us of Egon Schiele and the German Expressionists. They are redeemed by the overwhelming artistry in manipulating nude and half-clothed figures in compositions of majestic power; and by the realism that is startling in its potency despite the conventional distortion of the sexual organs, and despite the bald outlines of the flesh and the way the patterns of the dresses are flat-printed with little concession to the contours of the body underneath. In the *shunga* of later Ukiyo-e artists, lacking Hokusai's mastery, the violence and sadism become unbearable.

Hokusai's last *shunga* album was published about 1822/23 when he was in his early sixties and so far as we know he made no further erotic pictures during the remaining twenty-six years of his life.

158 From *Manpuku Wagō-jin*, *c.* 1821

14 Craftsmen's Books

One of the most popular subjects in Japan for paintings in scroll and album form and, from the seventeenth century, in illustrated books, was the *Shokunin-zukushi*, the 'Series of Craftsmen'. Every grade of *shokunin* – a word which embraced all those who created anything with their hands, from painters, potters and the noblest of the craftsmen, the swordsmiths, down to the meanest of the artisans, the dice and pin-makers – was given a place, and the pictures show each man surrounded by his products and the tools and other paraphernalia with which he had brought them into being. Once the illustrated book had become established in the seventeenth century, the widening interest of the *chōnin*, the 'townsmen' or bourgeoisie, in the cut and decoration of clothes, was met by a succession of volumes that gave patterns for *kimono*. Many of the major artists, from Moronobu and Sukenobu onwards, not only depicted the men and women of their genre scenes in stylish clothes that recorded the current fashions, but designed whole books of *kimono* patterns that were obviously intended for use by the dyers and brocade embroiderers. Other books were clearly aimed at a far wider range of craftsmen and artisans. An *ehon* like Masayoshi's *Shōshoku Gakan* 'A Mirror of Designs for All Crafts' (1794), for instance, was in the nature of a source book for carvers of *netsuke* and *okimono*, for painters and book-illustrators, for lacquerers and metal-workers, and for all those in fact in need of models.

Hokusai, so much a man of the people, of artisan stock himself, was certainly aware of the needs of craftsmen for models or patterns that could be drawn on at will, and he designed several books that were specifically made for the purpose, in some cases related to particular products. The *Manga* volumes were of course replete with a multitude of ideas for those in general who needed such aids to inspiration, but in three little volumes published in 1823, 'Models for Combs and Pipes of Today' (*Imayō Kushi-kiseru Hinagata*) Hokusai catered for the makers of these articles of everyday use. Combs and pipes were objects in almost universal use. Japanese women, even of the nobility, wore hardly any jewellery: the *kimono* was almost their sole adornment, though much play was made with fans, and at times with ornamented combs. The Japanese have a positive genius for the adaptation of natural forms in patterning everyday objects for wear or use: lacquer writing-boxes, and *inrō*, sword-guards,

159 Designs for combs.
From *Imayō Kushi-kiseru
Hinagata,* 1823

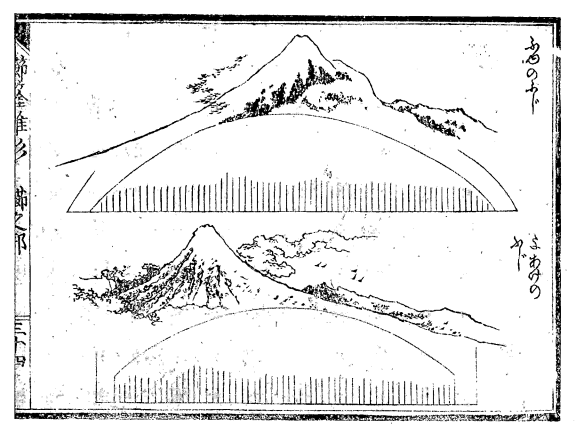

160 Further designs for
combs.
From *Imayō Kushi-kiseru
Hinagata,* 1823

From *Imayō Kushi-kiseru
Hinagata*, 1823

ceramics of all kinds, *kimono*; and Hokusai in his handling of the staple form of comb shows how intuitively he created apt motifs from anything from landscape to abstract geometric patterns (pls. 159, 160). Translated into coloured lacquer or inlayed shell on either tortoiseshell or lacquered wood, Hokusai's plain outlines would have been transformed into rich ornaments, for display as much as use, and though sometimes over-elaborate for our taste, they were, after all, designed largely for the current *nouveau riche* or the *demi-monde* and expressly called 'modern' in the title.

Tobacco pipes were in even more widespread use, by both men and women, and often beautifully ornamented. The second part of *Imayō Kushi-kiseru Hinagata* must be one of the most complete model books of pipes ever made for craftsmen, with pages of designs for pipe-bowls and about 150 suggestions for the decoration of the stems, the

patterns being flattened into oblong shapes for the convenience of those who were
going to transfer them to metal or lacquer. Hokusai runs through a vast repertoire of
designs, familiar enough to us already from the *Manga* and the *Ryakuga Haya Oshie*, but
with the subjects now adapted to the exigencies of the narrow bands of ornament on
the pipe-stems (pls. 161–63).

 Shingata Komon-chō, which has a preface dated 1824, is an 'Album of New Forms of
Fine Patterns'. It provides, in black outline only, a series of marvellously ingenious and
intricate patterns, mostly abstract and linear, in roundel form, suitable for application
to any surface needing decoration, but mostly no doubt taken up by textile designers
(pl. 164). A smaller section gives examples of calligraphic simplification of natural

162 Further designs for pipe-
stems.
From *Imayō Kushi-kiseru*
Hinagata, 1823

163 Further designs for pipe-
stems.
From *Imayō Kushi-kiseru*
Hinagata, 1823

164 Patterns for textile
designers and dyers.
From *Shingata Komon-chō*,
1824

forms: pl. 165 is a double page including the stylized wisteria blossom which the
great French collector Théodore Duret borrowed for his seal, and the wonderfully
simplified hare that may well have prompted one of those *netsuke* makers who, so long
before Brancusi, made sculpture that departed only so far from the ultimate egg-shape
as allowed them to identify a particular animal or bird. Another page, premonitory this
time of Art Nouveau, shows fanciful, flying cranes composed of flowers and fruits and
leaves (pl. 166).

The last page portrays the man for whom the book was primarily intended: the dyer,
the craftsman who translated Hokusai's designs into reality. He is depicted coming
from the vat, bearing lengths of treated cloth on the hangers from which they had been
suspended, his wrists and hands steeped in the dye (pl. 167). The print bears the
signature currently in use, Zen (formerly) Hokusai Iitsu.

Aside from books like those so far described for craftsmen's use, Hokusai also
occasionally illustrated books devoted to hobbies and pastimes. *Bonga*, 'tray-picture'-
making, was an indoor activity by which ephemeral artistic models were produced in
sand. It was sufficiently fashionable for Hokusai to have used as the centre-piece of an
elaborate *kyōka-surimono* a picture of a girl engaged in making a sand-picture of Fuji;[1]
and as a frontispiece to a manual of instruction, *Bonga Hitori Keiko* 'Tray-picture-
making Self Taught' of 1828, he designed a picture of mother and child kneeling before

[1] Illustrated in my *Hokusai: Paintings, Drawings, Woodcuts* (1955).

166 Further patterns.
From *Shingata Komon-chō*,
1824

167 The dyer.
From *Shingata Komon-chō*,
1824

their trays and with all the impedimenta of the pursuit, boxes of different coloured sand, modelling implements and feather, beside them (pl. 168). The rest of this interesting book, which is a very thorough manual, is illustrated by other artists with diagrams and patterns for students to follow, and concludes with advertisements of suppliers of materials and tools.

The other major book of craftsmen's designs by Hokusai was not published until 1836. Although the title gives the impression that this is another comprehensive source book – *Shōshoku Ehon Katsushika Shin Hinagata*, 'Picture-book of New Patterns for all Kinds of Trades' – it is concerned very largely with architectural, mainly wooden, structures and carvings. Hokusai, in fact, makes the intention of the book quite clear in his preface, in which he explains that architects are secretive about their methods of construction, and so artists are at a disadvantage when they come to include buildings in their pictures. The designs he is providing are intended to assist those who are studying the art of painting, not would-be architects.

Nonetheless, there is a certain amount of quasi-technical information. On one page, for instance, are diagrams to assist the accurate drawing of a temple, which also show Shintō craftsmen holding what seem to be ceremonial tools rather than implements of real use (pl. 169). That Hokusai really had studied the complicated wooden structures that he uses by way of illustration is proved by the meticulous drawing of the balcony of a bell-tower, with its elaborate bracketing and carved timbers (pl. 170).

Even as late as 1847, when Hokusai was in his eighty-seventh year, he was not above providing illustrations to a book for carpenters and carvers, with pictures of men at work, and of patterns for ornaments. The title is *Eyō Hinagata*. I have traced only one copy of this far from noteworthy book (in the Museum of Fine Arts, Boston), and it is hard to find any justification for its publication since it contains so small an amount of information and no pictures of a kind that would have made it worthwhile on their account alone. But, as will be shown, in the last decade of his life, when he was painting some of his masterpieces in *kakemono* form, Hokusai was frequently assisting in the illustration of quite insignificant books.

168 Making a tray-picture. From *Bonga Hitori Keiko*, 1828

169 Architectural plans and noble craftsmen. From *Shōshoku Katsushika Shin Hinagata*, 1836

170 Balcony of a bell-tower. From *Shōshoku Katsushika Shin Hinagata*, 1836

15 Miscellaneous Books, 1820~1840

171 A flock of herons.
From *Ippitsu Gafu*, 1823

Some of the books already discussed in the chapters on 'Portraits of Poets' and 'Craftsmen's Source Books' were published during these years, and others of the same period – those linked loosely together by their predominantly 'warrior' subjects or by their illustration of Chinese verse in the *Tōshisen* series, and the major work, the 'One Hundred Views of Fuji' – will be treated separately later. There still remains a list of books of infinitely varied content, beginning with the *Ippitsu Gafu* of 1823, and ending with the *Nikkō-San Shi* of 1837, which will briefly be described in this chapter.

171 A flock of herons.
From *Ippitsu Gafu*, 1823

The *Ippitsu Gafu*, 'One-brushstroke Drawing Book', is an enchanting succession of colour-prints that show Hokusai exulting in the virtuosity of his calligraphic line. There is the familiar jumble of subjects common to *Manga*-type books, but here they have been grouped in such a way on each page that attractive overall patterns result, both the shapes and the undulating line contributing, sometimes on a solid background of blue or pink (pls. 171, 172). It seems to have been intended for that surprisingly large public that had a taste for amusing or original sketches, but there are one or two puzzling features about even this seemingly straightforward book. To begin with, the preface and the wrapper (pl. 174) invoke as 'originator' the name of Fukuzensai, which was one of the art-names of Niwa Kagen, a Nanga artist who had died in 1786, and who was not notable, either in his extant paintings or in the colour-printed book after his designs, *Fukuzensai Gafu*, that came out in 1814, for the kind of trick brushwork in *Ippitsu Gafu*.

172 A flock of cranes.
From *Ippitsu Gafu*, 1823

Then, the colophon mentions (as in the case of the *Manga* and other books) the names of collaborators like Bokusen and Hokuun, but on two pages the pupil Taito II (who took over the name from Hokusai in 1819) adds his name as collaborator, and on a further drawing of tortoises (pl. 173) inscribes *Ippitsu-no-Taito-shihitsu* 'One brushstroke Taito, inherited brush', which at least gives the impression that he was wholly responsible for this design. The situation is further confused by the writer of the preface referring to the artist under the name of Taito, discarded by Hokusai several years before the 1823 date of the preface. The illustrations to this book raise in rather pointed fashion the question of just how much the pupils contributed to the many books where their assistance is acknowledged.

173 Tortoises.
From *Ippitsu Gafu*, 1823

174 *Fukuro* (wrapper) for
Ippitsu Gafu, 1823

175 The *kyōka* poets Ittai and
Shichō.
From *(Kyōka Shinsen) Kachō
Fūgetsu Shū*, 1824

In certain other *gasaku*, 'joint works', the distinction between the respective works of master and pupil is made clear. In the book *(Kyōka Shinsen) Kachō Fūgetsu Shū* 'A New Selection of *Kyōka* on Flowers, Birds, Wind and Moon', of 1824, Hokusai is named as the artist for the figures, and Ryūsai Hokusen (Taito II) for the remainder. The illustrations are printed in *sumi*, and Hokusai provides a series of portraits of *kyōka* poets, similar to those in books described in Chapter 5, engraved and printed with a skill that makes the book unusually attractive (pl. 175). Among Taito's contributions is a landscape signed Ryūsai, known to be one of his pseudonyms, but sealed Masazumi, a name that had hitherto been assumed to belong to a separate artist.

Hokusai was still occasionally involved with *kyōka* and *haiku* anthologies, though to a lesser degree than in the period 1795 to 1805, partly because he was now largely pre-occupied with painting, and partly because other artists, Hokkei, Gakutei, Eisen and others, were competent enough to handle commissions for such work. For one such book, published in 1826, Hokusai produced an especially fine colour-print of a wild rose and a bee (pl. 176). The book, which has the title *Renge-dai: Tokunari Bun Tsuizen Shū*, is a memorial volume dedicated by Tokunari to his father in commemoration of the seventh anniversary of his death. In it are poems and prints by men famed for their art as painters and calligraphers, and nothing could bear greater witness to the refinement of the cultured society of the day than the sensitivity and awareness of page design of individual contributors, and the controlling concept that welded alternate pages of individualistic calligraphy and drawings from artists of different schools into an artistically harmonious whole. W. J. Strachan, in his excellent *The Artist and the Book in France*, quotes André Malraux on *Le livre d'artiste*. Malraux wrote:

> 'A great text, that is already a sort of miracle: to give an illustration to it, is to will another: it is to ask that the text and the image should establish that mysterious bond between themselves that we call harmony . . .'[1]

In the Japanese counterparts, indeed, forerunners, to such books, it did not have to be 'un grand texte', it might even be quite trivial, but more importantly, hand-written by the author, or by an accomplished professional calligraphist, it was often visually significant. In the *Livres d'artiste* that such publishers as Vollard and Kahnweiler produced in France from 1900 onwards, the concinnity of text and illustrations was usually ensured by the prints being from the hand of a single artist accompanied by a suitable but uniform typography (or in rare instances, the artist's autographic text). In such books as *Renge-dai*, it is the woodcut medium that reconciles the pages of varying brush inscriptions of the poets and the colour-printed designs of artists, artists as far apart in style as Tani Bunchō of the Nanga School, Hōitsu of the Decorative, Kunisada of the Ukiyo-e, and Hokusai. Hokusai's print is given the last place in the book, perhaps by right of seniority, and as if, by 1826, he was recognized as being above school classification.

This memorial volume to the father of an obscure poet is excessively rare, and I have shown no more than one of the fifteen prints that adorn it, and none of the pages of calligraphy – which brings me back to the point I made in the Introduction; that nothing can do justice to such a book except the book itself. Even a complete reproduction would not be enough, because paper, printing, colour, everything is inimitable.

For another *kyōka-bon* Hokusai made a series of very beautiful bird-and-flower prints, in *sumi* only. This was the *Kachō Gasan Uta-awase*, 'A Competition of Inscriptions and Bird-and-flower Pictures'. It is not dated, but several of the prints are signed Getchirōjin Iitsu, with a 'fantasy' seal usually described by the Japanese as 'Two Men'. The Getchirōjin *gō* seems to have been used only in 1828. In the 1820s, Hokusai designed the splendid series of broadsheets known as the 'Small Birds' and the 'Large Flowers', and the drawings in this *kyōka-bon* show the same exciting handling of birds

176 Wild rose and bee. Signed Iitsu. From *Renge-dai: Tokunari Bun Tsuizen Shū*, 1826

177 Swallows and wisteria.
Signed Getchirōjin Iitsu.
From *Kachō Gasan Uta-awase*,
1828

and flowers, the creation of masterly patterns from birds in flight or at rest with sprays of flowers, naturalistically drawn but always astutely disposed to provide an effective composition. In the book, it is true, the designs are integrated, or even in competition with, the text of the *kyōka*, but the calligraphy is discreetly subdued by the block-cutter, and one admires the *mise-en-page* that lacks any jarring sense of conflict (pls. 177, 178).

Despite Hokusai's now universally accepted position as *grand maître*, the *sensei*, teacher, of a considerable proportion of the more active of the Ukiyo-e painters and print-designers in Edo, he still found time to assist, even in a minor capacity, in the illustration of some unlikely publications. There is, for instance, a miscellany like

178 Eagle on a plum-branch. Signed Getchirōjin Iitsu. From *Kachō Gasan Uta-awase*, 1828

Sukigaeshi (Kangon Shiryō) which might be translated 'Rejuvenated Scraps', first published in 1826. The author was Tanehiko, a novelist whose books Hokusai had illustrated twenty years earlier, so that there may have been a relationship between the two which would account for Hokusai assuming the humble role of copyist of old prints and paintings, reproduced in ink woodcuts in Tanehiko's text. His miscellany is an antiquarian hotchpotch that ranges not too consequentially over a wide range of topics, mainly social history and custom. It is interesting, however, to find reproductions at this date of early Ukiyo-e paintings and prints, including some from Moronobu *ehon*.

飲後七星湯とのむ圖

Even more unexpectedly, we find Hokusai contributing designs to a cook-book, 'The Cook-book of the Yaozen Restaurant in the Yoshiwara' (Parts 3/4, 1835). One print depicts a Chinese gourmet taking *shichiseito* (presumably, some sort of digestive) after dinner (pl. 179); another, a group of serving vessels, a print bearing a signature, and dated by the artist in his seventy-fifth year (pl. 180).

In 1828, the first part of *Ehon Teikin Ōrai* was published and completed by two further parts at a date unknown but no doubt within a year or two. It was the first book of what might be termed a serious, didactic type that Hokusai had been called upon to illustrate during his long career, and it may not be wrong to deduce the beginning of an

179 Chinese gourmet. From *(Edo Ryūkō) Ryōri-tsū*, Part 4, 1835

180 A group of serving
vessels. Signed Zen Hokusai
Iitsu at the age of seventy-
five. (1834)
From *(Edo Ryūkō) Ryōri-tsū*,
Part 4, 1835

acceptance by him of the responsibilities of old age: he was, after all, nearly seventy. He
had designed his last *shunga* several years earlier, and was to concern himself in the years
ahead with Confucius and with Chinese verse; in his separate sheet prints he was to
design a set based on the classic *Hyakunin Isshu*, 'One Poem from each of One Hundred
Poets', characteristically illustrating them from the viewpoint of an 'old nurse', and
providing vernacular, pictorial interpretations that reveal more about Hokusai than
they do about the verses. He now drew what he saw with an eye that had 'kept watch
o'er man's mortality'.

Teikin Ōrai was written by Gene Hoshi in the fourteenth century, but what he had intended as a set of models for letter-writing, became, on account of their literary value and ethical tone, a school textbook in the Tokugawa period. Hokusai's book is ingeniously designed, with pages divided in two, and text and illustration separated by a dividing line, but the positions of each part, and their proportions, varied from page to page. Hokusai makes no attempt directly to illustrate the letters, indeed, it would have been virtually impossible to do so, but seizes upon some incident or object mentioned by the author and builds a drawing around it, situating his pictures in

181 The premises of the publisher Nishimura Eijudō. From *Ehon Teikin Ōrai*, 1828

182 Benkei.
From *Ehon Teikin Ōrai*, 1828

contemporary Edo and his figures in 'modern dress'. Thus, one illustration (pl. 181)
gives us a picture of another famous publisher's bookshop (some thirty years after he
had drawn Tsutaya's shop, in *Azuma Asobi*, pl. 28). This time, it is the premises of
Nishimura Eijudō, the publisher of *Teikin Ōrai*, his sign and name being emblazoned
on the *noren* (or curtain) and on the lantern outside the premises. Another illustration is
of Benkei, with his armoury of fearsome weapons, standing on Gojo Bridge (pl. 182).

　　The next book of an edifying nature is *Hokusai Onna Imagawa* (if we are correct in
believing it to date about 1828: Japanese authorities quote 1844, but that seems too

late, and may be the date of a re-issue). *Onna Imagawa* was written by a woman named Sawada Kichi and takes the form of admonitions to young girls, for whom it became a standard school book, and the text a practice-piece for their calligraphic exercises. It was first published in 1700 and went through many editions, a number of them illustrated. Hokusai again avoids anything approaching direct illustration of the text and instead gives a series of pictures of women who exemplify the virtues of heroism, of religious dedication, of domestic contentment and the like; and in doing so, provides some of his noblest figure compositions since the *Gashiki* and *Soga* volumes of 1819 and 1820. The title-page is reproduced to show with what skill (so premonitory of Art Nouveau) Hokusai could adapt plant and flower to the frame around an inscription (pl. 183); the interior with a mother suckling a child and nearby other younger women making ceremonial clothes for their master, is in his suavest manner (pl. 185); and there is poignant drama in the picture of the cruel Iwafuji belabouring the submissive Onoe with her sandal (pl. 186). This last illustrated a story that inculcated everything a Japanese moralist wished his daughter to revere. The two women were both maids of honour at the court of the Prince of Kaga, but Iwafuji was superior in rank, and

183 Title-page of *Hokusai Onna Imagawa*, 1828

常州江戸寄

緑樹園

185 Domestic scene.
From *Ehon Onna Imagawa*,
1828

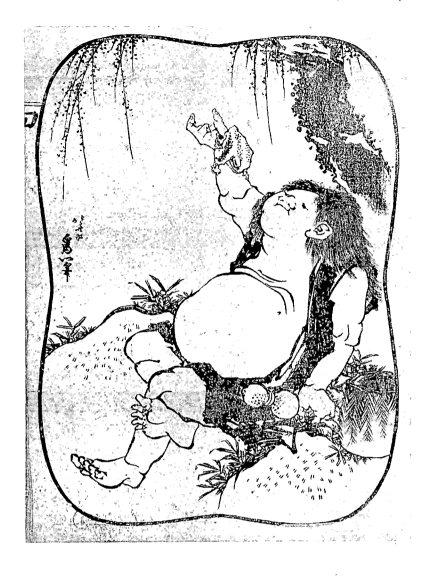

186 Iwafuji beating Onoe.
From *Ehon Onna Imagawa*,
1828

187 Gama Sennin from
(Kyōka) Ressen Gazōshū, 1829

corrupt, and because Onoe was virtuous, did her utmost to make Onoe's life unbearable. The crowning insult was this public beating with a sandal in the precincts of a temple. Onoe bore it unflinchingly and without retaliation, but returning to the Palace, she committed *seppuku*, leaving a letter that revealed Iwafuji's conspiracy with a certain minister against the Prince. Ohatsu, her faithful servant, read the letter and vowed vengeance, eventually killing Iwafuji with a dagger and then ending her own life, after she had revealed the events in a letter to the Prince. Once again, it is a story wholly centred on the virtue of loyalty and the inescapable duty of revenge.

In 1834/35 three books based on Chinese originals were published, each with *sumi* illustrations by Hokusai. They were *Ehon Chūkyō*, 'The Picture Book of Loyalty'; *Ehon Kōkyō*, 'The Picture Book of Filial Piety'; and *Ehon Senjimon*, 'The Picture Book of the Thousand Characters'. In this decade, when Hokusai was in his seventies, he was at his most creative, and they were the years when he illustrated not only these three books, but the books described in Chapters 16 and 17. He had arrived at that stage where he had a perfect understanding of what could be accomplished by the woodcut medium and the book page, and none of these books was colour-printed: he was content to deploy the unassisted ink-block, or, in the Fuji book, the full range of ink tones made possible by the use of multiple *sumi*-blocks.

In the three 'Chinese' books, Hokusai falls back on the repertoire of physical types, outlandish costume and accoutrements that he had created for earlier books with similar backgrounds, especially the Suikoden novel with which he was pre-occupied from 1805 onwards, but there are now flashes of genius that make certain of the prints arresting in a way hardly matched in earlier works. The opening pages of *Chūkyō* introduce a daring, imaginary portrait of the author, head bowed and supported on his brush hand as he interrupts his writing, the heavy asymmetrical placement achieving

188 Imaginary portrait of Confucius.
From *Ehon Chūkyō*, 1834

漢楚天下を争ふ時楚王大軍を以睢陽を圍む通るべき道かし紀伝濮王の衣服をぬいり濮王今糧そくて楚ふ濮系をくほる法軍東門小集る濮王西門よりのぐ走云をおり漢王を罵なり濮王を罵なり燈死を

189 The inundation of a
Chinese army.
From *Ehon Chūkyō*, 1834

originality even in a country where such a compositional ploy was frequent (pl. 188); and nothing in the whole range of Hokusai's prints, not even the better known colour-print in the broadsheet series *Chie-no-Umi*, a rough sea off the Shimosa coast,[2] has quite the impact of the scene of the inundation of an army (pl. 189).

Illustrations for the *Kōkyō* are more orthodox, or at least, more in conformity with other Hokusai books, especially those that deal with comparable incidents in the 'Warrior' books; but in the two volumes there are, again, a few brilliant

[2] See *Japanese Prints and Drawings in the Vever Collection* (1976), Vol 3, No 21.

improvisations, including the charming title-page, with opposing panels of crows on a plain ground and plovers in reserve on a black ground (pl. 190). *Hsiao-ching (Kōkyō* in Japanese) is a Chinese classic, and purports to record the wisdom of Confucius in teaching filial piety to his disciple Tsêng Ts'an. Hokusai departs at will from the text and his illustrations are drawn as much from Japanese sources as Chinese. One of them is of Bashō, showing the great *haiku* poet standing on a dangerous cliff-ledge path leading to the infamous Hanging Bridge of Kisō. He is in the very pose, bent over a supporting stick, that Hokusai adopted in a famous self-portrait, and the *haiku* by

190 Title-page for *Ehon Kōkyō*, 1835

191 Bashō on the path to the
Hanging Bridge.
From *Ehon Kōkyō*, 1835

Bashō inscribed above – 'The Hanging Bridge! Creeping vines entwine our life'[3] – may also have been quoted by Hokusai as expressing his own philosophic resignation to old age (pl. 191). The verse had been composed by Bashō when crossing the bridge while on a journey with his disciple Etsujin, as recounted by Bashō in his 'Diary of Travel through Sarashina'. The vines referred to in the poem grew along the bridge over an awesome ravine: the vines, like the men, entrusted their lives to the bridge. It was, in the typically oblique way of an *haiku*, an acknowledgement of the precariousness of human life.

[3] *Kakehashi ya mochi wo karamu tsuta katsura.*

Ehon Senjimon came out in the same year as *Kōkyō*, and the illustrations are of the same order. The Chinese book, *Ch'ien-tzŭ-wên*, 'The Composition of One Thousand Characters', on which it is based, has the kind of apocryphal text that was probably even in Hokusai's day viewed with some scepticism. Toda in the Ryerson Catalogue explains:

'According to Chinese tradition, *Senjimon* (*Ch'ien-tzŭ-wên*), the composition of one thousand characters, was written by Chung Yao, under the Emperor Wu-ti (reign 265–289), of Chin. Wu-ti was often attacked by the enemy, and, on one occasion, had to flee. He took the manuscript of *Senjimon* in his carriage, and while

192 Peak and flying geese; peasant family.
From *Ehon Senjimon*, 1835

193 A master reading to a circle of listeners. From *Ehon Chūkyō*, 1834

on his way to Tanyang, met a heavy shower. The manuscript was drenched, and some parts of the words became illegible: Later, the manuscript was acquired by the Emperor Wu-ti (reign 502–549) of Liang, and the lost part was rewritten by Chao Hsing-ssǔ, to make it a complete composition with one thousand letters. Scholars, however, think that Chao Hsing-ssǔ was the original writer of the whole work.'

There is a colour-printed frontispiece by Shōdō, and the rest of the illustrations are by Hokusai, in *sumi* (pls. 192, 193).

In 1837, a publishing venture of some magnitude was consummated by the printing of the five-volume set of *Nikkō-San Shi*, 'An Account of the Nikkō Mountains'. It must have been started at least six years earlier, since Hokusai's four-sheet print of the 'Ryūzu Waterfall', his only contribution to this sumptuous work on the mountainous area made famous as the site of the mausolea of the great Tokugawa founder, Ieyasu, and his grandson, Iemitsu, is dated in his seventy-second year, which, by Japanese computation (which assumes a person's age as one at birth), would have been in 1831. No expense or care had been spared to ensure that this work should be worthy of its illustrious subject, indeed, related as it was to a shrine of the reigning Tokugawa shogunate, it was mandatory that it should be seen to be a book of outstanding quality and prestige. The text, the calligraphy, the block-cutting, the fine covers blind-pressed with a design of pine saplings in bands of mist, are all exemplary; and the artists include leading masters of several schools, Aigai, Aiki, Chinnen, Chinzan, Hokuga and many others. Hokusai produced one of his grandest landscapes, of which the right-hand section is reproduced (pl. 194).

194 The Ryūzu waterfall. Signed Gakyōrōjin Manji in his seventy-second year. From *Nikkō-San Shi*, 1837

16 The 'One Hundred Views of Fuji'

In the early 1830s, Hokusai was at the height of his powers. An old but incredibly productive man of over seventy, he had behind him a series of achievements in a variety of styles, in painting, prints and illustrated books. At this zenith, he turned as to a monumental labour of love and homage to the preparation of a book of designs devoted to the 'Peerless Mountain'. From the first, it was conceived consciously as his masterwork: it was to be a final expression of faith such as another might have dedicated to a religious cause. It was to sum up his artistic philosophy and practice: it was to express the whole gamut of his experience, from the meanness of his fellow creatures toiling for a handful of rice, to the sublimity of the great mountain stark against the empty sky.

To appreciate Hokusai's book to the full we must know something of the veneration, amounting to idolatry, of this mountain peak among the Japanese. The bald geographical and geological facts about Mount Fuji are soon stated. A quiescent volcano, last active in 1707/8, it is 12,395 feet at Ken-ga-mine, the highest point of the crater wall at the summit, and is thus the highest mountain in Japan. In circumference, at the base, it is one hundred miles. In shape, seen from afar, it approximates to a cone, but the sides are not equal and each makes a sweeping catenary curve forming, with the broken apex, an asymmetrical pattern so utterly Japanese in spirit that one feels that if Fuji did not exist in actual fact, Japanese artists would have created it. Arising as it does, isolated in the midst of a broad plain, it is a dominant feature of the landscape of many surrounding districts, and a popular map is the *Fuji-mi Jūsanshū*, 'Thirteen Provinces whence Fuji can be viewed'. The ascent of Fuji, not particularly arduous or dangerous in the summer months, is a pilgrimage that every good Japanese makes at least once during his lifetime.

Fuji, in fact, has from earliest times been nothing less than an obsession with the Japanese. Other countries have natural features universally known within and beyond their borders – the Niagara Falls and the Table Mountain are instances that come to mind – but none of these has a significance to the inhabitants of the countries concerned comparable to that of Fuji to the Japanese. It is more than simply a symbol of the homeland; it is more than the abode of the gods, as Olympus was to the ancient

Greeks. It signifies the long history and the aspirations of the race; it is a token of all the scenic beauty of the land, and, by inference, represents the impressionability of the people to the beauties of nature. Among national symbols, perhaps the Statue of Liberty comes nearest to this summing up of a people's ideals, but that was man-made to represent those ideals.

Some of the first poems in the native language show that already, by the eighth century, Fuji was revered with superstitious awe. In the Nara anthology called *Manyōshū*, the 'Collection of One Thousand Leaves', is an anonymous poem that contains these lines:

'No words may tell of it, no name know I that is fit for it,
But a wondrous deity it surely is!
. . . It is the peace giver, it is the god, it is the treasure.
On the peak of Fuji, in the land of Suruga,
I never weary of gazing.'

The earliest scrolls in the true Japanese style of painting, the *Yamato-e* of the eleventh and twelfth centuries, contain memorable depictions of Fuji, isolated in grandeur, or as a back-drop to tempestuous events in the foreground. It is drawn with studied reverence, encircled with clouds that crown it as, in western painting, a nimbus marks a saintly head. In verse and scroll, it almost seems that as the new nation became aware of itself, Fuji was chosen as an emblem of artistic, as well as national, independence.

In the field of the decorative arts, especially in metal-work and lacquer, Fuji recurs again and again, on the large ink-box and on the exquisitely-made *inrō*, on sword-guard and stiletto-shaft, whether for writer or warrior, Fuji was equally appropriate. It is a favourite subject in landscape *netsuke*, accompanied sometimes by Saigyō, the medieval poet looking towards it for inspiration, or by Yoritomo, leader of the Minamoto clan in the twelfth century, shown boar-hunting with Nitta, his retainer, at the foot of the mountain. As one of the 'Three Lucky Things of which to Dream' (Fuji, falcon and egg-plant), Fuji often figured on *surimono*. It is a frequent motif in brocade pattern; in *bonzai* (dwarf gardens); in *bonga* (tray-pictures); in porcelain decoration, and in the ornament of practically everything the Japanese ever used or wore. It is like a signature tune denoting 'Japan'.

Hokusai was a sort of self-styled encyclopedist of Japanese life and custom. Birth, inclination and artistic gifts predestined him to such a function. He was steeped in the lore of his country, its traditions, its poetry, the associations of every place-name. Like Shakespeare, he makes us wonder how one so low born and so apparently ill-educated, could have attained to so universal a knowledge. Hardly any aspect of life in the diverse provinces that make up Japan escaped his notice, and it is not surprising that the form of Fuji appears as a *leit-motif* in his work from the very first book-illustrations of the 1780s to the last drawings of his old age, nearly seventy years later.

The *Fugaku Hyakkei*, 'One Hundred Views of Fuji', is printed in monochrome, but so exquisitely that the gradations of the black and grey of the ink give the effect of a

195 Wrapper of Volume 1 of
Fugaku Hyakkei, 1834

wider range of colour. The principal block-cutter, Egawa Tomekichi, was one whom Hokusai especially admired for his skill. Only the first edition of each of the first and second volumes is printed in this superfine way and does complete justice to the splendid designs. The first edition of Volume 1, which appeared in 1834, bears a title label on which the name is inscribed in a cartouche in the form of a feather, and it was issued in a *fukuro* (pl. 195) depicting a falcon. These features have led to it being called the 'Falcon's Feather' edition. Its covers are salmon pink, and embossed with a landscape design. The colophon bears the proud inscription 'Seventy-five years old, formerly Hokusai Iitsu, now changing his name to Old Man Mad about Drawing, Manji', and has a red seal with a stylized Fuji in white reserve. The second volume is dated 1835, and has similarly distinguishing label and covers, signature and seal. The third volume, for a reason never explained, was not published until after a long interval, in fact, on the evidence of the Introduction (for the volume is undated), not until Hokusai had 'outlived his ninetieth year'. This can only mean in 1849 when, by Japanese computation, Hokusai was ninety: the year of his death. By that time, the standard of printing had fallen below the extreme refinement of the first two volumes. At the issue of the third volume, the first and second volumes were reprinted, and there is a marked difference in the impressions of the 1834/35 editions and the 1849.

As to the title of the work, an obvious question arises. Why 'One Hundred Views of Fuji'? Why, in the earlier colour-printed set of broadsheets, 'Thirty-six Views'? It is one of the more curious foibles of the Japanese that they should have adopted a set number for categories as diverse as ancient poets, natural landscape features, or events in the lives of the saints. There are the 'Six Jewel Rivers'; the 'Eight Views of Ōmi'; the 'Seven Scenes from the Life of Ono-no-Komachi', the poetess; the 'Twenty-four Examples of Filial Piety'; and so on. We ourselves are not immune from a similar sort of reliance on the magic of numbers – there are the 'Seven Wonders of the World' and the 'Nine Worthies', for instance – but with the Japanese (and the Chinese for that matter), these groupings are much more common. The establishment of the canon, the fixing of the runic number, is invariably traced back to a remote antiquity. The orthodox number of 'Views of Fuji' became fixed at thirty-six or one hundred, but nobody seems to know when or how. It is rather a coincidence that two of the numerical categories most frequently referred to are the 'Thirty-six Poets of Antiquity', and the 'One Hundred Poems by One Hundred Poets', and it may be that the 'Views of Fuji' were linked to these: it would be quite in keeping with the national flair for associating incompatibles – they personified the 'Fifty-three Stations of the Tokaido' with portraits of reigning beauties, and thought nothing of turning the 'Eight Views of Lake Biwa' into 'Eight Views of Elegant Boudoirs'.

The preface to the first volume of Hokusai's book refers to the 'One Hundred Chapters on Fuji' by Keichū, and the 'One Hundred Sections on Fuji' by Tōko, and might have gone on, more appositely, to draw attention to another artist's 'One Hundred Views'. These are by Minsetsu, a minor artist of the Kanō school, and appeared in an ink-printed book published in 1785, when Hokusai was a young man of twenty-five. It is more than likely that the book was known to him, and may even have

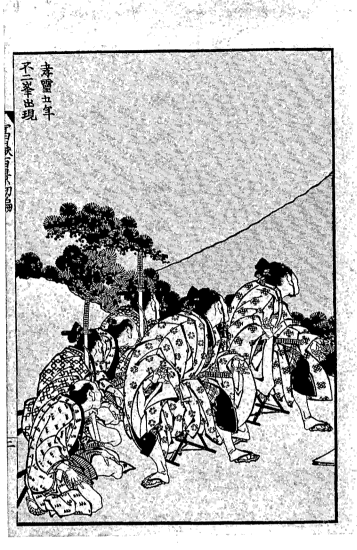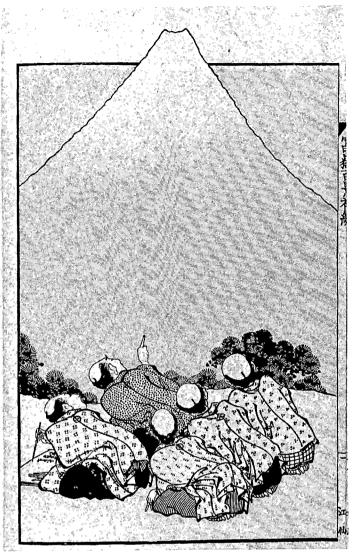

196 'The Manifestation of the Peak of Fuji in the fifth year of Kōrei, 285 B.C.' From *Fugaku Hyakkei*, Volume 1, 1834

been remembered by him when he came to compose his own 'One Hundred Views'. But a comparison, if one can be made at all between the two versions, would only be to point out the orthodoxy of Minsetsu's unimaginative prints and the extreme originality of Hokusai's.

For Hokusai's 'Views' are nothing more or less than the pictorial setting of an obsession. There is a quiet opening to the first volume, a picture of the 'Sublime Goddess, Bringer of Fruit and Flowers', serves as a prologue that hints at the genesis of the mountain from the chaos and mists of antiquity. The next picture shows the mythical creation of the mountain, an event supposed to have taken place in the year corresponding to 285 B.C. (pl. 196). From then on, the theme having been announced, Hokusai uses it like the great composer he was, bringing it into the foreground with sonorous brass, or veiling it with contrapuntal themes that all but disguise it, digressing only very infrequently with a reference to legend or history. Fuji straddles right across the page (pl. 198), or recedes to the far distance; it is white against a dark sky, or black under sunset clouds; it is seen through the stems of bamboo (pl. 200), or through the strips of dyed cloth hanging on poles to dry, or between the umbrellas in a makers yard (pl. 197). It is even seen as a reflection in lake or sea, and once, with typical Hokusai whimsicality, upside down in the wine cup of an old tippler (pl. 199).

197 Fuji seen from an umbrella-maker's yard in Aoyama.
From *Fugaku Hyakkei*, Volume 3, *c.* 1849

198 Fuji in clear weather.
From *Fugaku Hyakkei*, Volume 1, 1834

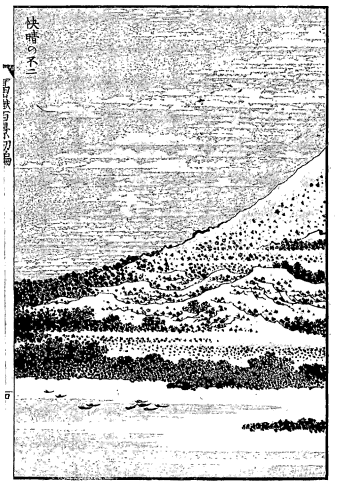

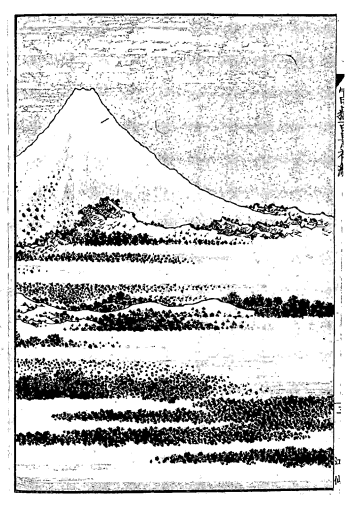

199 'All Fuji in a sake-cup'.
From *Fugaku Hyakkei*,
Volume 2, 1835

200 Fuji seen through a
bamboo grove.
From *Fugaku Hyakkei*,
Volume 2, 1835

201 Fuji through a summer downpour.
From *Fugaku Hyakkei*, Volume 2, 1835

The technique is almost that of the motion picture. We are switched from viewpoint to viewpoint, with a deliberate choice of 'angle'. Such a technique, for all the wealth of incident, focusses our attention on the mountain, so insists on its inevitability that when it is not prominent our eyes search for it. Everything revolves around that cone of volcanic rock. The mood and tempo change as swiftly as the viewpoint, from the sublime to the trivial, from the slow pace of peasants trudging under heavy loads, to the dash of a great wave breaking in a crest of foam. The element of surprise, the trick of astounding us, is another of Hokusai's stratagems. Fuji is glimpsed through the mesh of a fisherman's net, or beneath the arch of a bridge, faintly through a downpour of rain (pl. 201), or framed in a hole in a rock. The excitement of the Japanese in catching sight of the mountain is conveyed a number of times, best of all in the picture entitled 'The first *kakemono* of Fuji', where an old man flings out his hands in ecstasy at the vision of Fuji framed, like a hanging picture, in a circular window (pl. 202). Occasionally, one almost hears the impresario's roll of drums, the clap of thunder that precedes a stupendous feat of showmanship: most powerful of these, I think, is the dazzling vision of Fuji and a village at its foot caught in the blinding flash of lightning during a gale (pl. 203).

By great good fortune, a number of Hokusai's original sketches, first thoughts for illustrations of this book, have survived. This remarkable drawing (pl. 204) was the inspiration that led to the lightning-flash view of Fuji just mentioned: a drawing in inks of two colours, black and red, that was marvellously interpreted in the shades of *sumi* that was all the printer had at his disposal. It is immensely exciting, thus, to witness the genesis of some of the finest of the 'One Hundred Views'. Among them is the first idea

202 Fuji framed in a circular
window.
From *Fugaku Hyakkei*,
Volume 2, 1835

for the highly imaginative treatment for an age-old, not to say hackneyed, theme, the
'dragon of the storm', which is shown here with the resultant print (pls. 205 & 206). In
another strange composition, the poet Kakinomoto views Fuji across the salt-pans of
Matsuho. Hokusai insisted from the outset on separating the medieval poet from the
village he had immortalized in a verse with a patterned fabric design intended to denote
the passage of the centuries: he was not interested in the topography of Matsuho, that
only emerged in later studies (pls. 207, 208).

203 Thunderstorm over
Fuji.
From *Fugaku Hyakkei*,
Volume 2, 1835

204 First sketch for the
thunderstorm over Fuji in
Fugaku Hyakkei, Volume 2,
1835

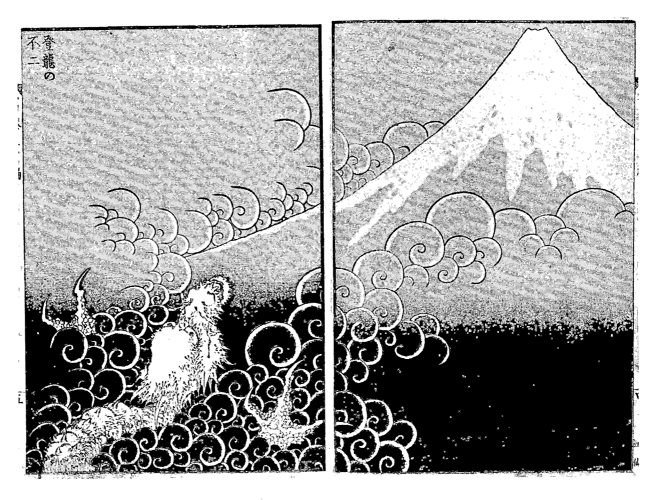

205 The dragon of the storm.
From *Fugaku Hyakkei*, Volume 2, 1835

206 First sketch for the dragon of the storm in *Fugaku Hyakkei*, Volume 2, 1835

One could dwell on the devices employed by Hokusai to gain his effects, to hold our attention, to display his virtuosity, but it is doubtful if it would bring us any nearer to accounting for the affection and the admiration that we have for this collection of prints. Nor is it style, nor skilful draughtsmanship, nor a genius for *mise-en-page*, that give the 'One Hundred Views' its universal acceptance: ultimately, it is the human element, the feeling that these are *peopled* landscapes, that beneath this sublime peak and upon its slopes, men and women, mostly of a humble, near-to-earth order, are living out their lives. It is what we call the 'common touch', which Hokusai, like Rembrandt, unknowingly possessed. The men and women are not quite in our likeness – they have an anatomy and a physiognomy devised as much by Hokusai as by mother nature – but the fishermen, woodmen, coopers, tea-pickers, builders, boatmen, sign-writers, umbrella-makers, the revellers, the pilgrims, the travellers, all are recognizably fellow human beings, enlisting our sympathy or raising our laughter.

The human element is not entirely lacking, even in those half-dozen or so prints from which man and his works are absent, when we are shown Fuji in the majesty of

207 The poet Kakinomoto-no-Hiromaro and Fuji. From *Fugaku Hyakkei*, Volume 2, 1835

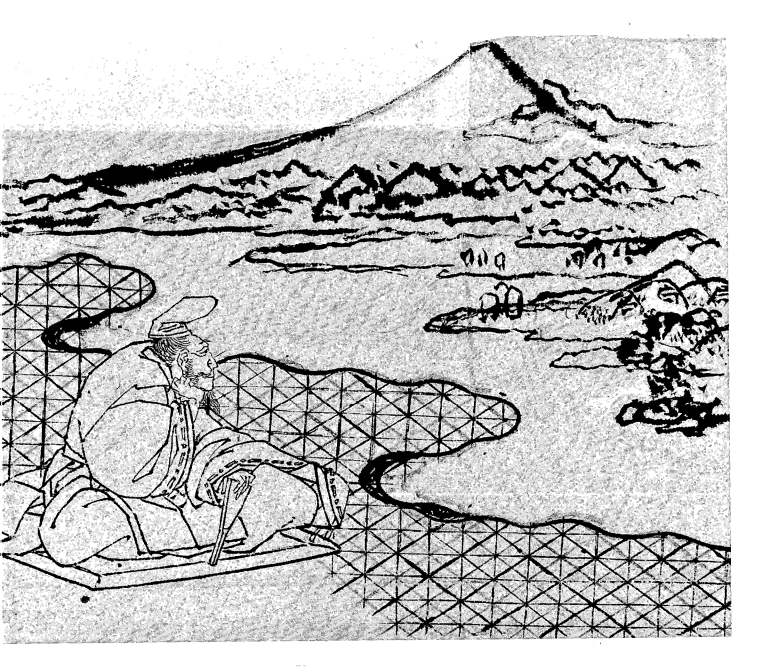

208 First sketch for the poet
Kakinomoto-no-Hiromaro
and Fuji in *Fugaku Hyakkei*,
Volume 2, 1835

isolation against a sky barred with cloud or across a great waste of grasses under a full moon: for the mind retains the memory of the poorly-clad peasants and artisans who people other pages of the book, and it occurs to us that the sublimity of the mountain, the awe that these great sketches of landscape inspire in us, were felt also by the humble toilers and travellers at the sight of the actual Fuji. Hokusai has left them out of these pictures and conveyed instead the uplift that the sight of the mountain brought to them, the sigh of wonder at the beauty of the land they lived in.

Hokusai, we can be sure, had no preconceived philosophic intent in depicting the life of these poor people against the immutable shape of Fuji, and yet the 'Peerless Mountain' becomes in this series of prints a symbol of permanency underlining the transience of the men and women of the 'Floating World' who gaze up to it with such reverence. Looked at in this way, it is far more than simply 'One Hundred Views of Fuji': it becomes a commentary on man's relationship to nature, and assumes the stature of an epic.

17 The 'Warrior' Trilogy, the 'Tōshisen' and the Final Decade, 1840~1849

Hokusai has often been praised as the greatest of the Ukiyo-e artists, but in fact the larger part of his work is anything but Ukiyo-e either in subject or treatment. This is particularly the case with his historical or 'warrior' prints, *musha-e*, which are almost invariably concerned with the heroes of the past, with battles and events that by his time were legendary or proverbial. But though the very antithesis to the 'Floating World' pictures of current affairs and fashions in the *demi-monde*, the historical prints were addressed to more or less the same audience and amounted at least to 'popular art' if not actually Ukiyo-e.

There was undoubtedly a taste for books and prints that saluted the virility and valour of the Japanese warrior class. The long peace imposed on the country by the Tokugawa rule had given little exercise to the martial spirit, but it had suppressed rather than extinguished it. The demand for highly-coloured stories based on the exploits of heroes like Yoshitsune, Tametomo and Kagesue, and for the equally imaginative illustration in painting and print of the brave deeds of such giants of the past, showed that manly attributes were still an essential concomitant of the *beau ideal* conceived by the stay-at-home and by now somewhat effete Edoites.

Hokusai was a master of the *musha-e*, and in 1836, two powerful ink-printed *ehon* were published: *(Wakan) Ehon Sakigake*, 'Picture-book of Leaders of China and Japan' in the seventh month, and *Ehon Musashi Abumi*, 'Picture-book of the Stirrups of Musashi' in the following month. He wrote the preface to the first book himself, and in it prides himself on showing the movements of the human body when wearing heavy armour. But that is not the first thing we notice: in a print like that of Amatsu-no-Koyane-no-Mito warding off the evil Iwanagahime with a magic mirror (pl. 209) it is the dramatic composition, and the richness of the texture of the woodblock-printing that impresses us; and the imaginative treatment of the apparition of the ghost-bird to Oki-no-Jirōemon Hiroari is one of a number of instances that reminds us how compelling Hokusai is as an illustrator (pl. 210). In *Musashi Abumi*, the glowering expressions of the warriors tend to become more stylized, and the embroglios of armour and weapon almost abstract in the manner that Hokusai whirls them about the page. Plate 211 shows Oyamada Tarō Takaie demonstrating a feat of arms which was

expected of warriors of his prowess, with a sword in either hand he is depicted cutting to pieces the arrows with which he was being assailed by the enemy. One can imagine the average town-dweller, pursuing his humdrum occupation, identifying himself with this concept of the 'happy Warrior', 'Who is he that every man in arms should wish to be'. Plate 212 depicts an incident in the interminable wars between the Minamoto and Taira factions which provided the quasi-historical background for the battle-pieces of Hokusai, and also for his contemporary peer in this sphere of print-making, Utagawa Kuniyoshi. The priest Ichirai, one of those who had sided with Minamoto-no-Yorimasa, is seen escaping from his pursuer by making a prodigious leap from one beam of the shattered Uji Bridge to another.

210 Oki-no-Jirōemon and the ghost-bird.
From (Wakan) Ehon Sakigake, 1836

211 Oyamada Tarō Takaie defying the enemy archers. From *Ehon Musashi Abumi*, 1836

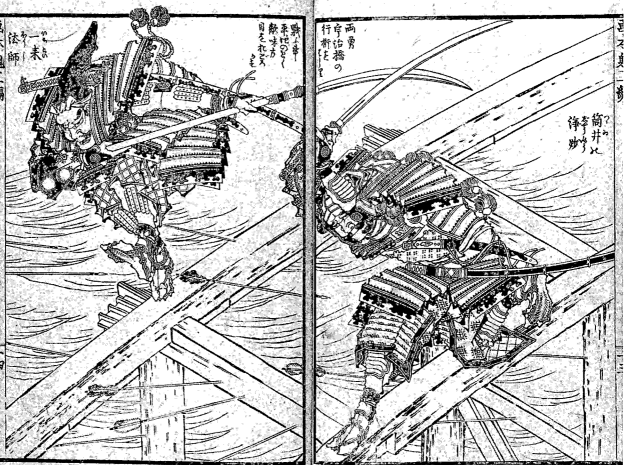

212 The escape of the priest chirai at Uji Bridge. From *(Wakan) Ehon Sakigake*, 1836

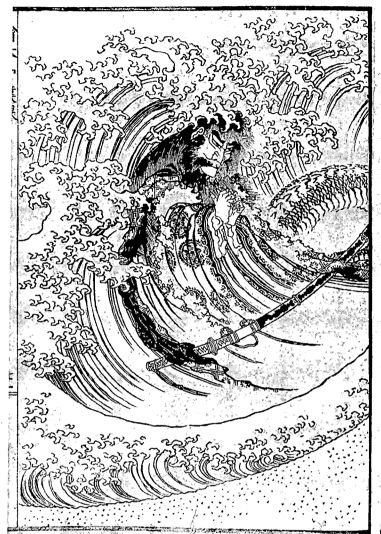

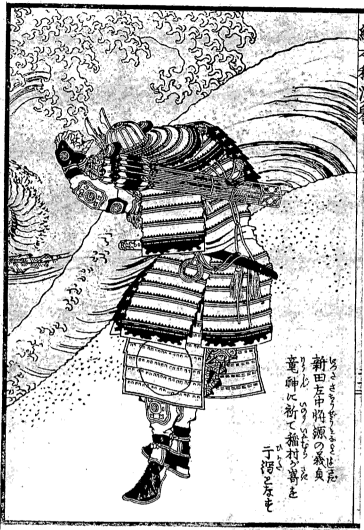

214 Nitta-no-Yoshisada praying to the sea-god to cause the sea to retreat at Inamura-ga-saki in the attack on Kamakura during the revolt against Takatori. From *(Wakan) Ehon Sakigake*, 1836

213 The feat of Kamada Matahachi. From *Ehon Wakan-no-Homare*, 1850

The third book in what can be considered a trilogy of the warrior genre was apparently designed first, but not printed until 1850, the year after Hokusai's death. The last design of *Ehon Wakan-no-Homare* 'The Picture Book of the Glories of China and Japan' shows Kamada Matahachi (best known for his exploit in killing a *nekomata*, a magic 'tiger-cat', with his sword), demonstrating his power by writing the title with a brush at the end of a rolled-up mat; and it is signed by Hokusai 'in his seventy-sixth year (i.e. in 1835; pl. 213). But no copy of the book is known with a colophon date earlier than 1850, and the title-page inside the front cover also bears that date. It is conceivable that the drawings for the three books were ready for publication at the same time in 1836, but that for some reason the blocks were only cut for the *Sakigake* and *Musashi Abumi*. Then, perhaps because of a falling-off in public demand, the third volume was deferred, and only eventually produced, by a different publisher, in the year after Hokusai's death, when there could well have been a new surge of demand for works by Hokusai. Egawa Tomekichi, the block-cutter most highly thought of by Hokusai, was responsible for the prints in the first two books, but it was his son, Egawa Sentarō, who cut the blocks for *Wakan-no-Homare* – further corroboration for the 1850 publication date. This last book was printed with an additional grey block and the cutting and printing are both of high quality for the period (pls. 214, 215).

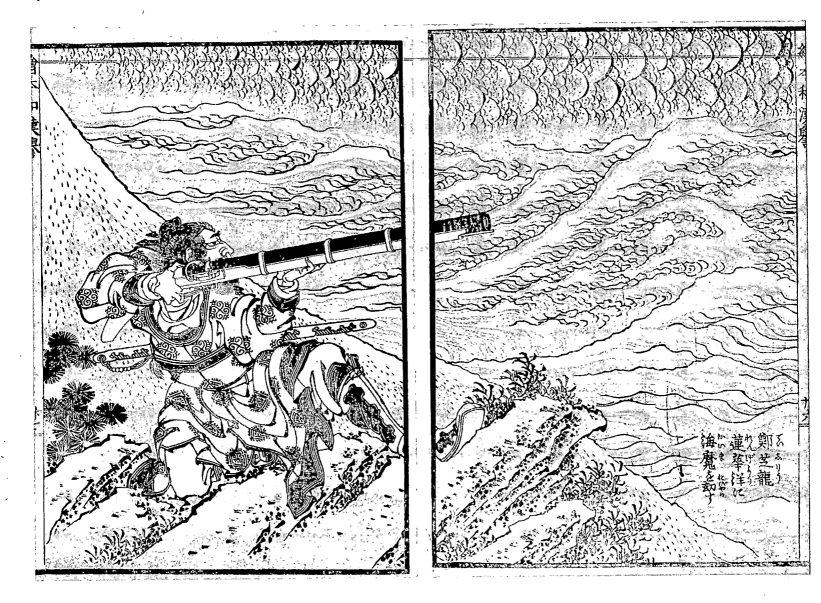

Yet despite the virtuosity of Hokusai apparent in almost every print in the long series making up the three books, of all his major works they least appeal to our taste today. There is a surfeit of bravery and bravado, a sense of having 'supp'd full with horrors', and a lack of sympathy for either the villains or the heroes, whose monstrous armour – for all Hokusai's protestations – encumbers the bearers and gives them the grotesque movements of Sicilian puppets. Yet the volumes were in no sense pot-boilers: Hokusai obviously took this kind of subject seriously, and countless brush-drawn sketches prove that he created them quite unprompted, and with a sort of convinction that we may find difficult to understand.

215 The Ming warrior Tei Shiryu and the devil of the deep sea.
From *(Wakan) Ehon Sakigake*, 1836

216 The outer wall of a palace.
From *Tōshisen Ehon Gogon-zekku*, 1833

217 Priest and servant.
From *Tōshisen Ehon Gogon-zekku*, 1833

Almost simultaneously with the warrior trilogy, Hokusai was at work on another commission that he must have undertaken with some pride. As early as 1788, the publisher Kobayashi Shimbei had begun a series of books entitled *Tōshisen Ehon*, 'Illustrated Chinese Poems'. This first part was illustrated by Tachibana Sekihō in patently Chinese style, perhaps even making copies from Chinese originals. In 1790 the second part appeared, illustrated by Suzuki Fuyō, a recognized Nanga artist; in 1791, the third, illustrated by Takata Enjō of the Kanō school; in 1793, the fourth, illustrated by Shigemasa, who adopted a pseudo-Chinese style, quite different from his normal Ukiyo-e manner, for the occasion. Then there was a long break (during which some of

218 Boats off a rocky coast.
From *Tōshisen Ehon Gogon-
zekku*, 1833

the earlier sets were reprinted) before the fifth part was published, in 1832, with illustrations by Komatsubara Suikei, who had obviously been chosen for his Chinese manner. It was at this date that Hokusai was invited to illustrate the two final parts of this monumental publishing undertaking. The preface to the sixth part, by Takai Ranzan, was written in 1832, the book being published in the following year. The seventh, and final, part was published in 1836.

The publishers could not have chosen a more fitting illustrator for these early, T'ang, poems, which appeared with translations into Japanese *hiragana* and explanatory commentaries. Hokusai had developed his own unmistakable idiom for Chinese subjects in the immensely long Suikoden novel that, begun in 1805, continued to occupy him, on and off, until 1835. The Tōshisen series were allied stylistically to the Suikoden prints, but now Hokusai was able to develop a more contemplative, poetic strain that gives the two sets of five volumes a sense of repose consistently lacking in the Suikoden, with landscapes in sparse outline that are intriguing and evocative beyond the powers of all the former illustrators. Occasionally, there is call for a scene of violent action, but usually the mood of the poems enjoins a quieter, less strenuous treatment than the novel (pls. 216, 219/220).

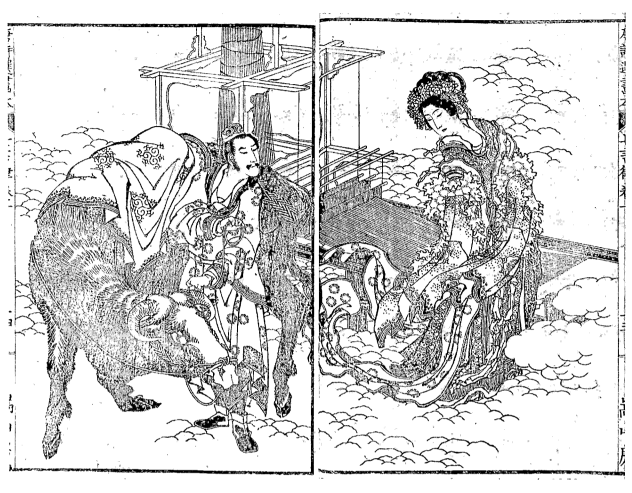

219 Chih Nü, the 'weaver' and the herdsman K'ien Niu (the origin of the Japanese Tanabata festival).
From *Tōshisen Ehon Shichigonzekku*, 1836

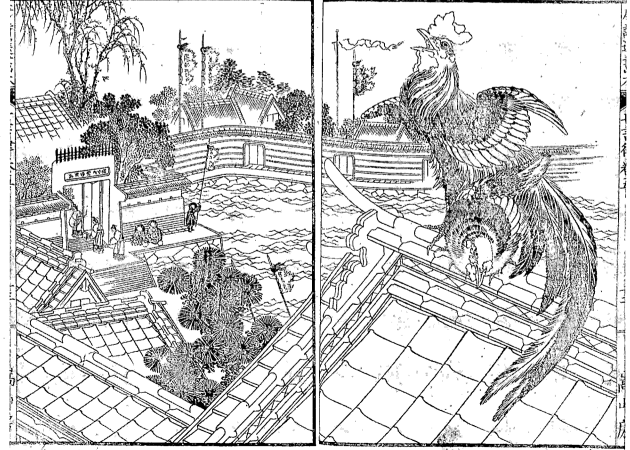

220 Gaining passage over the border by means of arousing cocks and causing them to crow.
From *Tōshisen Ehon Shichigonzekku*, 1836

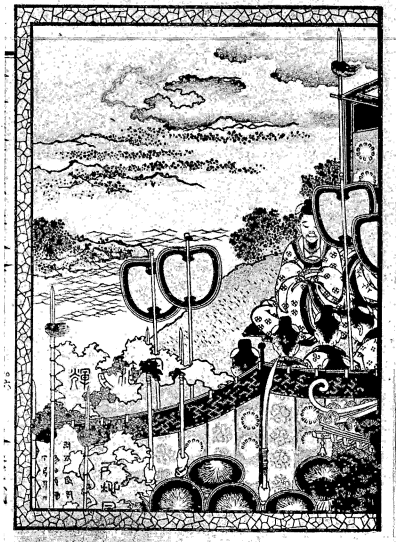

The *Ehon Kanso Gundan*, a novel published in two parts, each of ten volumes, in 1843 and 1845, combines the two forms of Hokusai's work in the Chinese idiom. Sadataka's novel has to do with Chinese imperial wars and, as in the Suikoden, Hokusai successfully creates an illusion of an alien country – remote, unreal, and yet believable as a setting for extraordinary events. The opening pages of the first pages of each set of ten volumes are elaborately printed in *sumi* of various shades, and are among the finest specimens of monochrome printing of the period (pl. 221). Throughout this long novel, Hokusai constantly creates prints of splendid invention and power. The mounted warrior engulfed in a sea that throws up a dragon in the hollow of a wave is typical (pl. 222).

There were other books of a somewhat similar character published in the 1840s. There is *Wakan Inshitsu Den* (1840), a 'History of the Hidden Protection of China and Japan', with the meaning that heaven works in mysterious ways to look after its own people; and a 'Pictorial History of Shakyamuni', *Shaka Go-ichi-dai-ki Zue* (1845), where

221 The Emperor T'ai Shih on a journey sees a strange cloud in the south-east. From *Ehon Kanso Gundan*, Part I, 1843

222 Mounted warrior engulfed by a wave and confronted by a dragon. From *Ehon Kanso Gundan*, Part I, 1843

Hokusai does his best to conform to a semi-religious text without, one senses, the same enthusiasm that renders his illustrations to the Chinese-type novels so stirring.

In 1843 there was a revival of the *Manga*-type miscellany in a book that appeared under two titles: printed in shades of *sumi*, it was entitled *Manji-Ō Sōhitsu Gafu* 'The Book of Cursive Drawings by Old Man Manji'; and, in colour, *Hokusai Manga: Sōhitsu-no-Bu*, 'Rough Sketches by Hokusai: Cursive Drawings Section'. There is a preface by Kagetoshi dated 1832 which appears in both versions, but no existing copies, so far as I have been able to trace, have a publication date earlier than 1843, and there is no explanation for the considerable delay between the writing of the preface and the issue of the book. It is a disappointing work compared, say, with the *Gashiki* of 1819 or the *Soga* of 1820 with which it has most in common, and though the collaboration of pupils is not acknowledged, as it often is in similar earlier volumes, it seems more than likely that they had a hand in the preparation of the designs for the block-cutters. There is a certain coarseness and ineptitude in some of the prints that is certainly not to be

223 Owl asleep.
From *Hokusai Manga: Sōhitsu-no-Bu*, 1843

なら あき
奈良此秋

224 Autumn at Nara.
From *Hokusai Manga: Sōhitsu-no-Bu*, 1843

detected in the artist's paintings and drawings of the last decades of his life, and the colour-printing in the colour version is crude. The germ of the 'Autumn at Nara' (pl. 224), for instance, may have been a drawing by Hokusai, but the detail, such as the gardener's right hand, bespeaks a pupil's copy; and the owl in his nightcap (reproduced in colour for comparison with earlier specimens (pl. 223)) could almost have been designed for the western tourist later in the century. In fact, this particular book was among those reprinted, assuredly for foreign buyers, in 1892, when it appeared under yet another title, *Hokusai Gaen* 'The Garden of Drawings by Hokusai'. Its first part consisted of a reprint of the colour version of *Sōhitsu-no-Bu*, with a second part that was a compilation of material much of which had no possible connection with Hokusai at all.

Another frequently met reprint should be mentioned here: the three-volume *Hokusai Gafu*, the third volume of which has a preface dated 1849. It consists of reprints from the outline blocks formerly used for the *Hokusai Gashiki* of 1819 and the *Hokusai Soga* of 1820, with additional blocks cut for rose and blue tints. It is a rather cheap-looking production, the printing and paper much inferior in comparison with the earlier books, the colour in particular being distressingly bad.

Hokusai's main work as an artist of the book was now almost over. One curious development of the late 1840s was his association with other artists, mainly of the Utagawa school, in a series of small, indifferently produced, poetry books, under such titles as 'One Poem from One Hundred Brave Men' or 'One Poem from One Hundred Men and Women of Refinement' (pl. 225). He seems to have been accorded the position of *doyen* (as well he might be in his mid-eighties) and was obviously given the place of honour in each of the volumes, providing the designs for the first few prints that were printed in two tones of *sumi*, whereas the remainder of the illustrations were in outline only. But artistically, these annual volumes (listed in the Appendix) are of

225 Travellers on the road above the shrine of the poet Hitomaro. Signed eighty-eight-year-old Manji. From *Shūga Hyakunin Isshu*, 1848

226 Fire-watching tower.
Signed eighty-eight-year-old
Manji.
From *Sōzan Chobun Kishū*,
1850

little note, and reveal the extent to which standards, both in public taste and in book production, had fallen since Hokusai's *kyōka* books described in the earlier chapters of this book.

Another unexpected place to find a contribution from Hokusai is in an odd miscellany perfectly summed up by the title 'A Collection of Strange Tales Overheard by Shōzan'. Hokusai's drawing, which is dull enough, is of three men in the look-out post of a fire-watching tower, exclaiming at the sight of an immense spider's web spun across the upper storey of the structure. It is dated in Hokusai's eighty-eighth year (1847) though the book seems not to have been published until 1850 (pl. 226).

227 Frontispiece to *Ehon Saishiki Tsū*, 1848

228 The white *hō-ō* bird.
From *Ehon Saishiki Tsū*, 1848

The only book of real interest in these last years of Hokusai's life is the 'Illustrated Book on the Method of Painting in Colours', *Ehon Saishiki Tsū*, published in 1848. There had been other earlier books of his touching on the art of painting, but none amounted to a serious manual of instruction such as this, written and illustrated by the artist as he approached his eighty-ninth year. The frontispiece is Hokusai's caricature of the virtuoso painter: he is seen inscribing the title of the book with a brush not only in either hand, but in the prehensile toes of either foot (pl. 227). The preface is an unusually matter-of-fact outline of the purpose of the book: it was to teach discrimination in the use of colours, and in the handling of the circle, the square, and lines straight or curved; it was to enable children to render the violence of the sea, the speed of a torrent, the serenity of lakes, the weaknesses and strengths of the living creatures of the world. The illustrations, even when they are no more than diagrammatic, have all the artist's individuality, and because this is an instructional manual, we do not complain when the text surrounds the pictorial explanations (pl. 228). Some of the demonstrations remind us of a virtuoso musician at a 'master class' who is as much intent on exhibiting his own skills as in encouraging pupils to emulate his methods (pl. 229).

229 Methods of painting insects, petals and dappled deer.
From *Ehon Saishiki Tsū*, 1848

In the second volume of this book, Hokusai talks of the Dutch method of printing from etched copper plates, and promises that he will explain it in a further volume: but he died in the following year without fulfilling his intention.

As can be seen from the books described in this chapter, the last years of Hokusai's life were the least productive of memorable book-illustrations. Yet this was the period when he painted many of his finest pictures, paintings almost invariably dated and showing no sign of a decline in his powers even to the last months of his life. Possibly he conserved his energies for these works, which in any case made less demands upon his eyes than the small scale, and the number, of drawings needed for the illustration of books. Perhaps, too, he was conscious that he was no longer so splendidly served by the block-cutters and printers, his collaborators in any book production; and disappointed with the acquiescence of the publishers in standards that he, more than any, recognized as relatively debased. For he could look back over a career extending over almost seventy years, during which there was hardly a year when he had not been concerned in the creation of one or more *ehon* or *gafu*, or the illustration, wholly or in part, of other kinds of book: he had himself been trained as a block-cutter, and had a wider experience of the wood-block print than any man alive. He knew that the greatest triumphs of the Japanese illustrated book had ended in the 1830s, with his own 'One Hundred Views of Fuji', the 'Warrior' trilogy, and the *Tōshisen* series.

List of Illustrations

Select Bibliography

This list is confined to publications that deal in more depth or more specifically with Hokusai's book-illustrations than is normal in general studies of the artist, and to others to which reference is made in the text.

ANON, *Japanische Erotik, Sechsunddreisig Holzschnitts von Moronobu, Harunobu, Utamaro* (Leipzig, 1907).

ASAKURA, KAMEZŌ, *Nihon Shōsetsu Nenpyō, shinshū* (rev. edn.), 'Chronology of Japanese Fiction' (Tokyo, 1926).

ASTON, W. G., *A History of Japanese Literature* (London, 1899).

BROWN, L. N., *Block Printing and Book Illustration in Japan* (London, 1924).

DICKINS, F. W., *Fugaku Hiyaku-kei or a Hundred Views of Fuji (Fusiyama) : by Hokusai* (London, 1880).

DICKINS, F. W., *One Hundred Views of Fuji*. Introduction by J. Hillier (New York, 1958).

DURÈT, T., *Catalogue des livres et albums illustrés du Japon de la Collection Duret au Cabinet des Estampes* (Paris, 1900).

EVANS, T. AND M., *Shunga: The Art of Love in Japan* (London, 1975).

GONCOURT, E. de, *Hokousaï* (Paris, 1896).

GONCOURT, E. de, 'Hokousaï. Ses albums traitant de la peinture et du dessin, avec ses prefaces', *Gazette des Beaux-Arts* (Paris, 1895).

HAVILAND, *Collection Ch. Haviland, Dix-huitième Vente: Estampes Japonaises Livres Illustrés*. Sale Catalogue (Paris, June 1927).

HAYASHI, YOSHIKAZU, *Empon Kenkyū: Hokusai* (Study of Erotic Books: Hokusai) (Tokyo, 1968).

HAYASHI, YOSHIKAZU, 'Two Rarities of Hokusai's Shunga', in *Ukiyo-e* No. 65 (Tokyo, 1976).

HILLIER, J., *The Harari Collection of Japanese Paintings and Drawings* (London, 1970 and 1973).

HILLIER, J. *Hokusai: Paintings, Drawings, Woodcuts* (London, 1955).

HILLIER, J. AND SUZUKI, JŪZŌ, 'The Hokusai/Ryūkōsai *Hyōsui Kiga* and *Ehon Ryōhitsu*', *Ukiyo-e Art*, No. 13 (Tokyo, 1966).

Kokusho sōmokuroku: General List of the Nation's Literature (Tokyo, 1963–77).

IIJIMA, HANJŪRŌ: *Katsushika Hokusai Den* (Tokyo, 1893).

Hokusai Kenkyū (Hokusai Studies), various authors (Tokyo, 1972 ff.).

KRAUSS, F. S., *Das Geschlechtleben in Glauben, Sitte, Brauch und Gewohnheitrecht der Japaner* (Leipzig, 1907).

LANE, R., 'A Preliminary Catalogue of Hokusai's *Shunga* Prints, Albums and Books', in *Ukiyo-e*, Special Number (Tokyo, 1977).

LANE, R., *Hokusai and Hiroshige* (Tokyo, Baltimore and Köln. 1977).

LANE, R., *Images from the Floating World* (Oxford, London and Melbourne, 1978).

LANE, R., *Masters of the Japanese Print* (London and New York, 1962).

LANE, R. and others, *Erotic Art of the East* (London, 1973).

MARCO, FAGIOLI, *Hokusai: Wakan Ehon Sakigake* (Florence, 1978).

MICHENER, J. A., *The Floating World. The Story of Japanese Prints* (New York, 1954).

MICHENER, J. A., *The Hokusai Sketchbooks: Selections from the Manga* (Rutland, Vt. and Tokyo, 1958).

MIZUTANI, FUTŌ, *Kohan Shōsetsu Sōga Shi* (A History of Early Illustrated Fiction) (Tokyo, 1936).

NAKATA, KATSUNOSUKE, *Ehon-no-Kenkyū* (A Study of Picture-books) (Tokyo, 1950).

NARAZAKI, MUNESHIGE, *Hokusai Ron* (A Discourse on Hokusai) (Tokyo, 1944).

NODA, MOTOO, 'The Expressive Words of Hokusai's "Tsumagasane"', in *Ukiyo-e*, No. 71 (Tokyo, 1977).

ODA, KAZUMA, *Ukiyo-e to Sashi-e Geijutsu* (*Ukiyo-e* and the Art of Illustration) (Tokyo, 1931).

OUWEHAND, C., 'An Annotated Description of Hokusai's *Shūga Ichiran*', in *Mededelingen van het Rijksmuseum voor Volkenkunde, Leiden*, No. 15 (Leiden, 1962).

PONCETTON, F., *L'Estampe Érotique du Japon* (Paris, 1927).

REVON, H., *Étude sur Hok'sai* (Paris, 1896).

SEIJI, NAGATA, *Hokusai Manga-no-Kenkyū* (Study of Hokusai's *Manga*), in *Ukiyo-e Art*, No. 47 (Tokyo, 1975).

SHIBUI, KIYOSHI, *Genroku Kohanga Shūei* ('Estampes Érotiques Primitives du Japon') (Tokyo, 1926 and 1928).

SHIBUI, KIYOSHI, *Ukiyo-e Naisi* (inner history of *Ukiyo-e*) (Tokyo, 1932 and 1933).

SIEBOLD, P. F. von, *Nippon Archiv zur Beschreibung von Japon* (Leiden, 1831).

SUZUKI, JŪZŌ and others, *Hokusai Yomihon Sashie Shūsei* (Compendium of Hokusai's Illustrations to Novels) (Tokyo, 1971–73).

SUZUKI, JŪZŌ and others, *Zaigai Hihō: Hokusai* (Treasures in Foreign Collections: Hokusai) (Tokyo, 1972).

TODA, K., *Descriptive Catalogue of Japanese and Chinese illustrated books in the Ryerson Library of the Art Institute, Chicago* (Chicago, 1931).

TOGASAKI, FUMIKO, 'Certain aspects of the basic compositional elements in Hokusai's work – "the Law of the Three Divisions" and "the Method of Ruler and Compass"', in *Ukiyo-e Art*, Nos. 51 and 52 (Tokyo, 1976).

YASUDA, GOZŌ, *Gakyō Hokusai* (Tokyo, 1971).

YASUDA, GOZŌ, '*Hokusai Shōki-no-Kibyōshi*' (Hokusai's Early *Kibyōshi*), in *Ukiyo-e Art*, No. 25 (1970) and No. 29 (1971).

YASUDA, GOZŌ: 'Hokusai's *Kibyōshi*' (Parts 3 and 4), in *Ukiyo-e Art*, Nos. 42 and 43 (Tokyo, 1974).

YASUDA, GOZŌ, 'Hokusai's *Kibyōshi*' (Part 5: a Study of Tokitarō and Kakō), in *Ukiyo-e Art*, No. 54 (Tokyo, 1977).

Appendix
Chronological List of Books with Illustrations by Hokusai

Where possible, corroborative references have been given in brackets at the end of each entry, abbreviated titles being given in full below and the books more fully detailed in the Select Bibliography:

BROWN: *Block Printing and Book Illustration in Japan.*

KS. *Kokusho Sōmokuroku*

LANE: *Images from the Floating World*

NARAZAKI: *Hokusai Ron*

RYERSON: *Descriptive Catalogue of Japanese and Chinese Illustrated Books in the Ryerson Library of the Art Institute, Chicago.*

YH: Yoshikazu, Hayashi: *Empon Kenkyū: Hokusai*

ZH: Suzuki, Jūzō: *Hokusai Nenfu* ('Chronological List') in *Zaihai Hihō*

Not every Hokusai book has been available for inspection and where the only reference is in western sale catalogues or other literature, it has not been possible to provide the Japanese *kanji* for the titles.

1 *Nichiren Ichidaiki* 日 蓮 一 代 記
 Kibyōshi. Signed Katsukawa Shunrō. 3 vols. 1780. (ZH).

2 *Meguro-no-Hiyokuzuka* 驪 比 異 塚
 Kibyōshi. Signed Katsukawa Shunrō. 2 vols. 1780. (KS 7/685).

3 *Isshō Tokubyōe Mitsu-no-Den* 一 寸 徳 兵 衛 三 の 伝
 Kibyōshi by Tsūshō. Signed Shunrō. 1780. (NARAZAKI p. 71).

4 *Ikichon-jon Kuruwa-no-Chaban* 大 通 一 寸 廓 茶 番
 Share-hon by Banri. Signed Katsukawa Shunrō. 2 vols. 1780. (KS 1/153).

5 *Kyokudaikon* 喜 夜 来 大 根
 Share-hon by Rihaku-sanjin. Signed Shunrō. 1 vol. 1781. (KS 2/556).

6 *Arigatai Tsū-no-Ichiji* 有 難 通 一 字
 Kibyōshi by Zewasai (possibly Hokusai). Signed Katsukawa Shunrō. 2 vols. 1781. (KS 1/106).

7 *Kōdai-no-Mudagoto* 公 大 無 多 言
 Share-hon. Signed Katsukawa Shunrō. 1 vol. 1781. (KS 3/268).

8 *Mame-batake* 間 女 畑
 Kobanashi (short story). Signed Katsukawa Shunrō. 1 vol. 1781. (KS 7/481).

9 *Fukagawa Haiken* 富 賀 川 拝 見
 Share-hon. Signed Shunrō. 1 vol. 1782. (KS 7/16).

10 *Ehon Kuragari-zōshi* 笑 本 股 庫 嘉 里 嫁 志
 Shunga. Signed Katsu Shunrō. 1 vol. 1782. (YH pp. 156/7).

11 *Kamakura Tsūshinden* 鎌 倉 通 臣 伝
 Kibyōshi. Signed Shunrō. 2 vols. 1782. (KS 2/217).

12 *Shi Tennō Daitsū-jidate* 四 天 王 大 通 仕 達
 Kibyōshi. Signed Shunrō. 2 vols. 1782. (KS 4/148).

13 *Kanyōkyu Tsū-no-Yakusoku* 感 陽 宮 通 約 束
 Kibyōshi. Signed Shunrō. 2 vols. 1784. (KS 2/373).

14 *Un-wa Hiraku Ōgi-no-Hanaga* 運 開 扇 之 花 香
Kibyōshi. Signed Shunrō. 2 vols. 1784. (KS 1/413).

15 *Kyōkun Zō-nagamochi* 教 訓 雑 長 持
Dangihon (moral storybook). Signed Katsukawa Shunrō. 5 vols. 1784. (KS 2/509).

16 *Nozoki Karakuri Yoshitsune Yamairi* 野 曽 喜 伽 羅 久 里 義 経 山 久 里
Kibyōshi by Ikuji Moūchi. Signed Katsu Shunrō. 3 vols. 1784. (KS 7/910).

17 *Oya-Yuzuri Hana-no-Kōmyō* 親 讓 鼻 高 名
Kibyōshi. Signed Shunrō *aratame* (changing to) Gummatei. 3 vols. 1785.
(KS 1/685).

18 *Onnen Uji-no-Hotarubi* 怨 念 宇 治 螢 火
Kibyōshi. Signed Katsu Shunrō. 2 vols. 1785. (KS 1/723).

19 *Ni-ichi Tensaku Nishinga Isshin* 二 一 天 作 二 進 一 十
Kibyōshi by Ichiba Dōshō. Signed Gummatei. 3 vols. 1786. (KS 6/316).

20 *Zen-zen Taiheki* 前 々 太 平 記
Kibyōshi by Unobore Sanjin. Signed Katsu Shunrō. 5 vols. 1786. (KS 5/206).

21 *Daibutsu Hidariyori* 大 仏 左 捻
Kibyōshi. Signed Hakusanjin Kakō (?Hokusai). 3 vols. 1786. (KS 5/473).

22 *Waga-ie Raku-no-Kamakura-yama* 我 家 楽 之 鎌 倉 山
Kibyōshi. Signed Gummatei, author and artist. 2 vols. 1786. (KS 8/206).

23 *Jabara-mon Hara-no-Nakachō* 蛇 腹 紋 原 之 仲 町
Kibyōshi. Signed Shunrō *aratame* Gummatei. 2 vols. 1786. (KS 4/220).

24 *Ningen Bonji Ni-ichi Tensaku Go* 人 間 万 事 二 一 天 作 五
Re-issue in 1788 and 1800 of *Ni-ichi Tensaku Nishinga Isshin*, No. 19 above, under
new title. (KS 6/424).

25 *Jinkoki Nishiki Mutsuki*
Kibyōshi. Signed Gummatei. 1788. (Listed in Revon *Étude sur Hok'sai*, 1898;
possibly confused with *Jinkoki Nishiki-no-Shōgatsu*, given to Masayoshi in *Nihon
Shōsetsu Nempyō*).

26 *Fuku-kitaru Warai-no-Kadomatsu* 福 来 留 笑 顔 門 松
Kibyōshi by Ichiba Tsūshō. Signed Katsu Shunrō. 2 vols. 1789. (KS 7/34).

27 *Sankoku-shi* 讃 極 史
Joke-book by Chiyo Okagusa. Signed Katsushika Hokusai. 1 vol., n.d. Kansei
period. (KS 3/778).

28 *Kusaki-mo-Nabiku Hirikura-no-Sakae* 臭 気 靡 放 昆 倉 栄
Kibyōshi. Signed Shunrō. 2 vols. 1789. (KS 2/638).

29 *Yorozuya Tokuzaemon* よ ろ づ や 徳 左 衛 門
Kibyōshi. Signed Katsu Shunrō. *c.* 1789 (RYERSON p. 231, MS date).

30 Lacking title. 欠 題
Shunga. 1 vol. *c.* 1789. (YH p. 53 and 179/180).

31 *Rokkasen Kyojitsu-no-Tensaku* 六 歌 仙 虚 実 添 削
Kibyōshi. Signed Shunrō. 3 vols. 1789. (KS 8/190).

32 *Hayari-uta Torikomi Shōbu* 流 行 混 雑 唱 舞
 Kibyōshi by Zōsui. Signed Shunrō. 2 vols. 1789. (KS 6/675).

33 *Heiji Taiheki* 平 治 太 平 記
 Kibyōshi by Ichiba Dōshō. Signed Shunrō. 3 vols. 1789. (KS 7/198)

34 *Hana Go Edo Shomonsai* 花 御 江 戸 将 門 祭
 Theatre booklet. Not signed. 1 vol. 1789. (ZH).

35 *Tatsu-no-miyako Sentaku-banashi* 龍 宮 洗 濯 噺 芋 蛸 の 由 来
 Imotako-no-Yurai
 Kibyōshi. Signed Shunrō. 1 vol. 1791. (KS 5/555).

36 *Myōdai Furisode* 名 代 振 袖
 Kibyōshi. Signed Shunrō. 2 vols. 1791. (KS 7/594).

37 *Tenjin Shichi-dai-ki* 天 神 七 代 記 or *Masumi-no-Kagami* 真 直 美 之 加 々 見
 Kibyōshi (popular guide to Shintōism). 5 vols. 1792. (Attributed to Hokusai; *vide*
 RYERSON p. 232).

38 *Nue Yorimasa Meika-no-shiba* 鵺 頼 政 名 歌 芝
 Kibyōshi. Signed Shunrō. 3 vols. 1792. (KS 6/435).

39 *Onna Sōji Kochō-no-yume* 女 荘 子 胡 蝶 夢 魂
 Kibyōshi. Signed Shunrō. 2 vols. 1792. (KS 1/718).

40 *Hana-no-Haru Shirami-no-Michiyuki* 花 春 風 道 行
 Kibyōshi by Bakin. Signed Shunrō. 2 vols. (KS 6/657).

41 *Jitsugokyō Osana-Kōshaku* 実 語 教 幼 稚 講 釈
 Kibyōshi by Santō Kyōden. Signed Katsu Shunrō. 3 vols. 1792. (KS 4/124).

42 *Momotaro Hottan-banashi* 桃 太 郎 発 端 話 説
 Kibyōshi by Santō Kyōden. Signed Shunrō. 3 vols. 1792. (KS 7/720).

43 *Mame-batake* 間 女 畑
 Shunga. Signed Shunrō. 1 vol. *c.* 1792. (YH p. 53 and 173) No. 8 is a different
 book with the same title.

44 *Himpuku Ryōdōchū-no-ki* 貧 福 両 道 中 之 記
 Kibyōshi by Santō Kyōden. Signed Shunrō. 3 vols. 1793. (Reprinted in 1795)
 (KS 6/857).

45 *Chie-shidai Hakone-zume* 智 恵 次 第 箱 根 詰
 Kibyōshi by Shundō. Signed Shunrō. 3 vols. 1793. (KS 5/607).

46 *Azuma Daibutsu Momiji-no-Meisho* 東 大 仏 楓 名 所
 Kibyōshi. Second edition of *Daibutsu Hidariyori* (No. 21 above). 3 vols. 1793.
 (KS 1/63).

47 *Fukujukai Muryō-no-Shinadama* 福 寿 海 天 量 品 玉
 Kibyōshi by Bakin. Signed Shunrō. 3 vols. 1794. (KS 7/36).

48 *Kakeai Kyōka Mondō* 掛 合 狂 歌 問 答
 Kyōka-bon. Katsukawa Shunrō. 1 vol. n.d. (KS 2/97).

49 *(Kobito-jima) Nanasato Fuki* 「 小 人 じ ま 」 七 々 里 富 貴
 Kibyōshi. Signed Shunrō. 2 vols. 1794. (KS 6/265).

50 *Nozoite-miru Tatoe-no-Fushi-ana* 覗 見 喩 節 穴
 Kibyōshi by Honzentei Tsubohira. Signed Shunrō. 2 vols. 1794. (KS 6/506).

51 *Kyōka Ren Awase Onna Shinasadame* 狂 歌 連 合 女 品 定
 Kyōka-bon. Signed Kusamura Shunrō. 2 vols. 1794. (KS 2/502).

52 *Ehon Matsu-no-Uchi* 絵 本 松 の 内
 Shunga. Signed Shishoku Gankō. 3 vols. *c.* 1794. (YH p. 54 and 172).

53 *Ehon Haru-no-Iro* 絵 本 春 の 色
 Shunga. Signed Shishoku Gankō. 3 vols. *c.* 1794. (YH p. 54 and 172).

54 *(Ehon) Iro-no-Wakaba* 「 絵 本 」 色 の 嫩
 Shunga. Signed Shishoku Gankō. 1 vol. *c.* 1794. (YH p. 54).

55 MS title *Kyōka Surimono Hon* 手 で 書 い た 題 。 狂 歌 摺 物 本
 Kyōka-bon. One print signed Sōri; another signed Kanko. 1 vol. n.d. *c.* 1794/5.
 (Haviland eighteenth sale, No. 653, now Pulverer Collection, Cologne) (See pl. 10).

56 *Shiwamiuse-gusuri* し わ み う せ 薬
 Kibyōshi by Honzentei Tsubohira. Signed Shunrō. 3 vols. 1795. (KS 4/627).

57 *Temaezuke Ako-no-Shiokara* 手 前 漬 赤 穂 の 塩 辛
 Kibyōshi by Honzentei Tsubohira. Signed Shunrō. 2 vols. 1795. (KS 5/804).

58 *Kyōka Edo Murasaki* 狂 歌 江 戸 紫
 Kyōka-bon. Sōri with Utamaro and others. 1 vol. 1795. (KS 2/487).

59 *Shiki-nami-gusa* 帰 化 種
 Kyōka-bon. Seiryōtei Kangi compiler. Signed Hyakurin Sōri. 1 vol. 1796.
 (KS 4/37).

60 *Asahina O-hige-no-chiri* 朝 比 奈 御 髭 之 塵
 Kibyōshi by Sakuragawa Jihinari. Signed Katsukawa Shunrō. 2 vols. 1796.
 (KS 1/36).

61 *Kyōka Ema Awase Onna Kanadehon* 狂 歌 絵 馬 合 女 仮 名 手 本
 Kyōka-bon. 1 vol. Unsigned. 1796. (ZH).

62 *Yomo-no-Haru* 四 方 の 巴 流
 Kyōka-bon. Signed Hokusai Sōri, with Eishi and Masayoshi. 1 vol. 1796.
 (Ex. Odin Sale, No. 101, now Chester Beatty Library, Dublin).

63 *Yomo-no-Haru* 四 方 の 巴 流
 Kyōka-bon. Signed Hokusai Sōri, with Santō Kyōden, Gentai, Sō Shizan and
 others. 1 vol. 1796. (Hayashi Sale Catalogue 1902, No. 1751). (Another edition of
 No. 62).

64 Lacking title. 欠 題
 Kyōka-bon. 4-page print signed Hokusai Sōri, seal Kanchi, two single-page prints
 signed Sōri, seal Kanchi. 1 vol. 1796. (British Museum: see illustration, pl. 11).

65 *Sandara Kasumi* さ ん だ ら 霞
 Kyōka-bon. Signed Hokusai Sōri, with Shigemasa and Ittei. 1 vol. 1797.
 (ZH; British Museum).

66 *Shioyaki Bunta Miyako Monogatari* 塩 焼 文 太 都 物 語
Kibyōshi by Sakuragawa Jihinari. Signed Katsukawa Shunrō. 3 vols. 1797.
(KS 4/12).

67 *Yanagi-no-Ito* 柳 の 糸
Kyōka-bon. Signed Hokusai Sōri, with Tōrin, Rinshō, Eishi and Shigemasa. 1 vol.
orihon. 1797. (KS 7/782).

68 *Shunkyōjō* 春 興 帖
Kyōka-bon. One print signed Sōri in one vol., dated 1797; another signed
Hokusai Sōri in one vol., dated 1798.

69 *Shunkyō* 春 興
Kyōka-bon. Signed Hokusai Sōri, with Shiransai and Shigemasa. 1 vol. *c.* 1798.
(British Library).

70 *Shunkyōjō* 春 興 帖
Kyōka-bon. Compiler Rinka Manzō. Sōri and Kyōden. 1 vol. Kansei period.
(KS 4/332).

71 *Shunkyōjō* 春 興 帖
Kyōka-bon. Sōri, with Utamaro and Toyohiro. 1 vol. (Hayashi Sale Catalogue
1902, No. 1749).

72 *Miyama Uguisu* 深 山 鶯
Kyōka-bon. One print signed Hokusai Sōri (after Kōrin); another by Shigemasa.
1 vol. Preface 1798. (KS 7/585).

73 *Otoka-Dōka* 男 踏 歌
Kyōka-bon. Signed Hokusai Sōri, with Tōrin, Shigemasa, Utamaro, Yōshi and
Eishi. 1 vol. 1798. (KS 1/659).

74 *Bakemono Yamato Honzō* 化 物 大 和 本 草
Kibyōshi by Santō Kyōden. Signed Kakō. 3 vols. 1798. (KS 6/589).

75 *Kyōka Hatsu Wakana* 狂 歌 初 若 菜
Kyōka-bon. One print signed Sōri *aratame* Hokusai; seal, Sankei. 1 vol. Preface
1798. (British Museum). (See pl. 19).

76 *Rakumon Binka-fu* 楽 門 瓶 花 譜
(later issue *Sashiire Hana-no-Futami*) 挿 入 花 の 二 見
Haiku and *ikebana.* Various signatures and seals involving the names Hokusai,
Sōri and Kanchi in combinations. 1 vol. 1798. (British Museum. Under different
titles in NARAZAKI pp. 137/141, and YASUDA pp. 352/355).

77 *Tarōzuki* 太 郎 月
Kyōka-bon. One print signed Sōri. 1 vol. *c.* 1797/8. (NARAZAKI, pl. 44).

78 *Haikai Shijiku-zōshi*
Haikai-bon. One print signed Sōri *aratame* Hokusai Tatsumasa. 1 vol. 1798.
(GONCOURT, *Hokusai*, p. 370).

79 *Hana-no-ani* 花 の 兄
Kyōka-bon. Two prints, one signed Sōri aratame Hokusai, the other, Hokusai
Tatsumasa. 1 vol. 1798. (MFA Boston, 73213; Hayashi Sale Catalogue, 1902, No.
1709, as *Hana-no-ye*).

80 *Sandara-kasumi* さ ん だ ら 霞
 Kyōka-bon. One print signed Hokusai Sōri, others by Shigemasa and Gengakusai
 Settan. 1 vol. 1798. (Javal First Sale, No. 80. A different book from No. 65).

81 *Sankoku-shi* 讃 極 史
 Share-bon. Signed Hokusai. 1 vol. *c.* late 1790s.

82 *Haru-no-Miyabi* 春 の み や び
 Kyōka-bon. Two prints signed Hokusai Sōri. *c.* 1798. 1 vol. (Morse Collection,
 Honolulu). (See pls. 12 and 13).

83 *Azuma Asobi* 東 遊
 Kyōka-bon. Signed Hokusai. 1 vol. 1799. (The first colour-printed version, under
 the title *Ehon Azuma Asobi*, appeared in 1800, with preface date altered from
 Kansei 11 to Kansei 12; the second, with entirely new preface, dated Kyōwa 2
 (1802)).

84 *Kozue-no-Yuki* こ ず ゑ の ゆ き
 Signed Fuzenkyō Hokusai. 1 vol. 1799. (YASUDA p. 304).

85 *Kyōka Hakuen Isshu Shō* 今 日 歌 白 猿 一 首 抄
 Kyōka-bon. One print signed Tawaraya Sōri, others by Kunimasa, Shunkō and
 Shunei. (Presumed to be Sōji, changing to Tawaraya Sōri). 1 vol. 1799. (KS 2/497).

86 *Kamado Shōgun Kanryaku-no-Maki* か ま ど 将 軍 肝 略 之 巻
 Kibyōshi. Signed Tokitarō Kakō. 3 vols. 1800. (KS 220).

87 *Anata Yomo-no-haru*
 Signed Hokusai, with Eishi and Tsunegaki (one print each). 1 vol. *c.* 1800.
 (BROWN p. 172).

88 *Tōto Meisho Ichiran* 東 都 名 所 一 覧 also *Tōto Shōkei Ichiran*. 東 都 勝 景 一 覧
 Ehon with *kyōka*. Signed Hokusai Tatsumasa. 2 vols. 1800. (KS 6/92).

89 *Chigo-Monju Osana-kyōkun* 児 童 文 殊 稚 教 訓
 Kibyōshi. Author and artist Tokitarō Kakō. 3 vols. 1801. (KS 5/625).

90 *Nishiki-zuri Onna Sanjū-rokkasen* 錦 摺 女 三 十 六 歌 仙
 Frontispiece to Eishi's *ehon* of 'Thirty-six Poets'. Signed Gakyōjin Hokusai.
 1 vol. 1801. (NARAZAKI pl. 54).

91 *Adatehon* 仇 手 本
 Share-bon. Signed Gakyōjin Hokusai. 1 vol. 1801. (KS 1/69).

92 Lacking title. 欠 題
 Kyōka-bon. One print signed Gakyōjin Hokusai. 1 vol. *c.* 1801. (British Museum.
 See pl. 23).

93 *Bon-odori* 盆 踊
 Kyōka-bon. Signed Hokusai and Gakyōjin Hokusai. 1 vol. *c.* 1801. (MFA Boston,
 20210; also Victoria and Albert Museum, under MS title *Shishoan-ren*, 07. A9).

94 *Isuzugawa Kyōka Kuruma* 五 十 鈴 川 狂 歌 車
 Portraits of comic poets with *kyōka*. Signed Hokusai Tatsumasa. 1 vol. 1802.
 (KS 1/188).

95 *Tsūshinkura* 通 神 蔵
Kibyōshi. A sequel to *Adatehon* (No. 91). Katsushika Hokusai. 1 vol. 1802.
(KS 5/730).

96 *Shimpan Jinkōki* 新 板 塵 劫 記
Kibyōshi by Tokitarō Kakō. Artist, Kakō. 3 vols. 1802. (KS 4/762).

97 *Miyako-dori* 美 や こ ど り
Kyōka-bon. Signed Gakyōjin Hokusai. 1 vol. 1802. (RYERSON p. 239).

98 *Itako Zekku Shū* 潮 来 絶 句 集
Ehon with verses. Not signed. 2 vols. 1802. (KS 1/225).

99 *Haru-no-Tawamure-uta* 春 の 戯 歌
Kyōka-bon. Two prints, one signed Gakyōjin Hokusai, the other Busentei Eiri.
1 vol. (ZH as 1801; British Museum, preface 1802, no colophon).

100 *Fude Hajime* 筆 は じ め
Story-book. 1 vol. 1802. (Reproduced in Shigeo's *Matsu Hankoku. Eiri Edo
Kohanashi Jūnishu*, 1966).

101 *Ehon Chūshingura* 絵 本 忠 臣 蔵
(Inside title to vol. 2, *Chūshingura Yakuwari Kyōka*) Ehon with kyōka. Compiler,
Sakuragawa Jihinari. Signed Hokusai Tatsumasa. 2 vols. 1802. (KS 1/497).

102 *(Katakitehon Kōhen) Tsūshingire* 「 仇 手 本 後 編 」 通 新 戯
Share-hon, author Kogane Atsumaru. c. 1802. Signed Gakyōjin Hokusai. (ZH).

103 *(Kokon Kidan) Ama-no-sutegusa* 「 古 今 奇 談 」 蜑 捨 草
Novel by Sankejin Hirozumi. Signed Gakyōjin Hokusai. 6 vols. 1803. (KS 1/87.
Hayashi 1902 under *Enshagusa*).

104 *Buchōchō Sokuseki Ryōri* 不 厨 庵 即 席 料 理
Kibyōshi. Author and artist Tokitarō Kakō. 3 vols. 1803. (KS 7/96).

105 *Munazanyo Uso-no-Tanaoroshi* 胸 中 算 用 嘘 店 卸
Kibyōshi. Author and artist Tokitarō Kakō. 3 vols. 1803. (KS 7/636).

106 *(Sankoku Mukashi Hanashi) Wakanran Monogatari*
「 三 国 昔 噺 」 和 漢 蘭 雑 話
Kibyōshi by Kanwatei Onimusashi. Signed Kakō. 3 vols. 1803. (KS 8/228).

107 *(Hinauta) Tsuki Kuwashi* 「 夷 歌 」 月 微 妙
Kyōka-bon. Three prints, two sealed Kishutsu Kisoku, one signed Gakyōjin
Hokusai. 1 vol. Preface dated 1803. (British Museum, see pls. 36 and 37).

108 *Fujimi-no-Tsura* 不 二 見 の 面
Kyōka-bon. Signed Gakyōjin Hokusai. 1 vol. 1803. (Javal 2nd sale, No. 96).

109 *A-a Shinkirō* 嗚 呼 蜃 気 楼
Kibyōshi. Signed Katsushika Hokusai. 3 vols. 1803. (KS 1/3).

110 *Haru-no-Fuji* は る の 不 盡
Kyōka-bon. Signed Gakyōjin Hokusai. 1 vol. 1803. (RYERSON p. 242).

111 *(Ehon) Ogura Hyakku Donsaku Kusen* 「 絵 本 」 小 倉 百 句 鈍 作 句 撰
Ehon with verses by Hakuen (Danjurō v). Signed Hokusai Tatsumasa. 1 vol.
1803. (KS 1/490).

112 *Hashika Otoshi-hanashi* は し か 落 噺
Story-book. 1 vol. (KS 6/594).

113 *(Otoshi-hanashi) Toshiotoko Waraigusa* 「 落 噺 」 年 男 笑 種
Story-book by Ki-Osamaru. Signed Tokitarō Kakō. 1 vol. 1804. (NARAZAKI
p. 274 and KS 6/159, referring only to *Nihon Shōsetsu Nempyō*).

114 *Ehon Kyōka Yama Mata Yama* 絵 本 山 満 多 山
Ehon with *kyōka*. Signed Hokusai. 3 vols. 1804. (KS 1/492).

115 *Musume Katakiuchi Imose-no-Tomotsuna* 娘 敵 討 陸 友 綱
or *Ryōmen Shusse Sugata Kagami* 両 面 出 世 姿 鑑
Kibyōshi. Part 2 signed Tokitarō Kakō. 2 vols. 1804. (KS 7/627).

116 *Misoka Tsuzura* 晦 日 蔦 籠
Kyōka-bon. Four designs signed Gakyōjin Hokusai. 1 vol. 1804. (ZH).

117 *Shōsetsu Hiyoku-mon* 小 説 比 翼 文
Novel by Bakin. Signed Hokusai Tatsumasa. 2 vols. 1804. (KS 4/433).

118 *(Shimpan Ryūko) Hanashi Kame* 「 新 板 流 行 」 は な し 亀
Story-book by Fukusuke. Signed Tokitarō Kakō. 1 vol. 1804. (KS 6/648).

119 *Otogi Yamazaki Kassen* 御 伽 山 崎 合 戦
Kibyōshi. Gakyōjin Hokusai. (RYERSON, p. 231; KS from *Nihon Shōsetsu Nempyō*,
giving date as 1804).

120 *Kyōka Sanjū-rokkasen* 狂 歌 三 十 六 歌 仙
Kyōka-bon with portraits of authors. 1 vol. *c.* 1804/5. (Peter Morse Collection,
see pls. 48/51) (ZH gives date as end of Kansei).

121 *Kyōka Momo Saezuri* 狂 歌 百 さ へ ず り
Kyōka-bon. Signed Gakyōjin Hokusai. 1 vol. 1805. (KS 7/718).

122 *(Fukushū Kiwa) Ehon Azuma Futaba Nishiki* 「 復 讐 奇 話 」 絵 本 東 嫩 錦
Novel by Shigeru. Signed Gakyōrōjin Hokusai, seal Gakyōjin. 5 vols. 1805.
(KS 1/488).

123 *Shimpen Suiko Gaden* 新 編 水 滸 画 伝
Novel by Bakin and Ranzan. Part 1, 6 vols., 1805; Part 1 (second section)
5 vols., 1807; remainder, 5 parts, 10 vols each, between 1828 and 1835.
(KS 4/770).

124 *Ehon Sumidagawa Ryōgan Ichiran* 絵 本 隅 田 川 両 岸 一 覧
Ehon. Hokusai named in the preface. 3 vols. *c.* 1805. (KS 5/51).

125 *Saifu-no-himo Shirami-use-gusuri*
Story of a miser. Signed Hokusai. 1 vol. *c.* early 1800s. (BROWN p. 184, who
states it was also written by Hokusai, under the name Tenbohiro).

126 *Jimoku Shū* 耳 目 集
Kyōka-bon. One print signed Hokusai. 1 vol. 1806. (NARAZAKI p. 223).

127 *Tōkaidō Gojūsan-tsugi* 東 海 道 五 十 三 次
Ehon. 2 vols. Probably a re-issue of separately-published prints with an added
preface. *c.* 1806. (KS 6/12. LANE No. 155, as 1810).

128 *Jiraiya Setsuwa*　自 来 也 説 話
Novel by Onitake. Signed Katsushika Hokusai. 11 vols. 1806. (KS 4/613).

129 *(Shunshō Kidan) Ehon Tama-no-Ochibo*　「 春 宵 奇 談 」 絵 本 璧 落 穂
Novel by Shigeru. Signed Katsushika Hokusai. Two parts, each of 5 vols. 1806
and 1808. (KS 1/496).

130 *Uwaki Zōshi*　浮 気 草 紙
Kibyōshi by Rani. 3 vols. 1806. (NARAZAKI p. 276).

131 *Kyōka Sanai Shū*　狂 歌 三 愛 集
Kyōka-bon. Signed Hokusai. 1 vol. Bunka period, *c.* 1803/1812. (KS 2/491).

132 *Kyōka Otsudoi*　狂 歌 大 つ ど い
Kyōka-bon. Signed Hokusai. 1 vol. *c.* 1803/1812. (KS 2/48).

133 *(Yaguchi Shinrei) Nitta Koshinroku*　「 箭 口 神 霊 」 新 田 功 臣 録
A later edition of *Ehon Tama-no-Ochibo* (No. 129 above) 10 vols. 1806/7.
(KS 6/371).

134 *Chinsetsu Yumiharizuki*　椿 説 弓 張 月
Novel by Bakin. Signed Katsushika Hokusai. 29 vols. Part 1, 1807; Parts 2/3,
1808; Part 4, 1810; Part 5, 1811. (KS 5/722).

135 *Katakiuchi Urami Kuza-no-ha*　敵 討 裏 見 葛 葉
Novel by Bakin. Signed Katsushika Hokusai. 5 vols. 1807. (KS 2/153).

136 *Sumidagawa Bairyū Shinsho*　墨 田 川 梅 柳 新 書
Novel by Bakin. Signed Katsushika Hokusai. 6 vols. 1807. (KS 5/51).

137 *Sono-no-Yuki*　そ の の ゆ き
Novel by Bakin. Signed Katsushika Hokusai. 5 vols. 1807. (KS 5/539).

138 *Shin Kasane-gedatsu Monogatari*　新 累 解 脱 物 語
Novel by Bakin. Signed Katsushika Hokusai. 5 vols. 1807. (KS 4/636).

139 *Karukaya Kōden Tamakushige*　刈 萱 後 伝 玉 櫛 笥
Novel by Bakin. Hokusai is named in the preface by Bakin. 3 vols. (*Hokusai
Yomihon*, Vol. 1, p. 53.; KS 2/256).

140 *Kimiga (Yūkun) Misao Renri-no-Mochibana*　遊 君 操 連 理 餅 花
Re-issue of No. 117 under a new title. Signed Gakyōjin Hokusai. 2 vols. 1807
(YH p. 91).

141 *Yuriwaka Nozue-no-Taka*　由 利 稚 野 居 鷹
Novel by Mantei Sōba. Signed Katsushika Hokusai. 5 vols. 1808. (KS 7/870).

142 *(Katakiuchi) Migawari Myōgō*　「 敵 討 」 身 代 利 名 号
Kibyōshi by Bakin. Signed Katsushika Hokusai. 5 vols. 1808. (KS 2/159).

143 *Onnamoji Nue Monogatari*　国 字 鵺 物 語
Novel by Shakurakutei Nagane. Signed Katsushika Hokusai. 5 vols. 1808.
(KS 1/722).

144 *Raigō-ajari Kaiso Den*　頼 豪 阿 闍 梨 怪 鼠 伝
Novel by Bakin. Signed Katsushika Hokusai, seal Hokusai. First part, 5 vols.,
1808; second part, 4 vols., 1808. (KS 8/4).

145 *San-shichi Zenden Nanka-no-Yume* 三 七 全 伝 南 柯 夢
Novel by Bakin. Signed Katsushika Hokusai, seal Kishutsu Kisoku. 6 vols.
1808. (KS 3/784).

146 *Awa-no-Naruto* 阿 波 之 鳴 門
Novel by Ryūtei Tanehiko. Signed Katsushika Hokusai. 5 vols. 1808 (KS 1/115).

147 *(Kinsei Kaidan) Shimoyo-no-Hoshi* 「 近 世 怪 談 」 霜 夜 星
Novel by Ryūtei Tanehiko. Signed Katsushika Hokusai. 5 vols. 1808. (KS 4/196).

148 *Kitabatake Onna Kyōkun* 北 畠 女 教 訓
Novel by Jippensha Ikku. Signed Kyōjin Hokusai. 5 vols. 1808. (KS 2/429).

149 *Yūryaku Onna Kyōkun* 勇 略 女 教 訓
Moral tales by Jippensha Ikku. Signed Gakyōjin Hokusai. 5 vols. 1808. (KS 7/847
gives date as 1808; LANE cites it as sequel to No. 148, *c.* 1810).

150 *Kasa Tsukushi* 笠 つ く し
Theatre booklet. Signed Katsushika Hokusai. 1 vol. 1808. (British Museum.
See pl. 110).

151 *Kyōkun Ono-ga-tsue* 教 訓 己 が 津 衛
Moral tales by Jippensha Ikku. Signed Gakyōjin Hokusai. 5 vols. 1808.
(NARAZAKI p. 277; KS 2/508).

152 *Ishidōmaru Karukaya Monogatari* 石 堂 丸 刈 萱 物 語
Another edition under a changed title of No. 139 above. 3 vols. 1806.

153 *Hitori Hokku* 独 発 句
Haiku-bon. One print by Gakyōrōjin Hokusai. 2 vols. *c.* 1808. (KS 6/785).

154 *Anokutara Kashiko Monogatari* 安 耨 多 羅 賢 物 語
Novel by Shinrotei. Katsushika Hokusai. 5 vols. 1808 (KS 1/78).

155 *Katakiuchi Mukui-no-Ja-yanagi* 仇 討 報 蛇 柳
Novel by Sanwa. Katsushika Hokusai. 6 vols. 1808. (KS 2/119).

156 *Sanshō-dayū Eiko Monogatari* 山 枡 太 夫 栄 枯 物 語
Novel by Baibori Kokuga. Signed Katsushika Hokusai, seal Kishutsu Kisoku.
5 vols. 1809. (KS 3/802).

157 *Chūkō Itako-bushi* 忠 考 潮 来 府 志
Novel by Danshurō Emba. Signed Katsushika Hokusai. 5 vols. 1809. (KS 5/655).

158 *Hida-no-Takumi Monogatari* 飛 弾 匠 物 語
Novel by Rokujuen Meshimori. Signed Katsushika Hokusai. 6 vols. 1809.
(KS 6/769).

159 *Agemaki Monogatari* (Second Part) 総 角 物 語 後 編
Novel by Ryūtei Tanehiko. Signed Katsushika Hokusai. 2 vols. 1809. (The first
part of this novel, published in 1808, was illustrated by Yūyūsai Tōsen). (KS 1/32).

160 *(Kanadehon) Gonichi-no-Bunshō.* 「 假 名 手 本 」 後 日 の 文 章
Novel by Danshurō Emba. Signed Katsushika Hokusai. 3 vols. 1809. (KS 2/198).

161 *(Oriku Kōsuke) Yume-no-Ukibashi* 「 於 陸 幸 助 」 恋 夢 艦
Novel by Rakurakuan Tōei. Signed Katsushika Hokusai. First part. 3 vols.
1809. (KS 7/866).

162 *Tamakushige Ishidōmaru Monogatari* 玉 櫛 笥 石 堂 丸 物 語
Novel by Bakin. 3 vols. 1809. (NARAZAKI p. 279, KS 5/575. Another edition of
139 and 152).

163 *Ki-no-hana-zōshi*
Novel by Shigeru. Signed Katsushika Hokusai. 1809. (LANE, No. 146).

164 *Futatsu Chōchō Shiraitō Sōshi* 双 蛺 蝶 白 糸 冊 子
Novel by Shakurakutei Nagane. Signed Katsushika Hokusai Tatsumasa. 5 vols.
1810. (KS 7/91).

165 *Onnyō Imoseyama* 朳 朳 妹 背 山
Novel by Shinrotei. Signed Katsushika Hokusai. 6 vols. 1810. (KS 1/724).

166 *Onoga Bakamura Mudaji Ezukushi* 己 嶷 群 夢 多 字 画 尽
Joke-book. 1 vol. Signed Katsushika Taito. 1810. (KS 1/666).

167 *Chamise Suminoe Zōshi* 茶 店 墨 江 艸 紙
Theatre-book. Frontispiece to vol. 1 signed Katsushika Hokusai. (Principal
illustrator Asayama Ashikuni. 9(?) vols. 1810. (Waseda Theatrical Museum
Library).

168 *Kyōka Tō-megane* 狂 歌 登 遠 眼 可 繝
Kyōka-bon. Hokusai and others. 1 vol. 1810. (ZH).

169 *Seta-no-hashi Ryūnyō-no-Honji* 勢 田 橋 龍 女 本 地
Jōruri for reading by Ryūtei Tanehiko. Signed Katsushika Hokusai, seal
Raishin. 3 vols. 1811. (KS 5/147).

170 *Tsuya-no-Fushi* 露 の 淵
Kyōka-bon. Compiler Segawa Rōchō, for first anniversary Buddhist ceremony of
death of Segawa Kikunojō III. *Sumi* prints by Hokusai, Toyokuni and others.
1 vol. 1811. (*Hokusai Kenkyū* No. 8, Sept. 1974).

171 *(Shimpen) Tsuki-no-Kumasaka* 「 新 編 」 月 の 熊 坂
Tales. Signed Tokitarō Kakō. 3 vols. 1811. (KS 4/771).

172 *Jodan Futsuka Yoi* 串 戯 二 日 酔
or *Kokkei Futsuka Yoi* 滑 稽 二 日 酔
Joke-book by Jippensha Ikku. 2 vols., vol. 1 illustrated by Hokusu, vol. 2 by
Hokusai. 1811. (KS 3/503).

173 *Zoku Hizakurige Nihen* 続 膝 栗 毛 二 編
Joke-book by Jippensha Ikku. 2 vols. (NARAZAKI p. 279; ZH).

174 *(Horikawa Tarō) Hyakushudai Kyōka Shū* 堀 川 太 郎 百 首 題 狂 歌 集
Kyōka-bon. 1 print signed Katsushika Hokusai, others by Shigemasa, Shunman
and others. 2 vols. n.d. (ZH gives 1811).

175 *Matsuo Monogatari* 松 王 物 語
Novel by Shigeru. Signed Hokusai. 6 vols. 1812. (KS 7/451).

176 *Yume Awase Nanka Goki* 占 夢 南 柯 後 記
Novel by Bakin. Signed Katsushika Hokusai Tatsumasa, seal Raishin. 8 vols.
1812. (KS 7/865).

177 *Aoto Fujitsuna Moryo-an*　青 砥 藤 綱 模 稜 案
Novel by Bakin. Part 1, signed Katsushika Hokusai Raishin, 5 vols; Part 2,
signed Katsushika Hokusai, 5 vols. 1812. (KS 1/14).

178 *Ryakuga Haya Oshie*　略 画 早 指 南
Ehon. Signed Katsushika Hokusai. Part 1, 1 vol. 1812; Part 2, 1 vol. 1814; Part 3,
see No. 181. (KS 8/47).

179 *Kyōka Ichie Osumo*　狂 歌 一 会 大 角 力
Kyōka-bon. Signed Hokusai. 1 vol. 1812. (MFA Boston 20210).

180 *Haikai-uta Ichie Osumo Tate*　誹 諧 哥 一 会 大 角
Haikaibon. Signed Hokusai. 1 vol. *c.* 1812. (MFA Boston 20210).

181 *Gadō Hitori Keiko*　画 道 独 稽 古
Ehon. (*Ryakuga Haya Oshie Sampen*). 1812 and 1815. (KS 2/189). Variant re-issued
later as *Ryakuga Haya Manabi Kohen* (MFA Boston 20125).

182 *Hokuetsu Kidan*　北 越 奇 談
Novel by Shigeyo. Signed Katsushika Hokusai, seal Raishin. 6 vols. 1812.
(KS 7/305).

183 *(Katsushika Zushi) Taguri Bune*　「 勝 鹿 図 志 」 手 糸 繰 舟
Miscellany with verses. One print signed Hokusai; others by Tōrin, Tani Bunchō,
Nanrei, Sōchō and others; 1 vol. Prefaces dated 1812 and 1813. (British Museum.
See pl. 109).

184 *Oguri Gaiden*　小 栗 外 伝
Novel by Shigeru. Part 1, 6 vols., signed Katsushika Hokusai, seal Gayū, 1813;
Part 2, 4 vols, same signature and seal, 1814; Part 3, 5 vols, signed Katsushika
Hokusai-Ō, seal Gayū, 1815. (KS 1/636).

185 *Hokusai Shashin Gafu*　北 斎 写 真 画 譜
Ehon. Hokusai named in cover title. 1 vol. Preface dated 1814. (KS 7/307).

186 *(Denshin Kaishu) Hokusai Manga*　「 伝 神 開 手 」 北 斎 漫 画
Ehon. Vol. 1, signed Katsushika Hokusai, seal Raishin, 1814; vols. 2/3, 1815;
vols 4/5, 1816; vols 6, 7 and 8, 1817; vols. 9/10, 1819; all signed Hokusai
aratame Katsushika Taito; vol. 11, no colophon, *c.* 1834; vol. 12, no colophon,
preface dated 1834; vol. 13, no colophon, preface dated 1849. (KS 7/307).

187 *Kinoe-no-Komatsu*　喜 能 会 の 故 真 通
Shunga. Signed Shinunan Gankō. 3 vols. Preface dated 1814. (KS 2/445).

188 *(Ehon) Jōruri Zekku*　「 絵 本 」 浄 瑠 璃 絶 句
Illustrations to *jōruri.* Signed Katsushika Hokusai, seal Raishin. (ZH gives
alternative title *Ehon Chōseiden*　絵 本 長 生 殿). 1 vol. 1815.

189 *Beibei Kyodan*　皿 皿 郷 談
Novel by Bakin. Signed Zen Hokusai Taito, seal Kishutsu Kisoku. 6 vols. 1815.
(KS 7/203).

190 *(Mongaku Shōnin Hosshin-no-Ki) Hashikuyō*
「 文 覚 上 人 発 心 の 記 」 橋 供 養
Novel by Shigeru. Signed Katsushika Hokusai-Ō (the first three prints in vol. 1;
the remainder of the illustrations are by Yasuda Raishu). 5 vols. 1815. (KS 6/595).

191 *Odori Hitori Geiko* 踊 独 稽 古
Dance instruction *ehon*. Signed Katsushika Hokusai. 1 vol. 1815. (KS 1/663).

192 *Nihon Saijiki Kyōka Shū* 日 本 歳 時 記 狂 歌 集
Kyōka-bon: Signed Taito *c.* mid-1810s. (KS 6/386).

193 *Santai Gafu* 三 体 画 譜
Ehon. Signed Hokusai *aratame* Katsushika Taito. 1 vol. 1816 (KS 3/814).

194 *Ehon Tsuhi-no-Hinagata* 絵 本 つ ひ の 雛 形
Shunga. Unsigned. 1 vol. *c.* 1816. (KS 1/497).

195 Title lacking. 欠 題
Shunga. 1 vol. See LANE in *Ukiyo-e,* Special New Year's Issue, 1977 and *Images,* 111/7).

196 *Ehon Hayabiki* 画 本 早 引
Ehon. Part 1, signed Katsushika Taito, 1 vol., 1817; Part 2, signed Zen Hokusai Katsushika Taito, 1 vol. 1819. (KS 1/499).

197 *Fukujusō* 富 久 寿 楚 宇
Shunga. Unsigned. 1 vol. 1817. Later recut issues (with mica-ground to prints), had titles *Ehon Sasemo ga Tsuyu* and *Nami Chidori* (provisional title). (YH 120/122 etc.). 会 本 佐 勢 毛 が 露　　浪 千 鳥

198 *Tsuma-gasane* 津 満 加 佐 根
Shunga. Unsigned. 3 vols. 1818. (KS 5/764).

199 *(Jūni-hyō Jūroku-dai) Kyōka Kunizukushi* 「 十 二 評 十 六 題 」 狂 歌 国 尽
Kyōka-bon. First print signed Hokusai, remainder by pupils. 1 vol. *c.* 1818. (KS 2/489).

200 *Denshin Gakyo* 伝 心 画 鏡 or *Shūga Ichiran* 秀 画 一 覧
Ehon. Signed Katsushika Hokusai. 1 vol. Preface dated 1818. (KS 5/835).

201 *Hyōsui Kiga* 萍 泙 水 奇 画
Ehon with *haikai.* 2 vols. Hokusai and Ryūkōsai named as 'collaborators' but in fact Hokusai took over, and altered, blocks made for Ryūkōsai's *Gekijō Gashi* 劇 場 画 史 (1803). (British Museum. See Chapter 10).

202 *Ehon Ryōhitsu* 画 本 両 筆
Kyoka-ehon. (Later issue, with additional colour-prints, of No. 201, *Hyōsui Kiga*). 1 vol. *c.* 1819. (KS 1/504).

203 *(Komawaka Zenden) Sakaro-no-Matsu* 「 高 麗 若 全 伝 」 逆 櫓 松
Novel by Nanritei Kiraku. Signed Zen Hokusai Taito, seal Raishin. In collaboration with Hokuun. 6 vols. 1819. (KS 3/563).

204 *(Denshin Kaishu) Hokusai Gashiki* 「 伝 神 開 手 」 北 斎 画 式
Ehon. Signed Tōto Gakō Zen Hokusai Sensei Katsushika Taito. 1 vol. 1819. (KS 7/306).

205 *Hokusai Soga* 北 斎 麁 画
Ehon. Hokusai named in preface. 1 vol. 1820. (According to NAKATA p. 101, there was an earlier title, *Ryōbi Saihitsu*) (KS 7/307). 良 美 麗 筆

206 *Wago Inshitsu Bun Eshō* 和 語 陰 隲 文 絵 抄
Ehon. Hokusai Taito. 1 vol. 1820. (ZH).

207 *Tama-kazura* 玉 加 津 羅
Shunga. Unsigned. 3 vols. *c.* 1870.

208 *(Kyōka Gafu) Hakoya-no-Yama* 「 狂 歌 画 譜 」 藐 姑 射 山
Kyōka-ehon. Later re-issue of No. 202, *Ehon Ryōhitsu.* Signed Zen Hokusai
Sensei. 1 vol. 1821. (Rijksmuseum, Leiden, Holland).

209 *Manpuku Wagō-jin* 万 福 和 合 神
Shunga. Unsigned. 3 vols. 1821. (KS 7/497).

210 *Kusa-no-Hara* 草 の は ら
Kyōka-bon. Signed Hokusai, with Hokkei, Hōitsu and others. 1 vol. 1821.
(NARAZAKI p. 343).

211 *Tōkai Tango* 東 海 探 語
Share-hon. Hokusai and Hokushu. 1 vol. 1821. (ZH).

212 *Enmusubi Izumo-no-Sugi* 偶 定 連 夜 好
Shunga. Unsigned. 1 vol. (YH p. 54 and 161. Re-issued in Meiji period under title
Tsuya-no-Hinuma).

213 *Imayō Kushi-kiseru (Sekkin) Hinagata* 今 様 櫛 簪 雛 形
Ehon, craftsmen's design book. Signed Zen Hokusai Iitsu Sensei. 3 vols. 1822/3.
(KS 1/295 and 2/642).

214 *Ippitsu Gafu* 一 筆 画 譜
Ehon. Signed Katsushika Hokusai, assisted by Hokutei, Bokusen and Hokuun.
1 vol. 1823. (KS 1/259).

215 *(Kyōka Shinsen) Kachō Fūgetsu Shū* 「 狂 歌 新 撰 」 花 鳥 風 月 集
Kyōka-bon. Signed Katsushika Iitsu (for figures), Genryūsai Hokusen (Taito II)
for the rest. 1 vol. 1824. (MFA Boston 20208, see pl. 175; also V & A 07.A12).

216 *Kyōka Kachō Fūgetsu Shū* 狂 歌 花 鳥 風 月 集
Kyōka-bon (KS 2/488 gives this as an alternative title to last, No. 215, but ZH
indicates a different book).

217 *Shingata Komon-chō* 新 形 小 紋 帳
Ehon of craftsmen's designs. Signed Zen Hokusai Iitsu. 1 vol. Preface 1824.
(KS 4/637).

218 *(Edo Ryūkō) Ryōri-tsū* 「 江 戸 流 行 」 料 理 通
Cookery book. Part 2 with print signed Hokusai Iitsu, seal Getsu(?) (with
Bunchō and others), 1 vol. 1825; Part 4, one print signed Zen Hokusai Iitsu at
75 (1834), others unsigned, (with Chinnen and others). 1 vol. 1835. (KS 8/98).

219 *Aki-no-Hana Tori Shū*
Kyōka-bon. Hokusai, Hokkei and Gyokutei. 1 vol. 1826. (BROWN p. 183, 187).

220 *Kyōka Seiryū Hyakkachō* 狂 歌 正 流 百 花 鳥
Kyōka-bon. Hokusai and Hokkei. 1 vol. 1826. (KS 2/494).

221 *Sukigaeshi (Kangon Shiryō)* 還 魂 紙 料「 か ん ご ん し り ょ う 」
Miscellany, compiler Tanehiko. Copies of old prints etc. Signed Iitsu. 2 vols.
1826. (KS 5/33).

222 *Renge-dai: Tokunari Bun Tsuizen Shū* 蓮 華 台 徳 成 文 追 善 集
Kyōka-bon. Memorial volume for Tokunari's father. 1 print signed Iitsu, others
by various artists. 1 vol. 1826. (ZH; Morse Collection, Honolulu, see pl. 176).

223 *Kyōka Shoga Jō* 狂 歌 書 画 帖
Kyōka-bon. Signed Hokusai *aratame* Iitsu, seal Fuji-no-Yama. 1 vol. 1820s.
(NARAZAKI p. 344).

224 *Ashi-no-Hitomoto* あ し の ひ と も と 「 安 詞 迺 比 斗 茂 渡 」
Haikai with commentary compiled by Tanikawa Morimono. 1 print signed
Hokusai *aratame* Iitsu. 1 vol. 1827. (KS 1/53; *Hokusai Kenkyū* No. 8 Sept. 1974).

225 *Utei Embagashō* 烏 亭 焉 馬 賀 章
Kyōka-bon. Compiler Bunbunsha Kaishimaru; Hokusai Iitsu. 1 vol. n.d.
(KS 1/386).

226 *Haikai Sanjū-rokkusen* 俳 諧 三 十 六 句 仙
Haikai-bon with portraits of *haijin*. Signed Katsushika Iitsu. 1 vol. 1827.
(KS 6/533).

227 *Bonga Hitori Keiko* 盆 画 独 稽 古
Tray-picture manual by Tsukibana Eijo. One print signed Iitsu. 1 vol. 1828.
(KS 7/370).

228 *Kachō Gasan Uta-awase* 花 鳥 画 賛 歌 合
Kyōka-bon. Signed Getchi Rōjin Iitsu. 1 vol. *c*. 1828. (MFA Boston 20210, see
pls. 177/8; BROWN p. 185 under sub-title *Shunshū-an Yomihatsu Mushiro*).

229 *Kyōka Muma Zukushi*.
Kyōka-bon. One print signed Getchi Rōjin Iitsu. *c*. 1828.

230 *Ehon Teikin Ōrai* 絵 本 庭 訓 往 来
Ehon. Signed Zen Hokusai Iitsu, seal (?). 3 vols. Vol. 1 dated 1828. Vols. 2/3
n.d. (KS 1/497).

231 *(Kyōka) Ressen Gazōshū* 「 狂 歌 」 列 仙 画 像 集
Kyōka-bon. First print signed Hokusai *aratame* Iitsu, but majority signed, or by,
Hokuga. 3 vols. 1829. (NARAZAKI p. 344; Rijksmuseum voor Volkenkunde
Leiden, Holland, 2748–1).

232 *Ehon Suikoden* 絵 本 水 滸 伝
Ehon. Signed Katsushika Zen Hokusai Iitsu. 1 vol. 1829. (KS 1/495).

233 *Chūgi Suikoden Ehon* 忠 義 水 滸 伝 画 本
Yaoya Seitan Shōzō 百 八 星 誕 肖 像
Ehon. Signed Katsushika Zen Hokusai Iitsu Rōjin. 1 vol. (KS 5/653).

234 *Ehon Hitori Keiko* 画 本 独 稽 古
Ehon. Based on *Hokusai Manga*, vol. 1. 1 vol. 1829. (MFA Boston 20121,
KS 1/300).

235 *Onna Ichidai Eigashū* 女 一 代 栄 華 集
Verse anthology. Two prints signed Zen Hokusai Iitsu at age of 72. 1 vol.
1831. (GONCOURT, p. 369; ZH).

236 *Kyōkun Kana-bumi Shikimoku* 教 訓 假 名 書 式 目
Ehon. Katsushika Hokusai. 1 vol. *c.* 1830 (RYERSON p. 266. Doubtful).

237 *Hana Fubuki En-no-Shigarami* 花 雪 吹 縁 柵
Tales by Isobe. Hokusai (cover design) and Kuniyoshi (illustrations). 6 vols.
1832. (KS 6/659).

238 *Tōshisen Ehon Gogon-zekku* 唐 詩 選 画 本 五 言 律
Illustrations to Chinese verse with commentaries. Signed Zen Hokusai Iitsu.
5 vols. 1833. (KS 6/49–50).

239 *Shusse Yakko Koman-no-Den* 出 世 奴 小 万 伝
Miscellany compiled by Ryūtei Tanehiko. Zen Hokusai Iitsu (cover), main
artist Kuninao. 4 vols. (ZH; KS 4/319).

240 *Ehon Chūkyō* 絵 本 忠 経
Illustrated 'Book of Loyalty'. Signed Katsushika Zen Hokusai Iitsu. 1 vol.
1834. (KS 1/496).

241 *Fugaku Hyakkei* 富 嶽 百 景
Ehon. 3 vols. Vols. 1/2 signed Zen Hokusai Iitsu Gakyōrōjin Manji, Fuji seal (at
age of 75 and 76 years respectively), dated 1834 and 1835; vol. 3, n.d., *c.* 1849.
(KS 7/18).

242 *Ehon Kōkyō* 画 本 考 経
(inside title *Ehon Kobun Kōkyō*) 画 本 古 文 考 経
Illustrated Confucius. Signed Zen Hokusai Manji Rōjin. 2 vols. 1834. (KS 1/493).

243 *Ehon Senjimon* 画 本 千 字 文
Chinese classic. Signed Zen Hokusai Iitsu-Ō (the frontispiece by Shōdō). 1 vol.
1835. (KS 1/495).

244 *(Shōshoku Ehon) Katsushika Shin Hinagata* 「 諸 職 絵 本 」 葛 飾 新 鄒 形
Patterns for craftsmen. Signed Zen Hokusai *aratame* Gakyōrōjin Manji. 1 vol.
1836. (KS 4/764).

245 *(Wakan) Ehon Sakigake* 「 和 漢 」 絵 本 魁
Ehon, musha-e. Signed Hokusai *aratame* Gakyōrōjin Manji. 1 vol. 1836.
(KS 1/494).

246 *Ehon Musashi Abumi* 画 本 武 鐙
Ehon, musha-e. Signed Zen Hokusai Gakyōrōjin Manji. 1 vol. 1836. (KS 1/502).

247 *Tōshisen Ehon Shichigon-zekku* 唐 詩 選 画 本 七 言 律
Illustrations to Chinese verse with commentaries. Signed Gakyōrōjin Manji-Ō.
5 vols. 1836. (KS 6/49–50).

248 *Genji Ittō Shi* 源 氏 一 統 志
Story-book by Shōtei Kinsui. Hokusai Iitsu. 10 vols. 1836. (KS 3/114; RYERSON
p. 268).

249 *Nikkō-San Shi* 日 光 山 志
Topographical description of the Nikkō Shrine. One four-page landscape
signed Gakyōrōjin Manji, other illustrations by various artists. 5 vols. 1837.
(KS 6/634).

250 *Kachō Gasan-shū* 花 鳥 画 賛 集
Kyōka-bon. Katsushika Hokusai. 1830s. (*Kyōka Shōmoku Shūsei*; possibly identical
to *Kachō Gasan Uta-awase*, No. 228 above).

251 *Iitsu Manga* 為 一 漫 画
Ehon. Reduced version of vol. 2 of *Imayō Kushi-kiseru Hinagata*. 1 vol. 1838.
(MFA Boston).

252 *Wakan Inshitsu Den* 和 漢 陰 隲 伝
Moral instruction. Signed Zen Hokusai *aratame* Gakyōrōjin Manji. 1 vol. 1840.
(KS 8/229, citing earlier, but unconfirmed, editions).

253 *Shaka Go-icki-dai-ki Zue* 釈 迦 御 一 代 記 図 会
Story of Shakyamuni by Yamada Issai. Signed Zen Hokusai Manji Rōjin.
6 vols. 1841. (KS 4/199) (Re-issued in 1845).

254 *(Gempei Nakashira) Ehon Musha Burui* 「 源 平 名 頭 」 絵 本 武 者 部 類
Ehon, musha-e. Signed Hokusai *aratame* Katsushika Iitsu. 1 vol. 1841. (KS 1/499,
but with variant title).

255 *Ippitsu Ehon* 一 筆 絵 本
Ehon. Reduced version of *Ippitsu Gafu* No. 214. 1 vol. 1842. (LANE No. 247).

256 *(Teisei Hokoku) Ehon Kanso Gundan* 「 訂 正 補 刻 」 絵 本 漢 楚 軍 談
Novel by Shōryō Sadataka. Signed Katsushika Manji-Ō Hachiemon. Part 1,
10 vols., 1843; Part 2, 10 vols., 1845. (KS 1/492).

257 *Manji-Ō Sōhitsu Gafu (sumi)* 卍 翁 草 筆 画 譜 (墨 摺)
Hokusai Manga: Sōhitsu-no-Bu (colour-printed)
北 斎 漫 画 草 筆 之 部 (彩 摺)
Ehon. Signed Hokusai Manji-Ō. 1 vol. 1843. (Also re-issued 1877 under title
Hokusai Gaen). 北 斎 画 苑 (KS 7/306).

258 *Ehon Onna Imagawa* 絵 本 女 今 川
Ehon. Hokusai. 1 vol. 1844 or *c*. 1828(?). (KS 1/491).

259 *Hokusai Manga* 北 斎 漫 画
Ehon. Katsushika Hokusai. 1 vol. 1845. (Not connected with the well-known
series). (RYERSON pl. 264).

260 *Hokusai Manga Haya Shinan* 北 斎 漫 画 早 指 南
Ehon. Re-issue of *Haya Oshie* volumes. 2 vols. *c*. 1845. (KS 7/307).

261 *Retsujo Hyakunin Isshu* 烈 女 百 人 一 首
Verse anthology. Compiler Rokutei Senryū. Signed Katsushika Manji Rōjin (in
collaboration with Kunisada). 1 vol. 1847. (KS 8/145).

262 *Eyō Hinagata* 絵 様 鄙 形
Pattern-book for craftsmen. Signed Gakyōjin Hokusai. 1 vol. 1847. (MFA
Boston 26999).

263 *Ehon Saishiki Tsū*　絵 本 彩 色 通
Painting instruction manual. Signed Gakyōrōjin Manji. 2 vols. 1848. (KS 1/494).

264 *Shūga Hyakunin Isshu*　秀 雅 百 人 一 首
Verse anthology. Signed 88-year-old Manji. (In collaboration with Kuniyoshi, Kunisada, Eisen and Yanagawa Shigenobu). 1 vol. 1848. (KS 4/240).

265 *Sokuseki Hōchō*　即 席 庖 丁
Cookbook. Colour frontispiece signed Manji Iitsu, aged 89. *c.* 1848. (LANE No. 256).

266 *Hokusai Gafu*　北 斎 画 譜
Ehon. Compilation from *Hokusai Gashiki* and *Hokusai Soga*, (Nos. 204/205). Preface to vol. 3, 1849. 3 vols. (KS 7/307).

267 *Zoku Eiyū Hyakunin Isshu*　続 英 雄 百 人 一 首
Verse anthology. Signed Zen Hokusai Manji Rōjin. (In collaboration with Kuniyoshi, Sadahide, Yanagawa Shigenobu and Kunisada). 1 vol. 1849. (KS 302).

POSTHUMOUSLY PUBLISHED BOOKS

Only those books published in the first few years after Hokusai's death are listed. Hokusai is known, in some cases explicitly, in others by inference, to have made designs for these books: later books bearing his name are compilations – such as the *Manga* vols. 14 and 15 – made by aftercomers.

268 *Ehon Wakan-no-Homare*　画 本 和 漢 誉
Musha-e ehon. Signed Zen Hokusai Gakyōrōjin Manji. 1 vol. 1850. (KS 1/504).

269 *Sōzan Chobun Kishū*　想 山 著 聞 奇 集
Guide-book. Two prints signed 88-year-old Manji. Other illustrations by various artists. 3 vols. 1850. (KS 5/259).

270 *Giretsu Hyakunin Isshu*　義 烈 百 人 一 首
Verse anthology. Signed Zen Hokusai Manji Rōjin, (in collaboration with Kuniyoshi, Yoshitora, Sadahide and Kunisada). 1 vol. 1850. (KS 2/577).

271 *Kijin Hyakunin Isshu*　畸 人 百 人 一 首
Verse anthology. Hokusai (unsigned, but presumed to be his work from the style) for the opening section, the remainder by Utagawa artists. 1 vol. 1852. (KS 2/414).

272 *Hokusai Ringa: Shōhen*　北 斎 臨 画 初 篇
Ehon, based on *Hokusai Gaen* and *Hokusai Zuko*, n.d. 1 vol. (KS 7/307).

Glossary and Index

Figures in italic refer to the Appendix on page 261; those in roman to the text page numbers